Compositions Book 14

Music for Large Ensembles

by
Ken Langer

Compositions Book 14

Original Music for Large Ensembles

by
Ken Langer

Compositions Book 14
Original Music for Large Ensembles
by Ken Langer

Klangermuzik
http://klangermuzik.com

First Edition (Softcover)

Copyright © 2013, Ken Langer

ISBN: 978-1-300-92529-3

All rights reserved. No Part of this book may be reproduced or transmitted in any form or by any means, electronic or mechanical, including photocopying, recording or by any information storage and retrieval system, without written permission from the author, except for the inclusion of brief quotations with proper annotation.

Produced in the United States of America

The author may be contacted at ken@kenlanger.com.

Table of Contents

1	A Single Voice	horn solo, wind ensemble	9
2	Catamount Arise	orchestra	31
3	Journey Up Star Mountain	wind ensemble	53
4	Voices of 1918	orchestra	83

Introduction

This is a collection of four works for large ensembles. *A Single Voice* was commissioned by Dr. Susan Salminen. It is written for solo horn and wind ensemble. *Catamount Arise* was written for the University of Vermont Orchestra and was premiered by them. It honors the college's mascot. *Journey Up Star Mountain* was written for the Eurydice Community Orchestra of Roanoke, Virginia. It is actually written for wind ensemble and commemorates the large illuminated star that is a famous landmark for Roanoke. *Voices of 1918* was commissioned by the Vermont Symphony Orchestra. The commission required the inclusion of a poem from Vermont poet Ellen Bryant Voigt. The poem described the horrors of the effects of the 1918 influenza epidemic that hit the country just at the end of World War I.

For more information and to hear recordings and transcriptions of music in this and all the other collections please visit http://klangermuzik.com.

A Single Voice

(commissioned by Dr. Susan Salminen)

Ken Langer

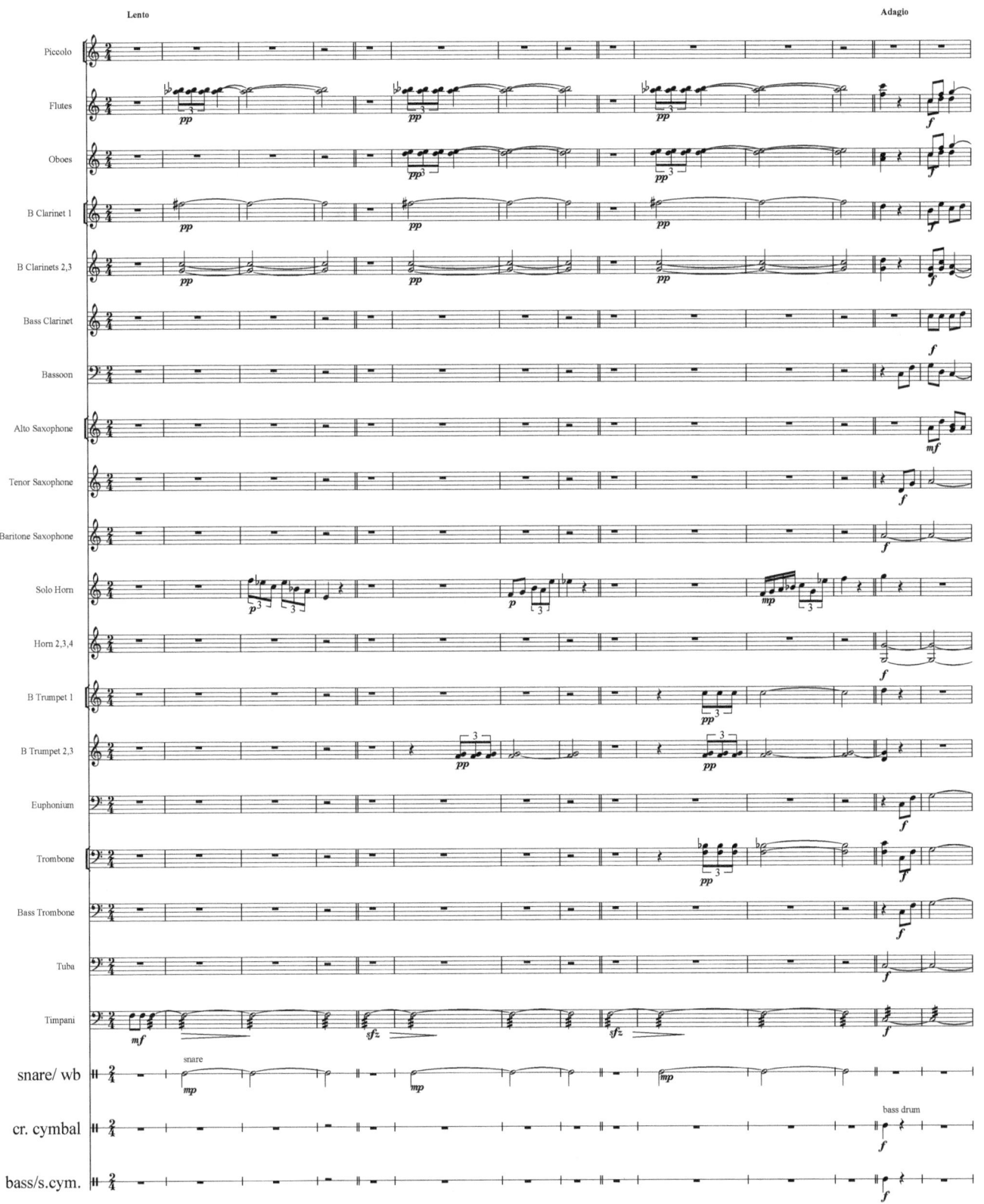

9

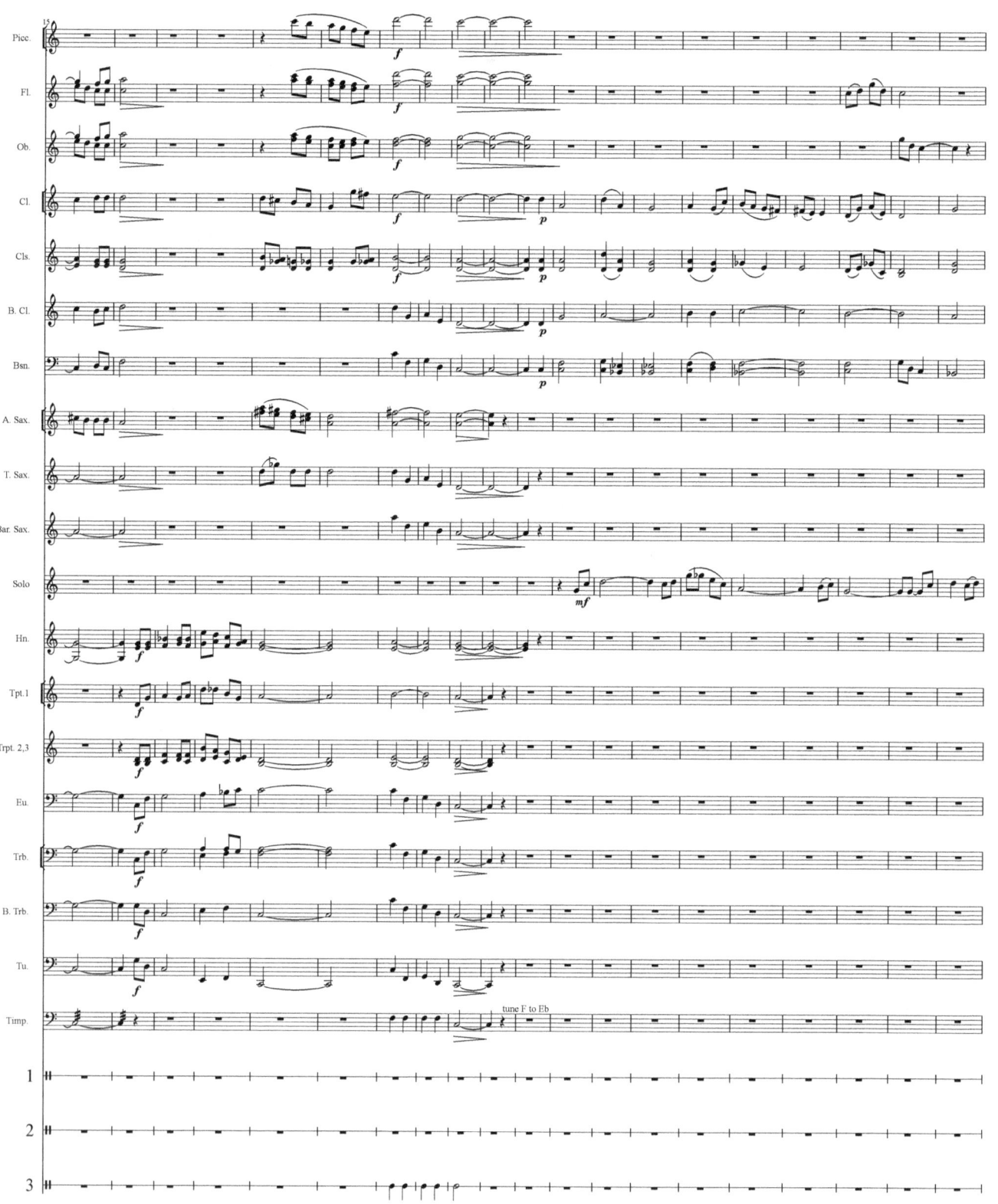

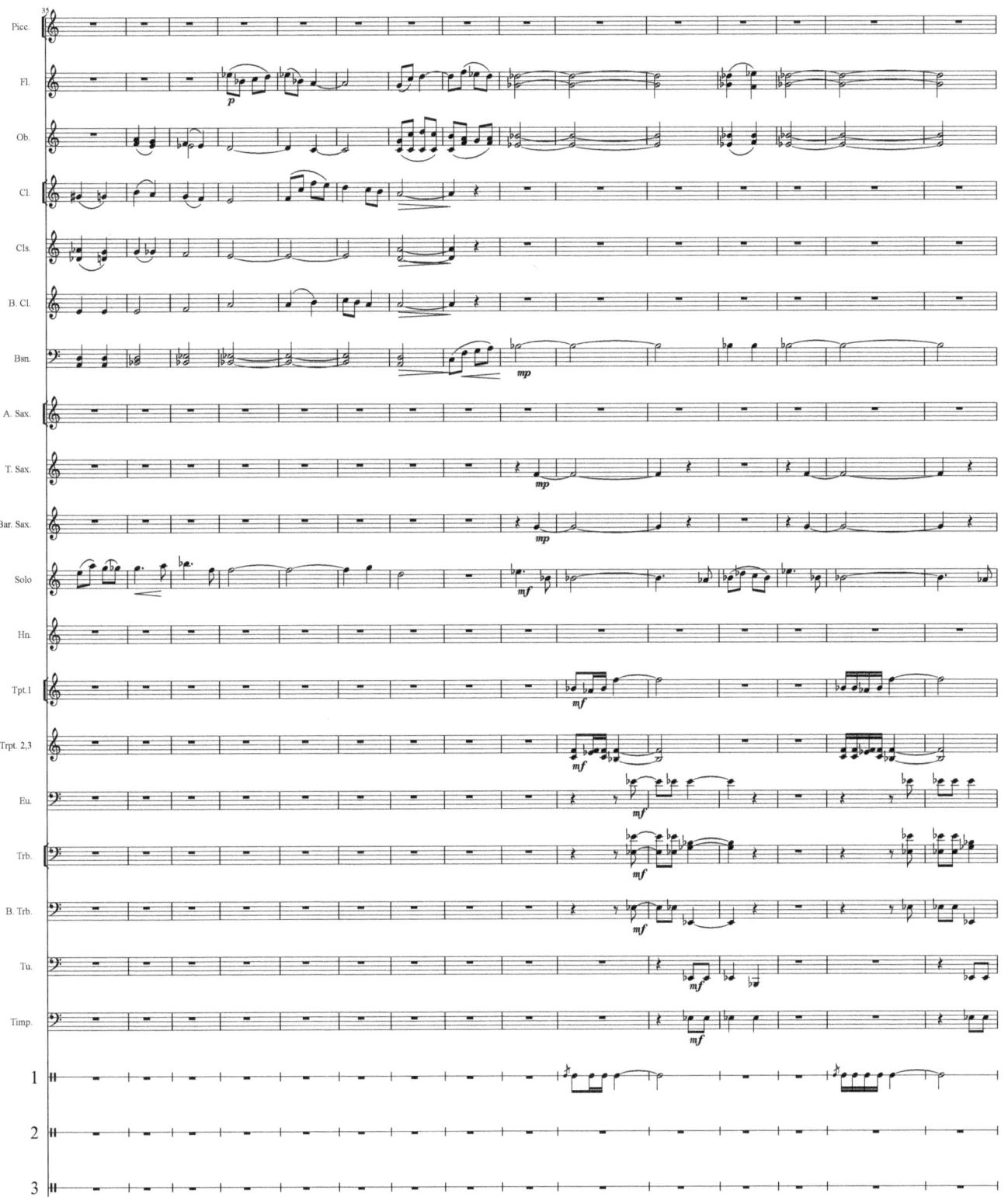

11

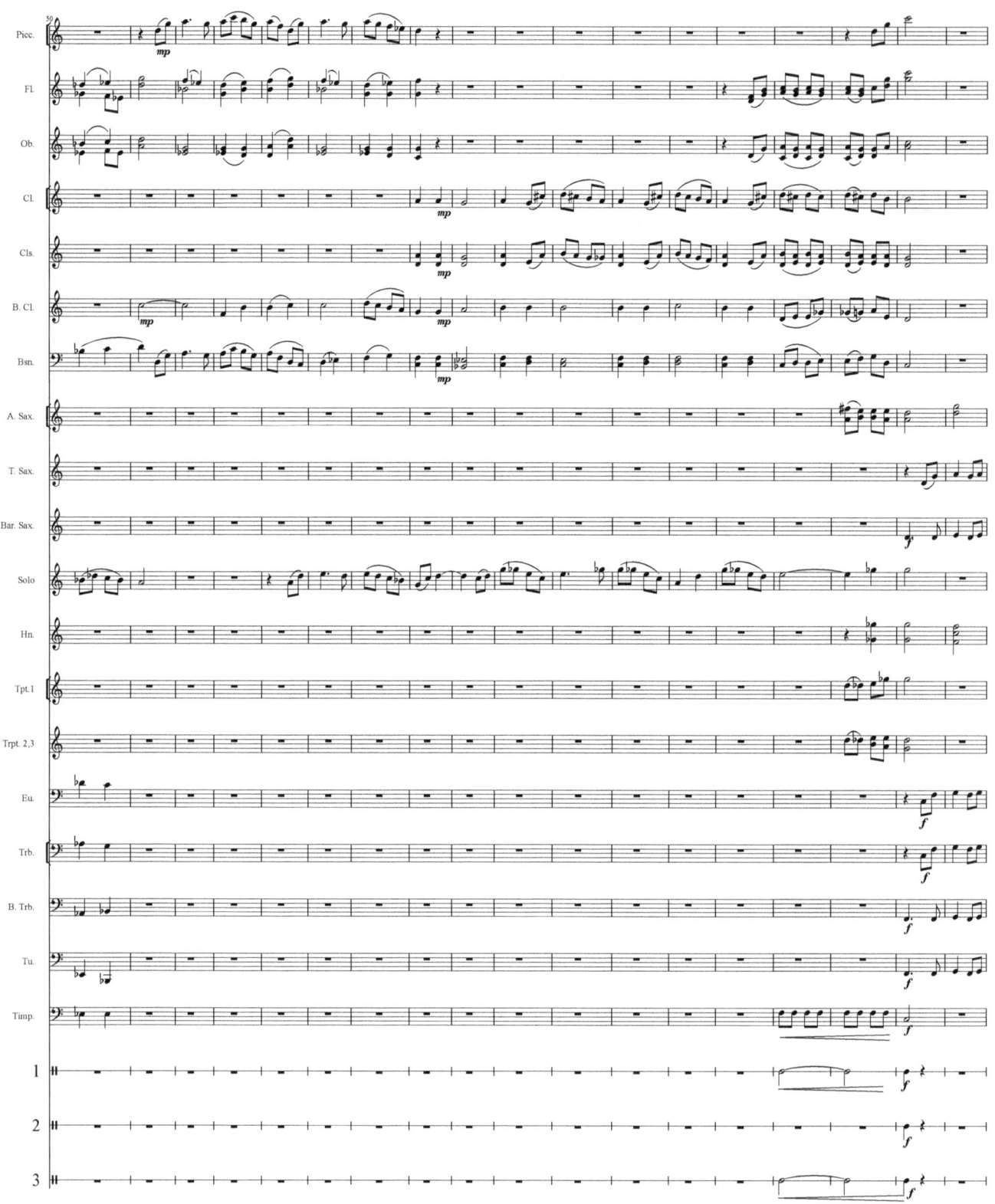

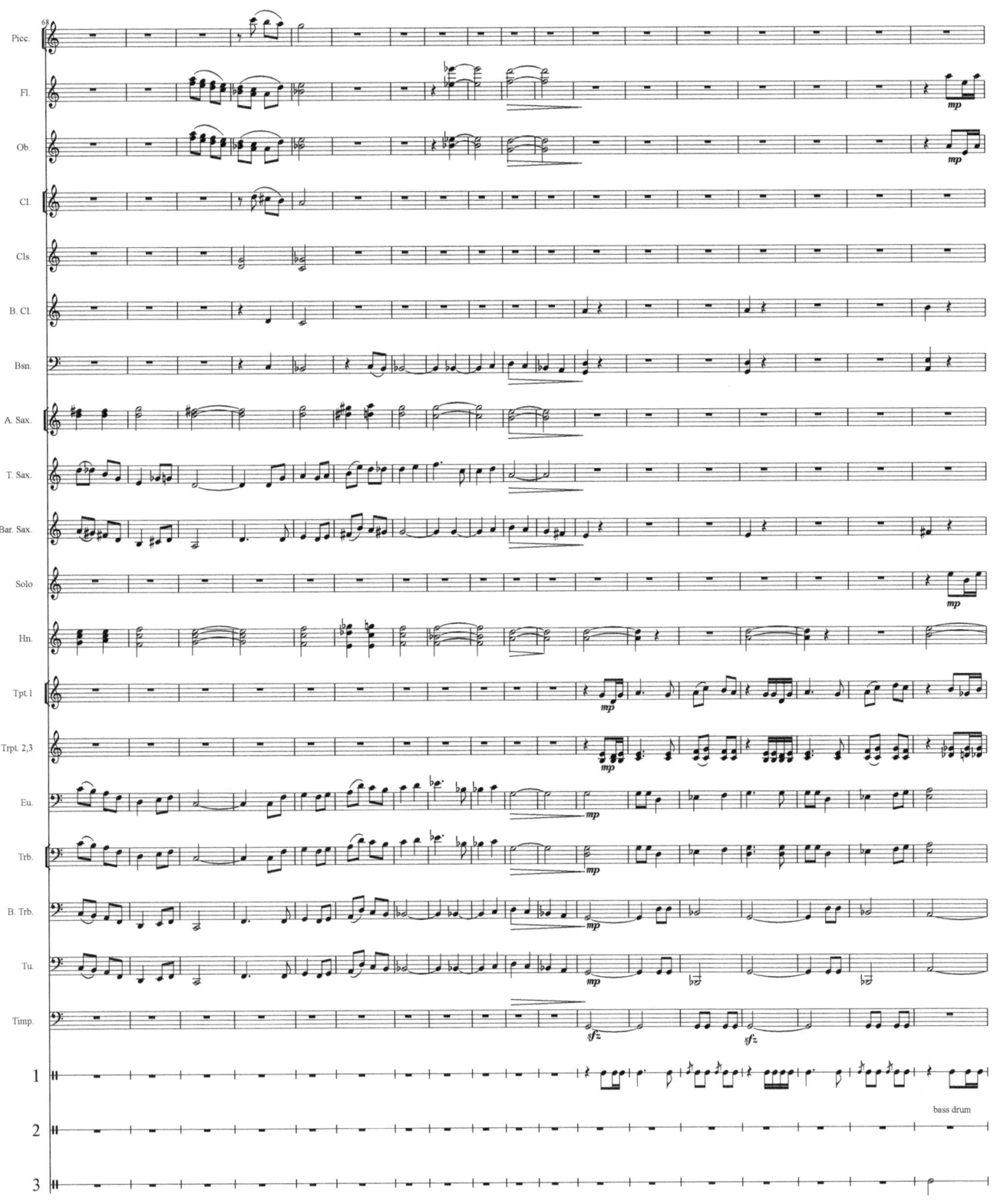

13

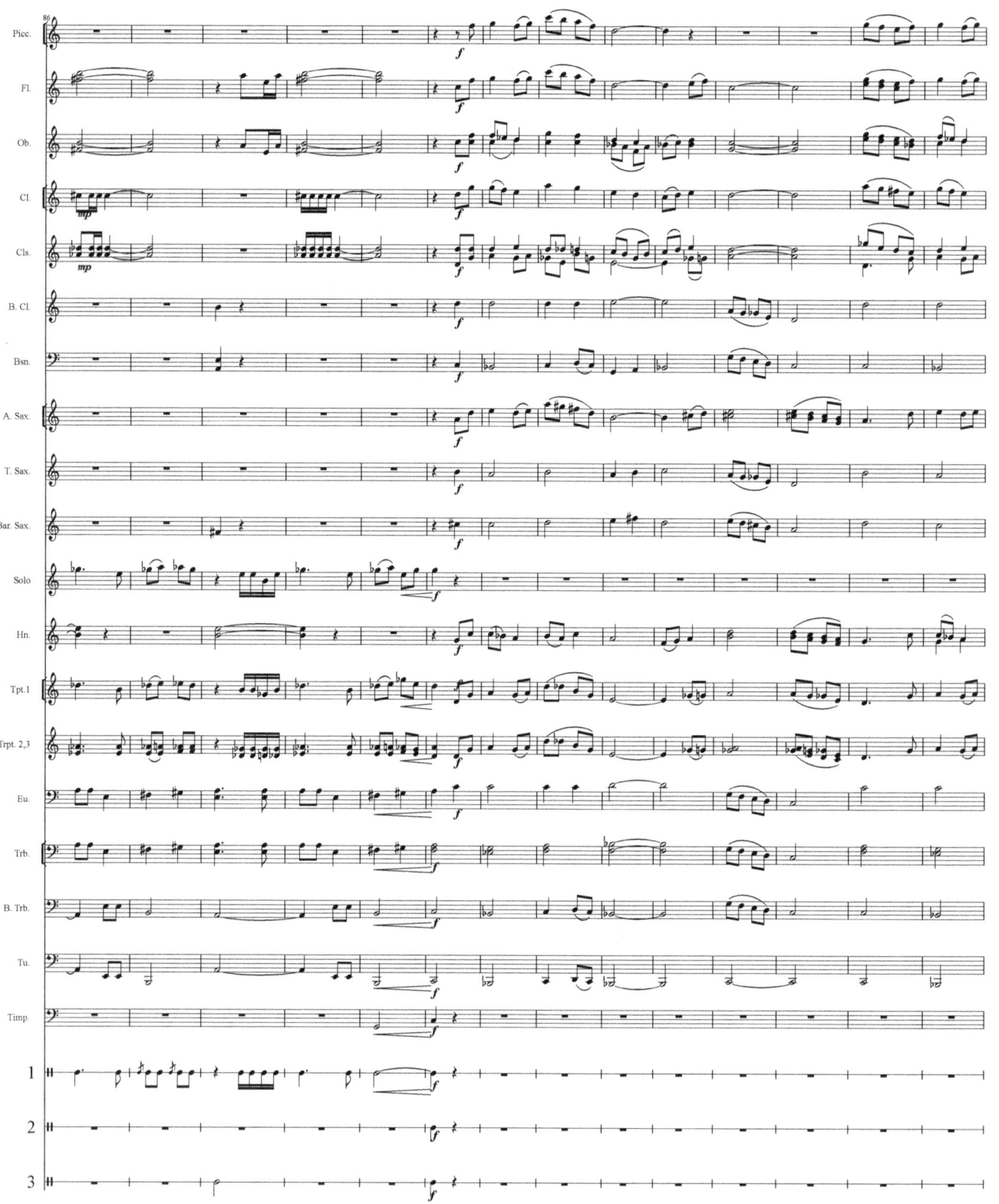

15

16

19

21

22

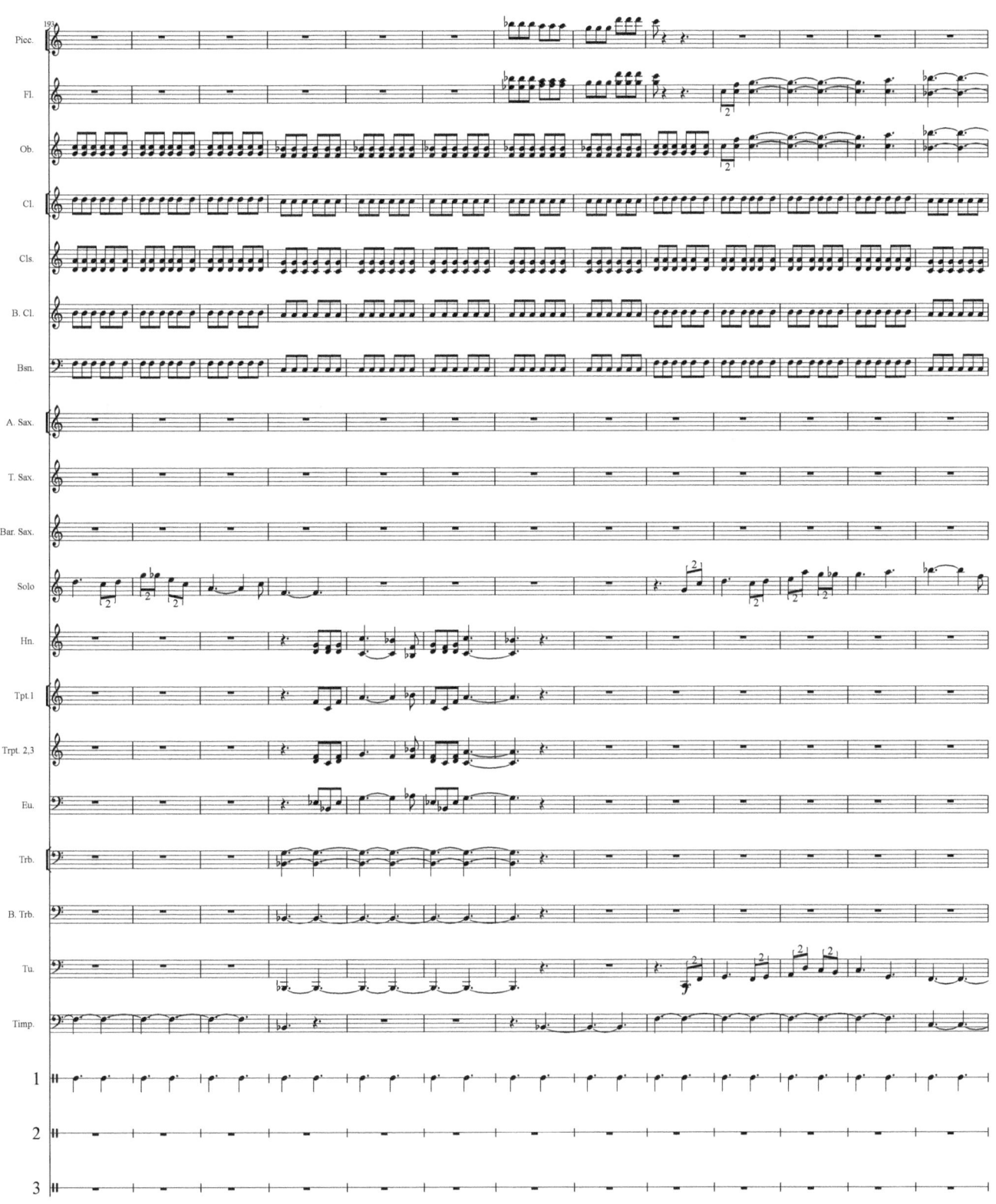

23

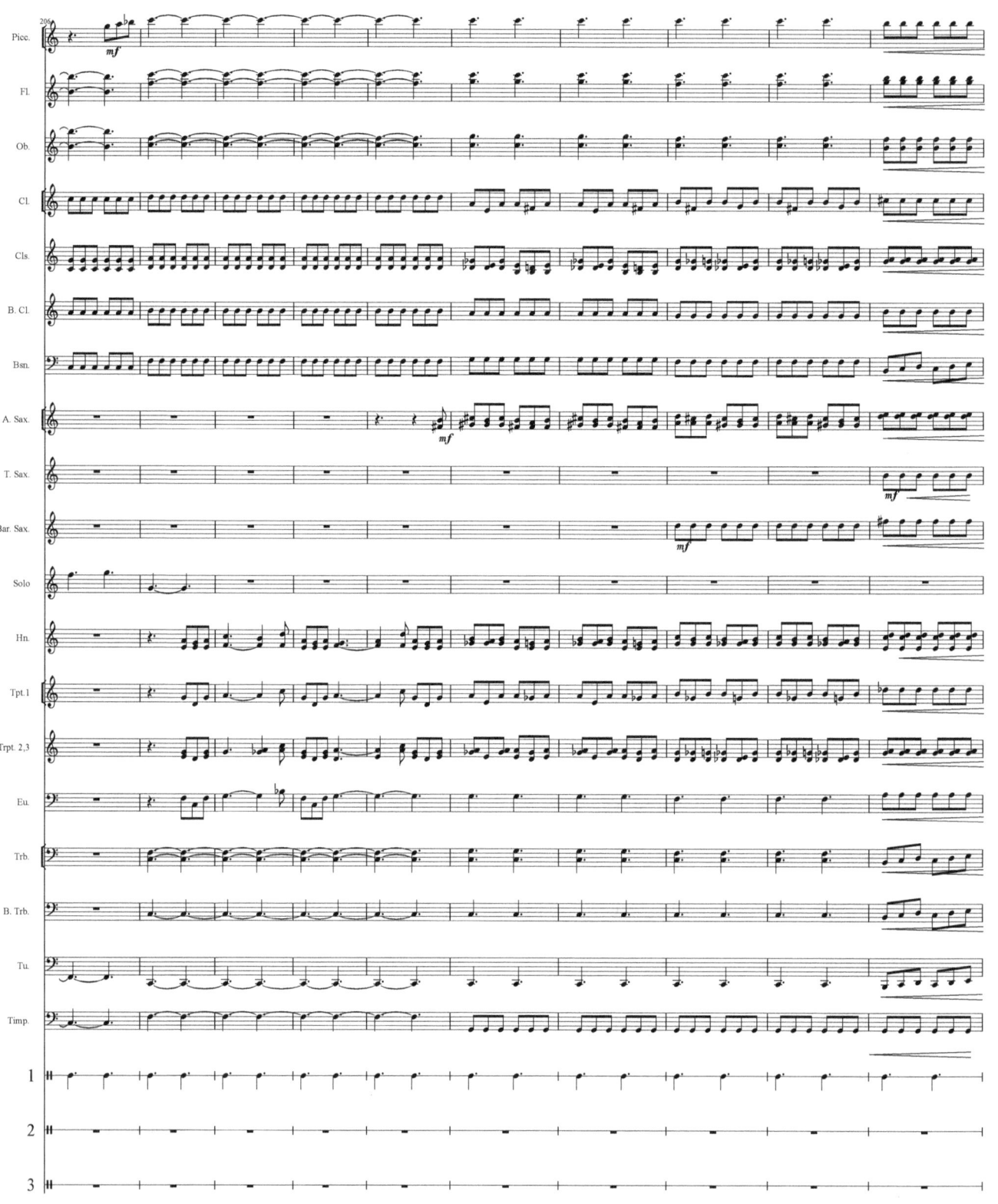

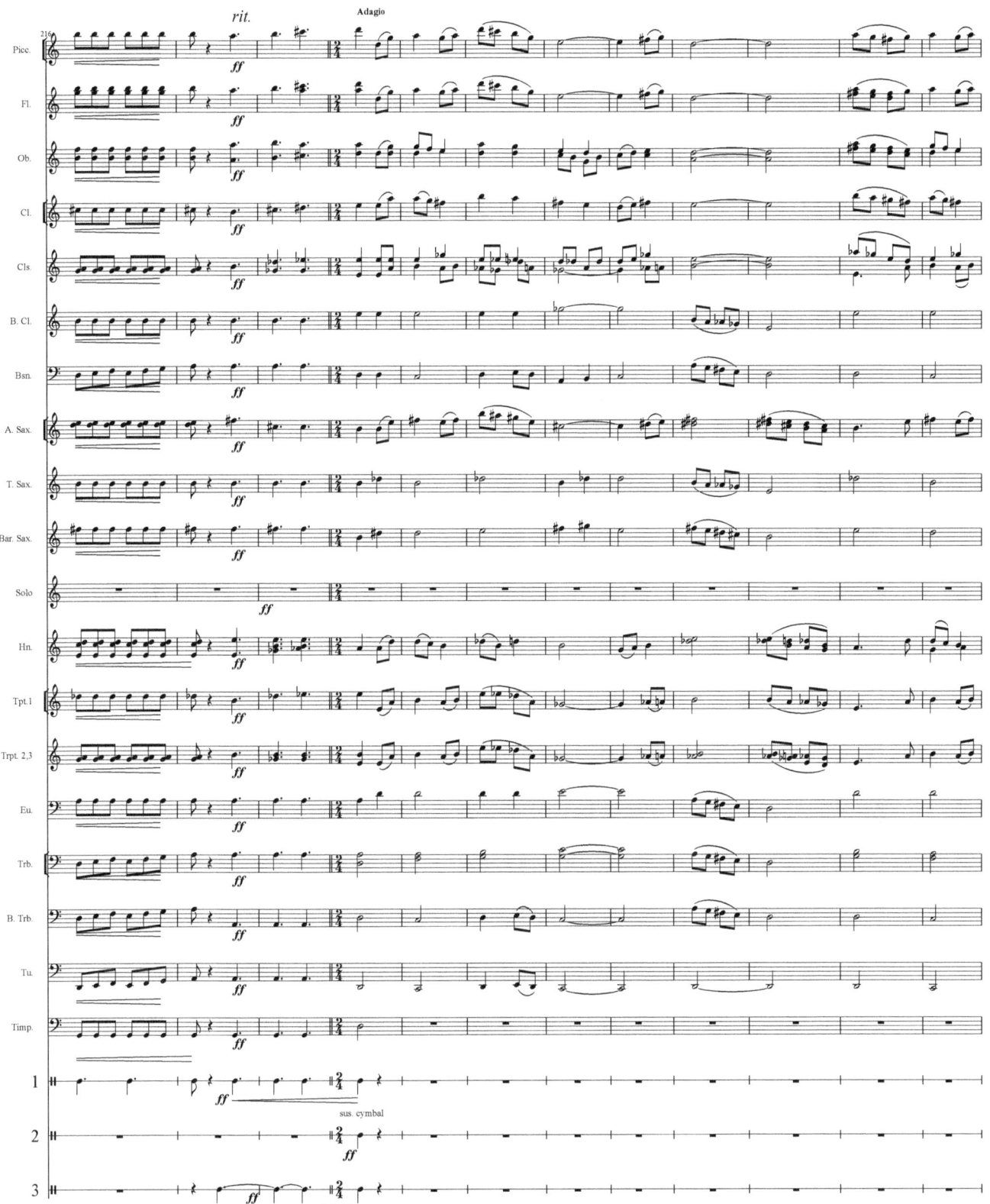

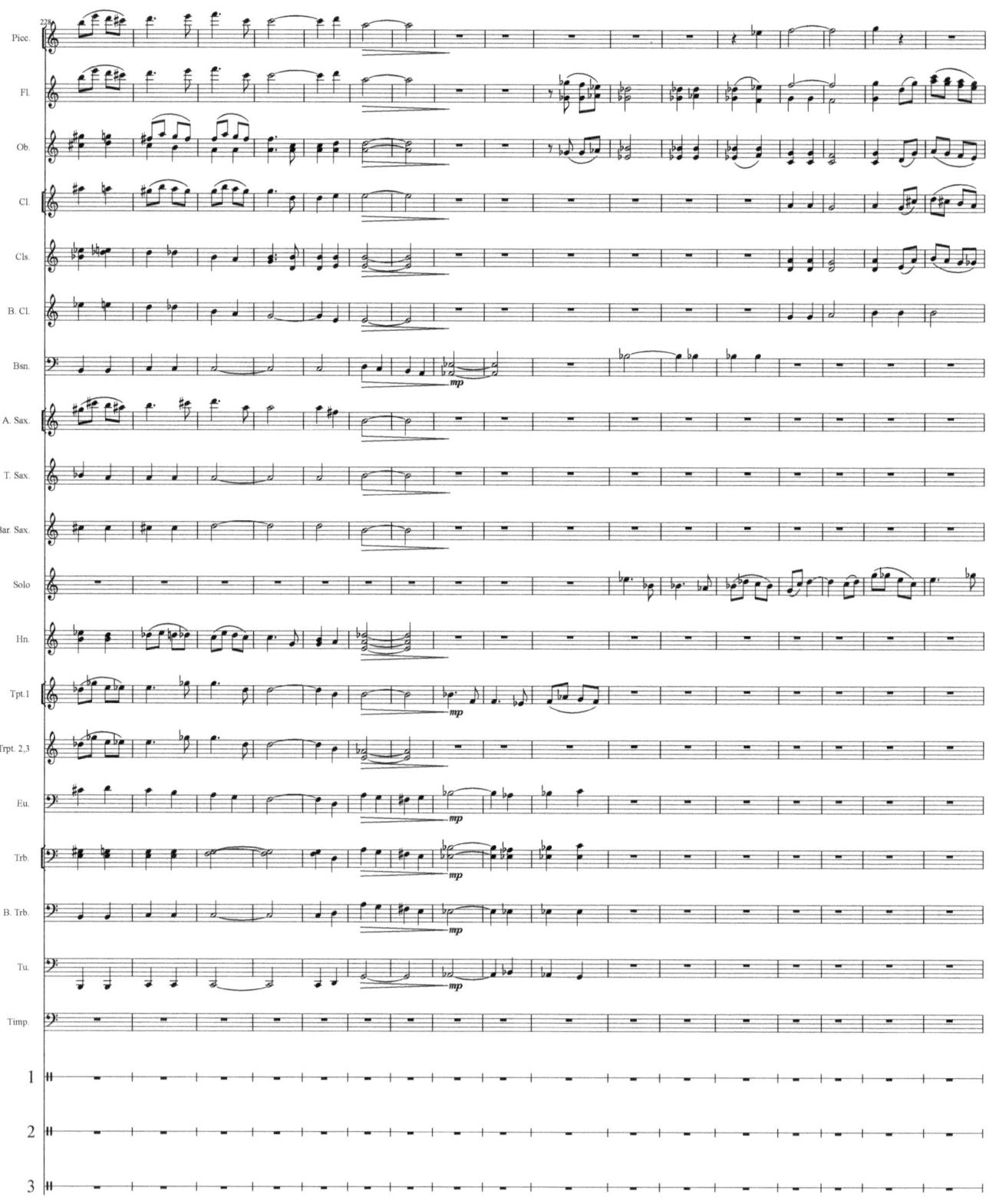

Catamount Arise

Ken Langer

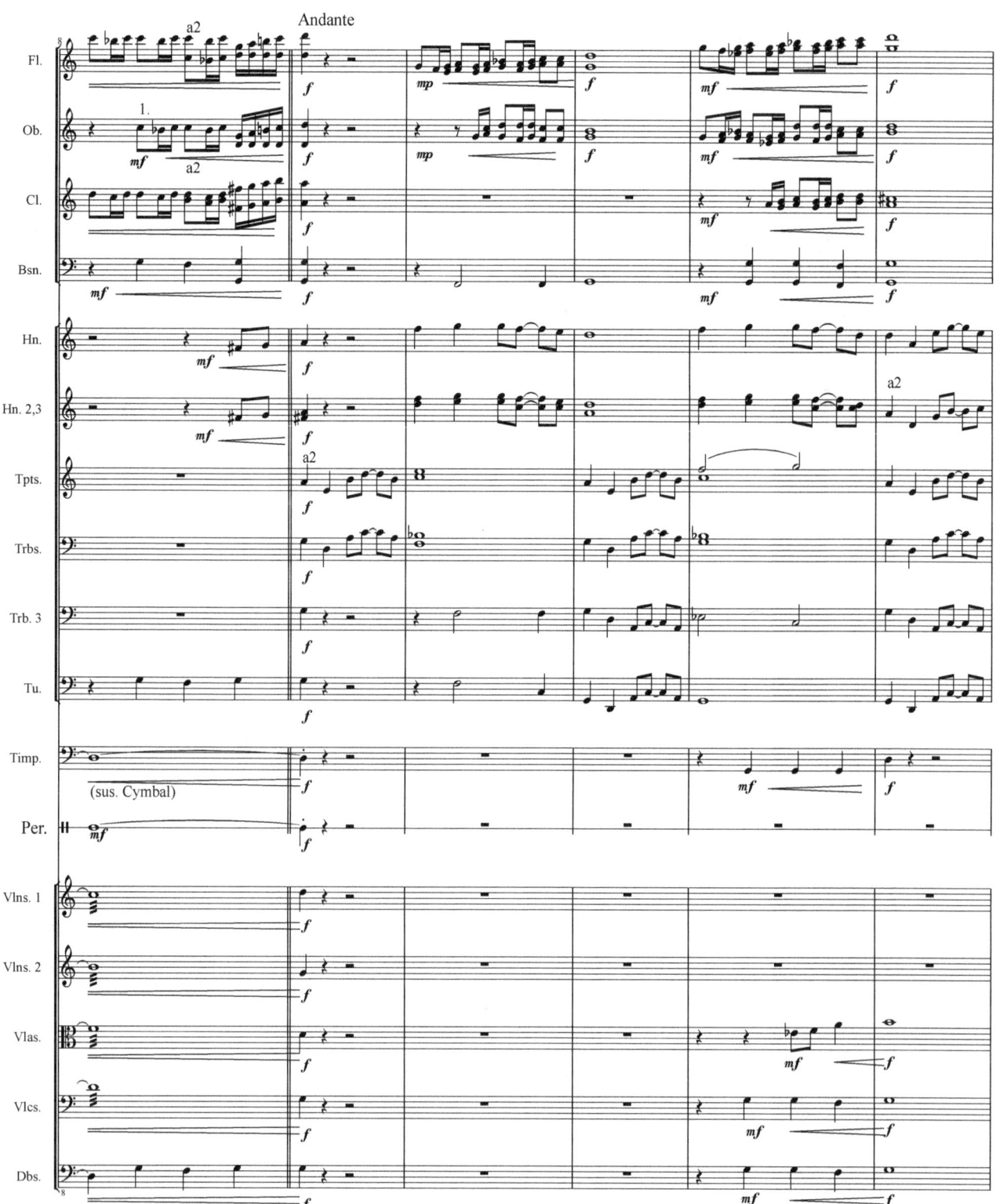

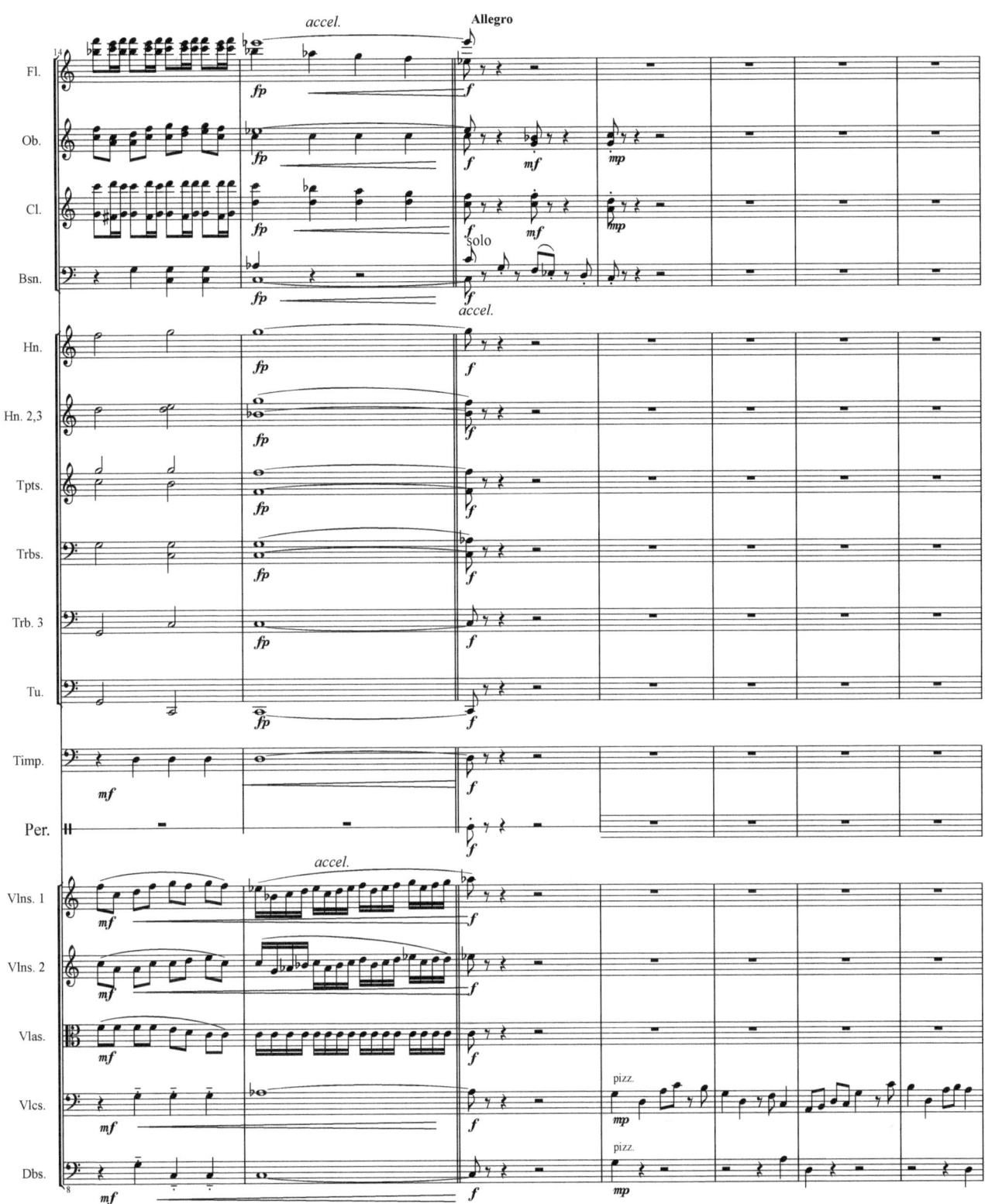

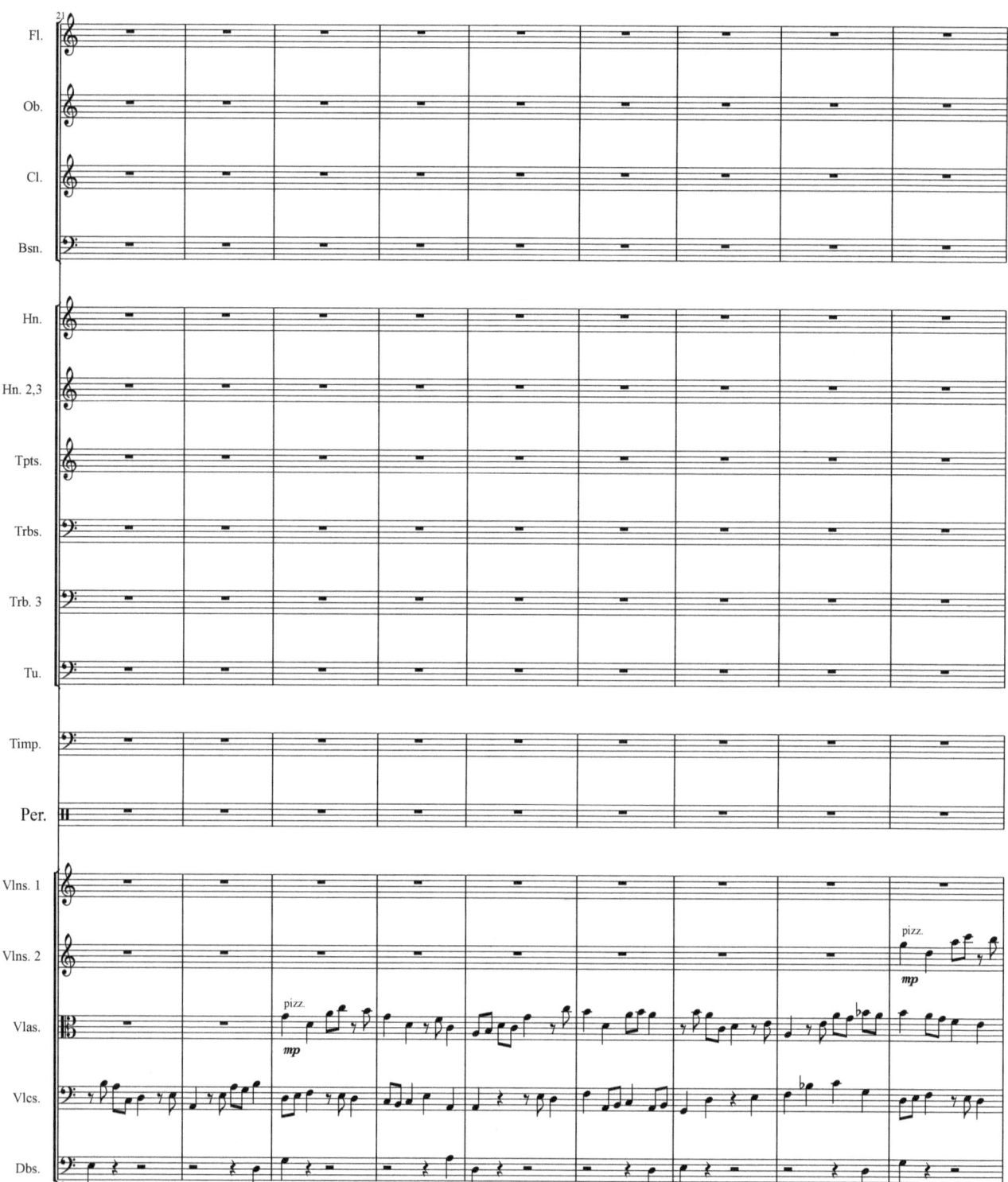

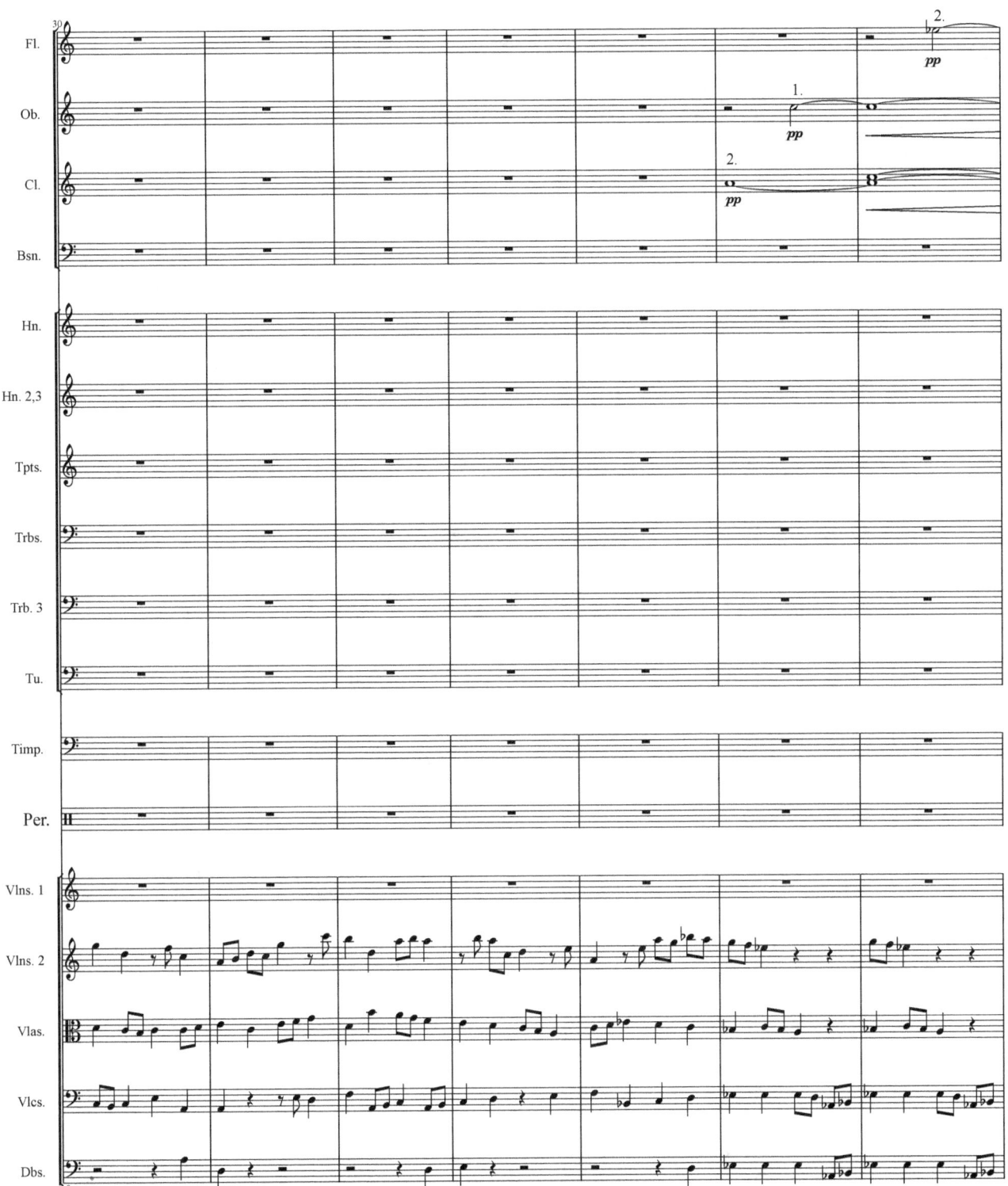

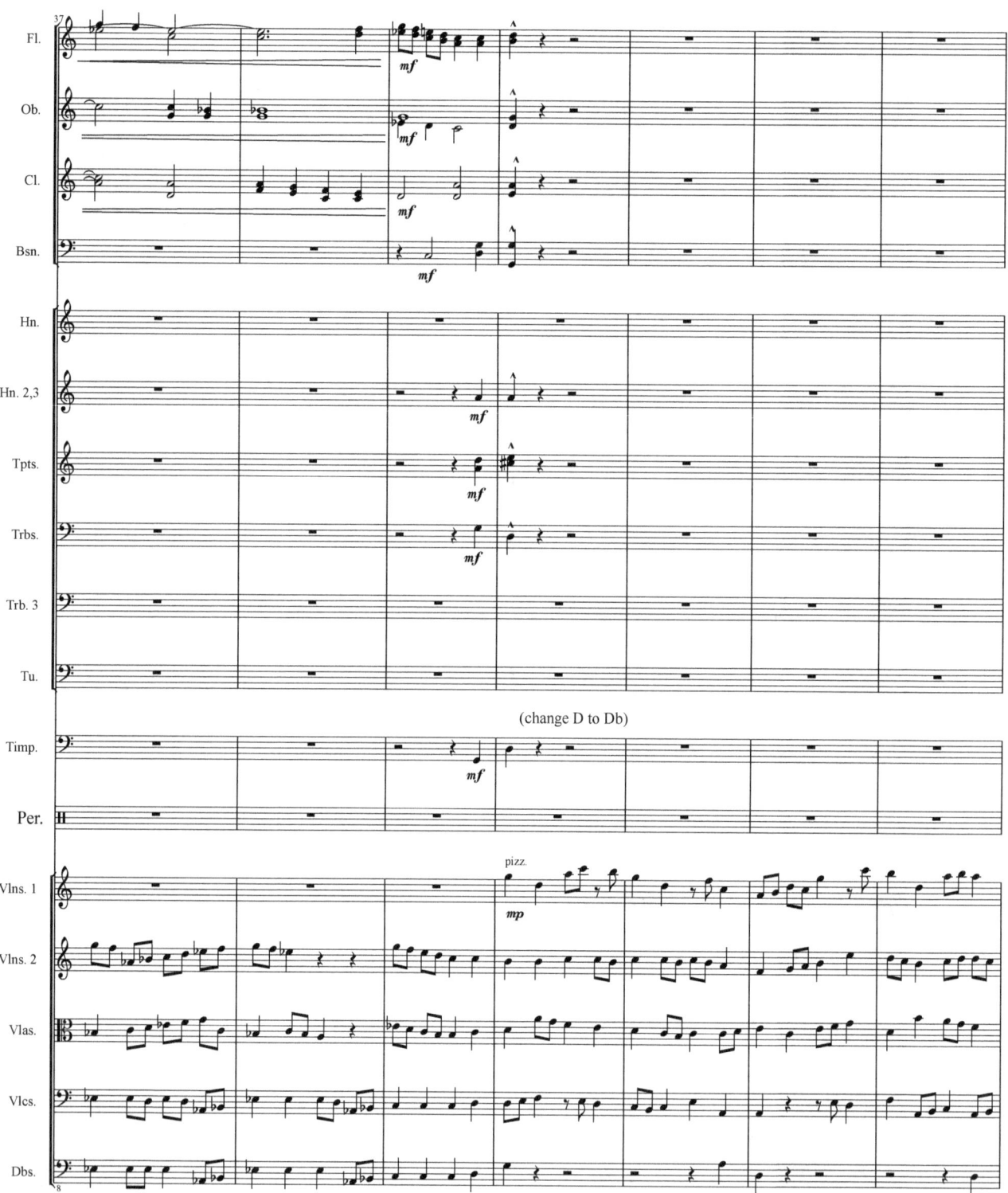

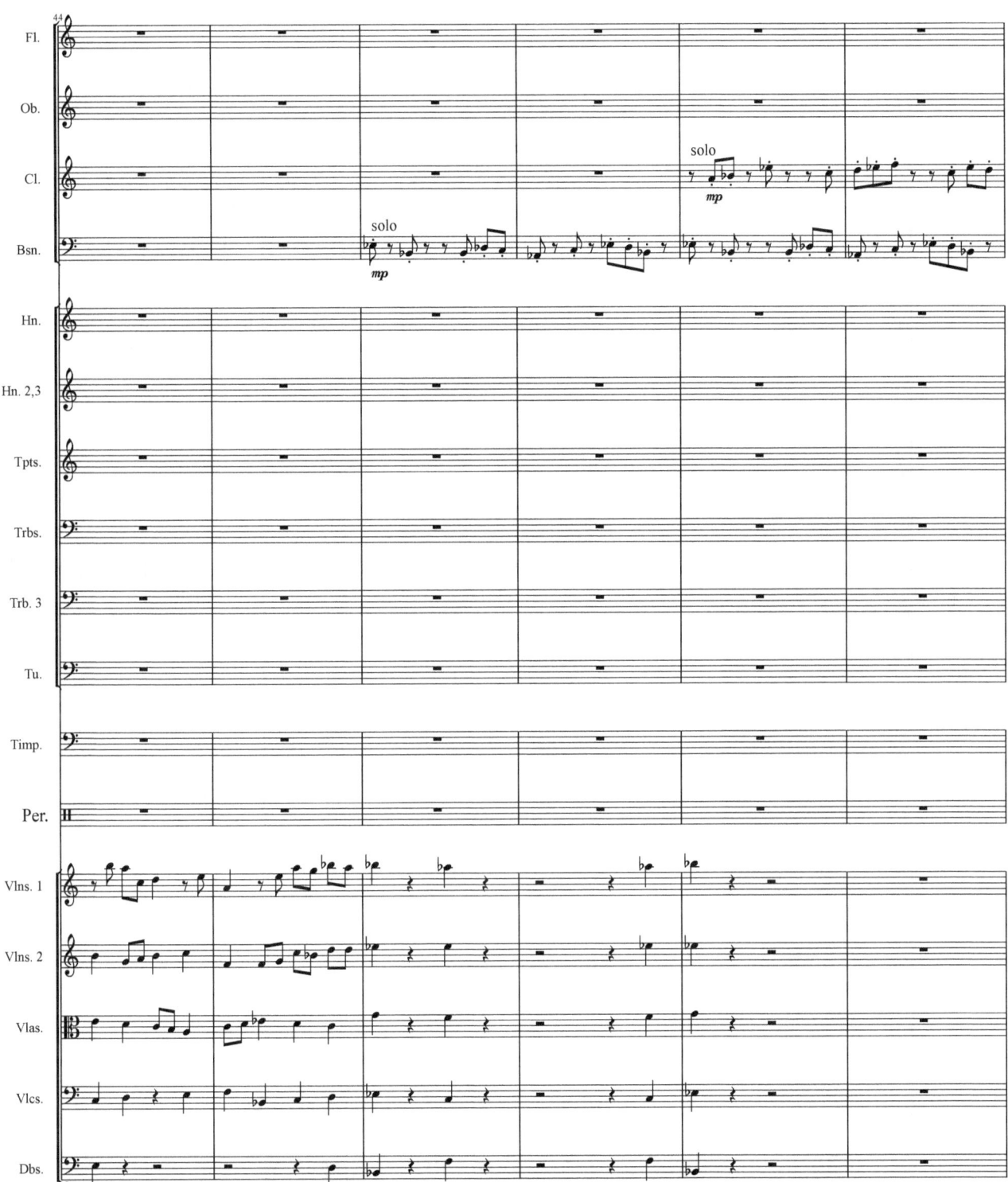

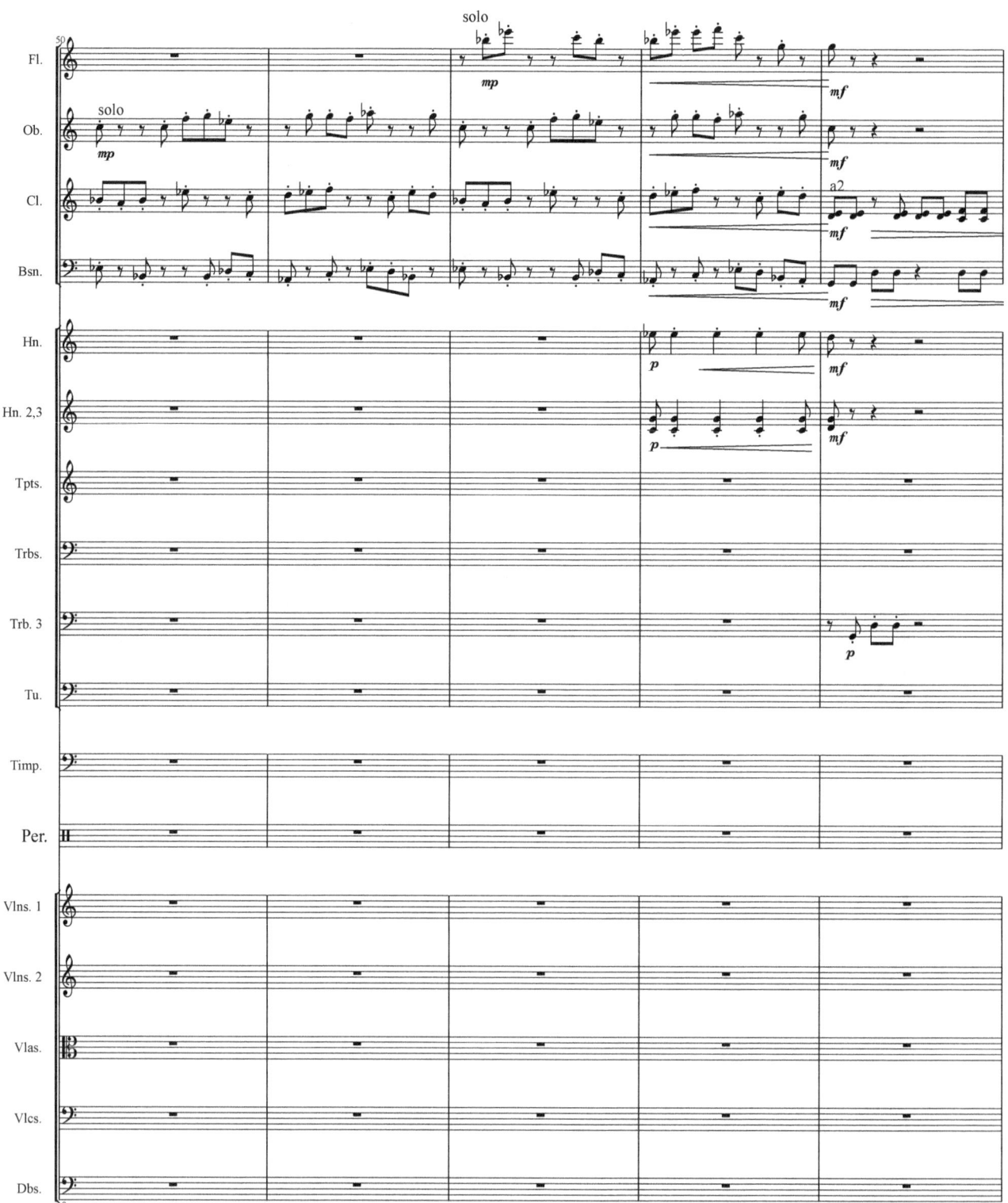

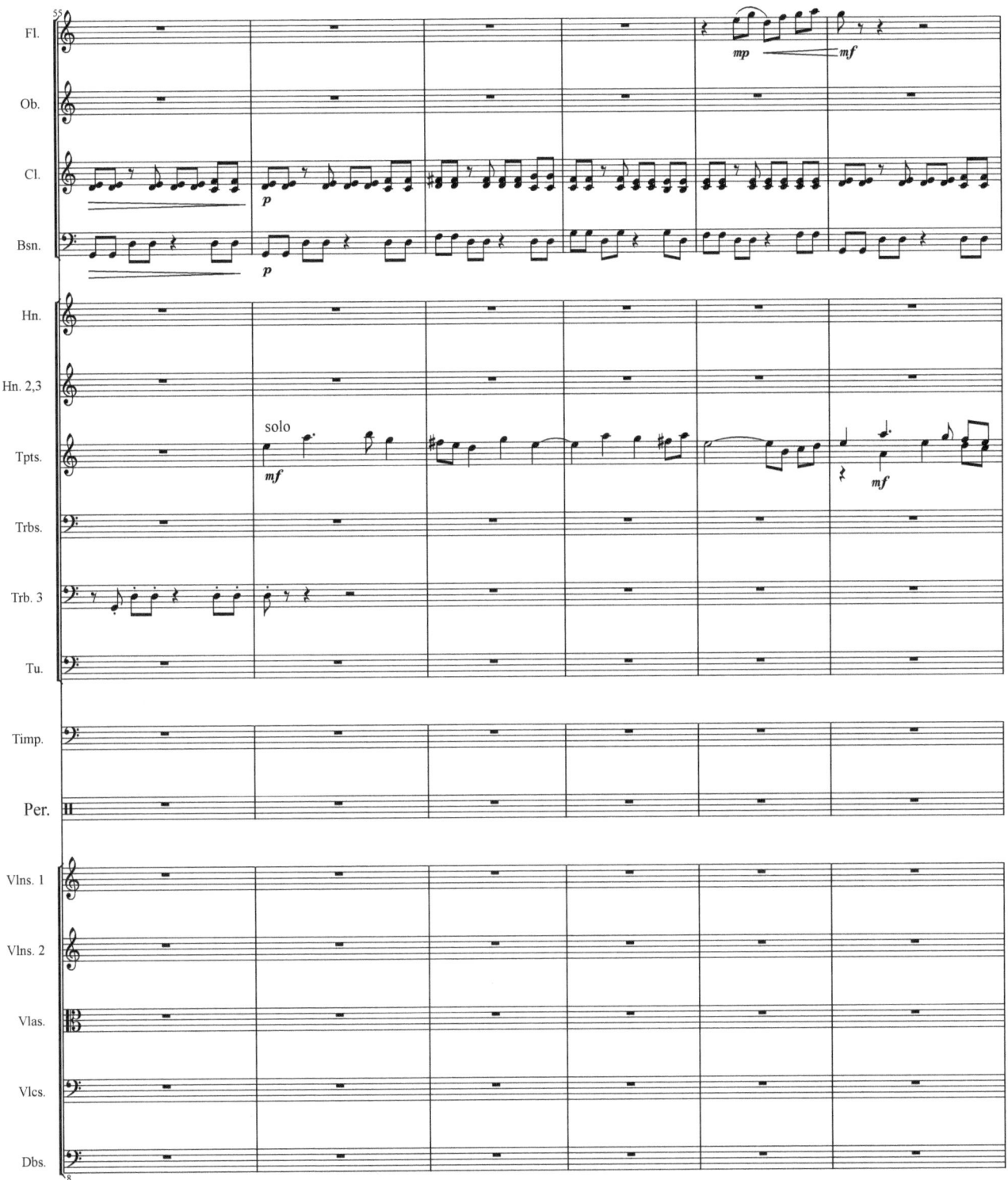

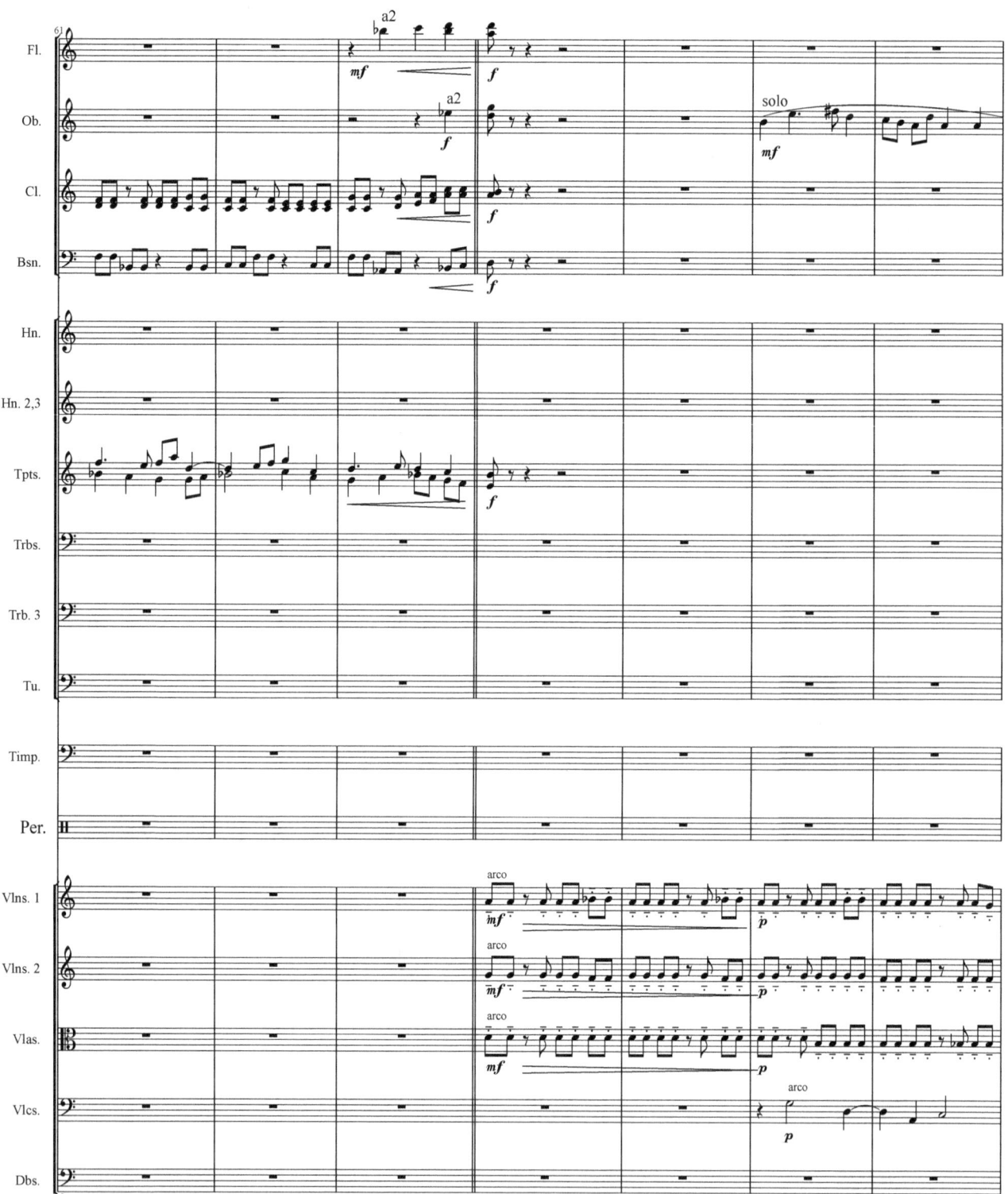

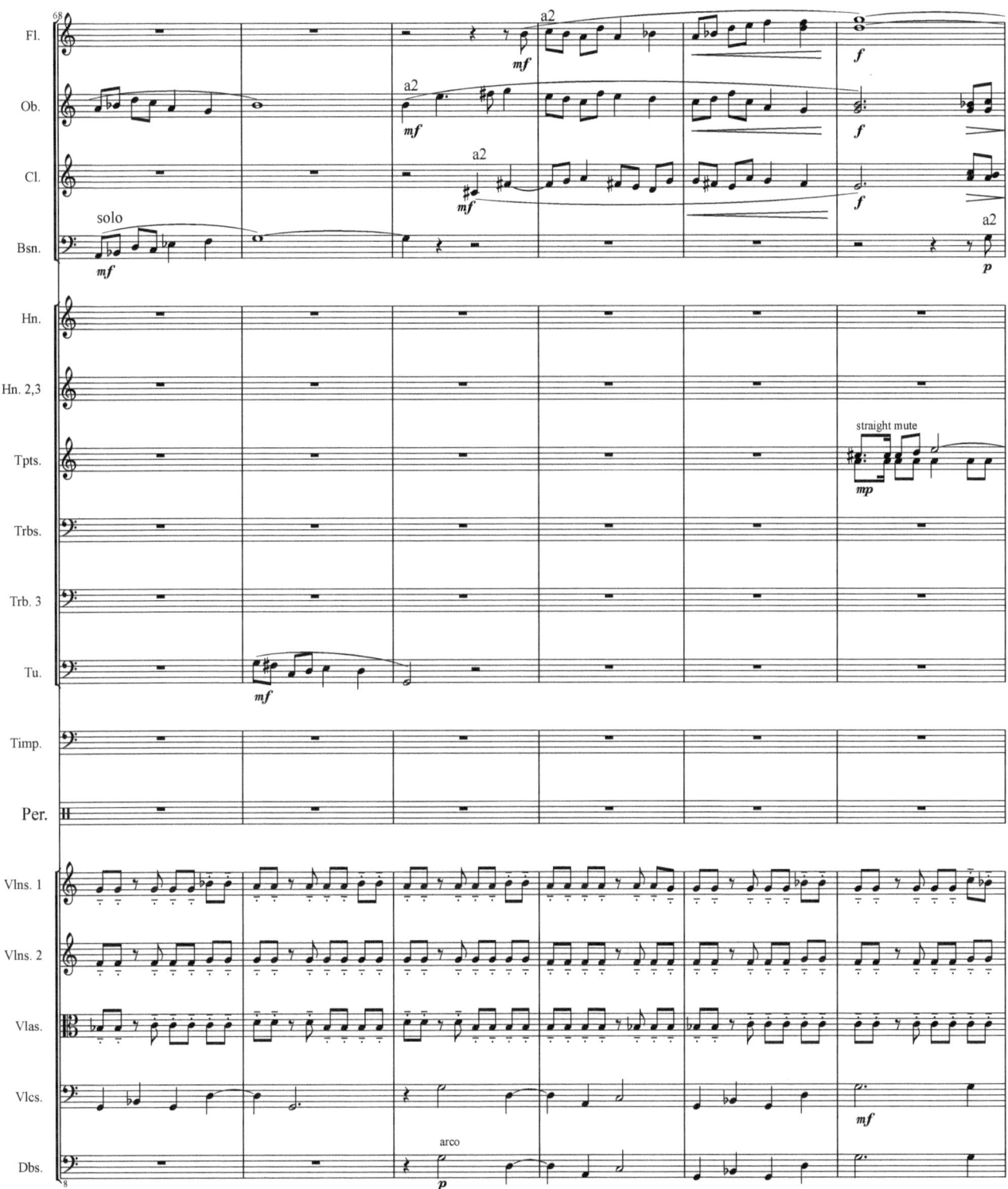

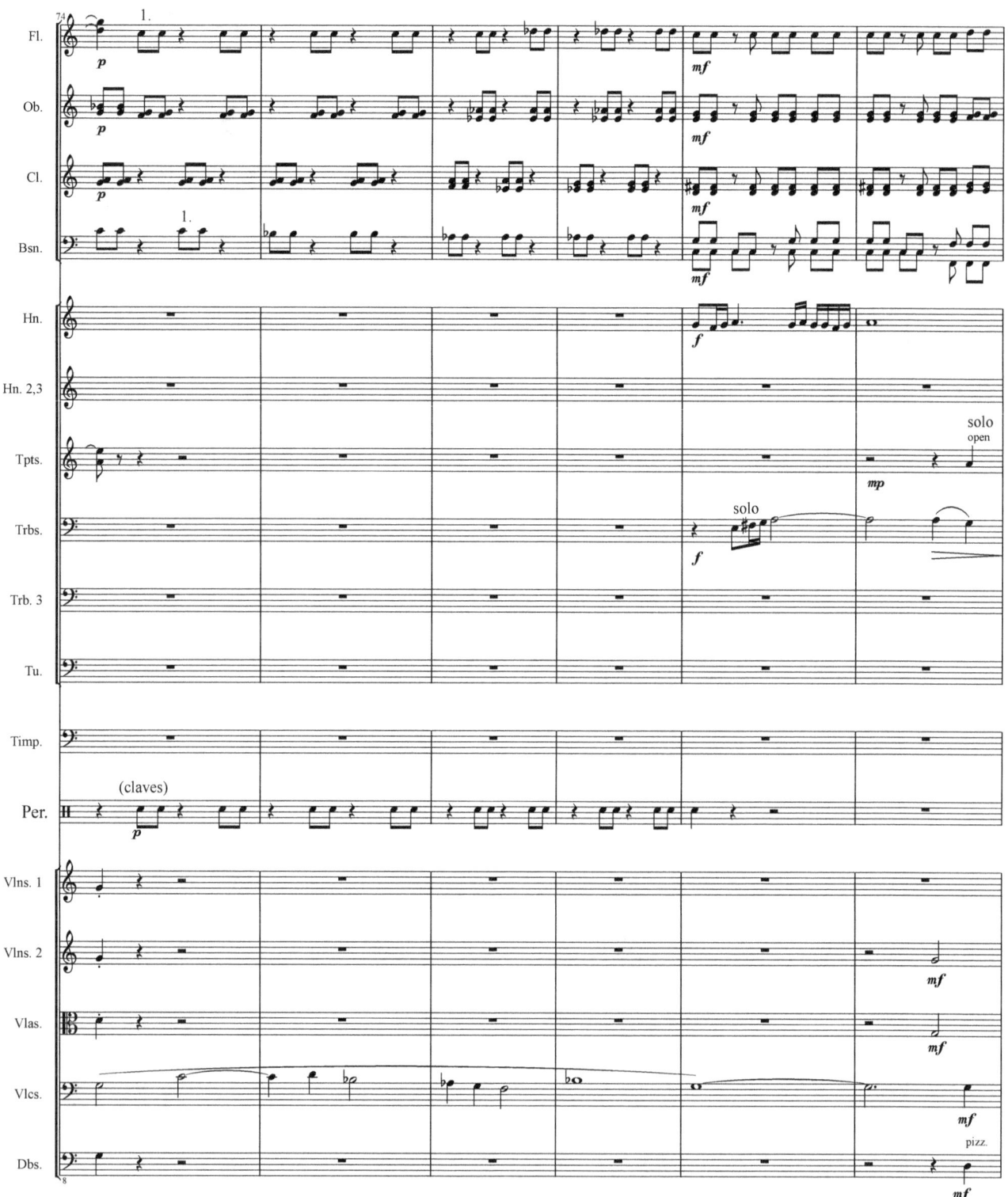

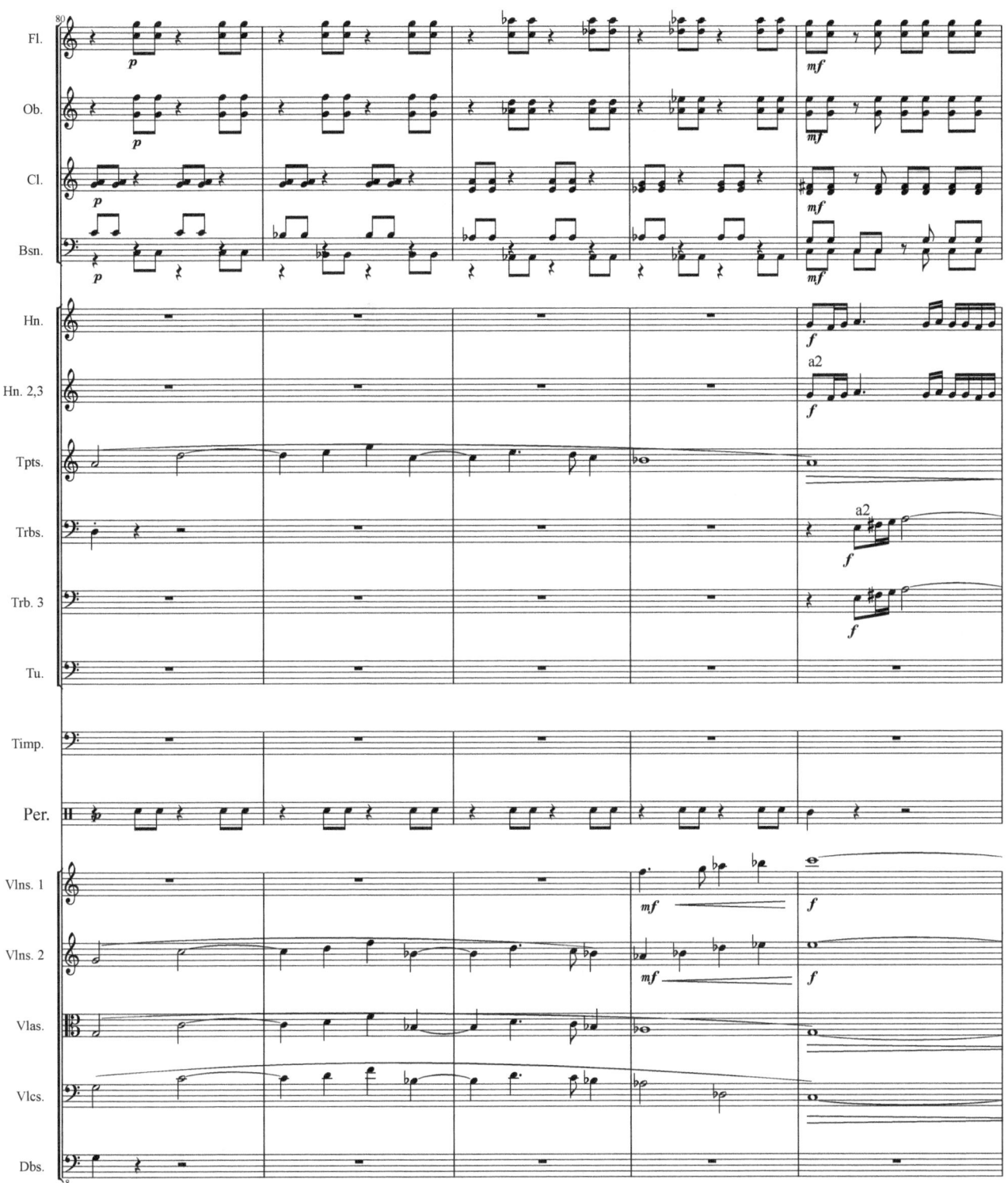

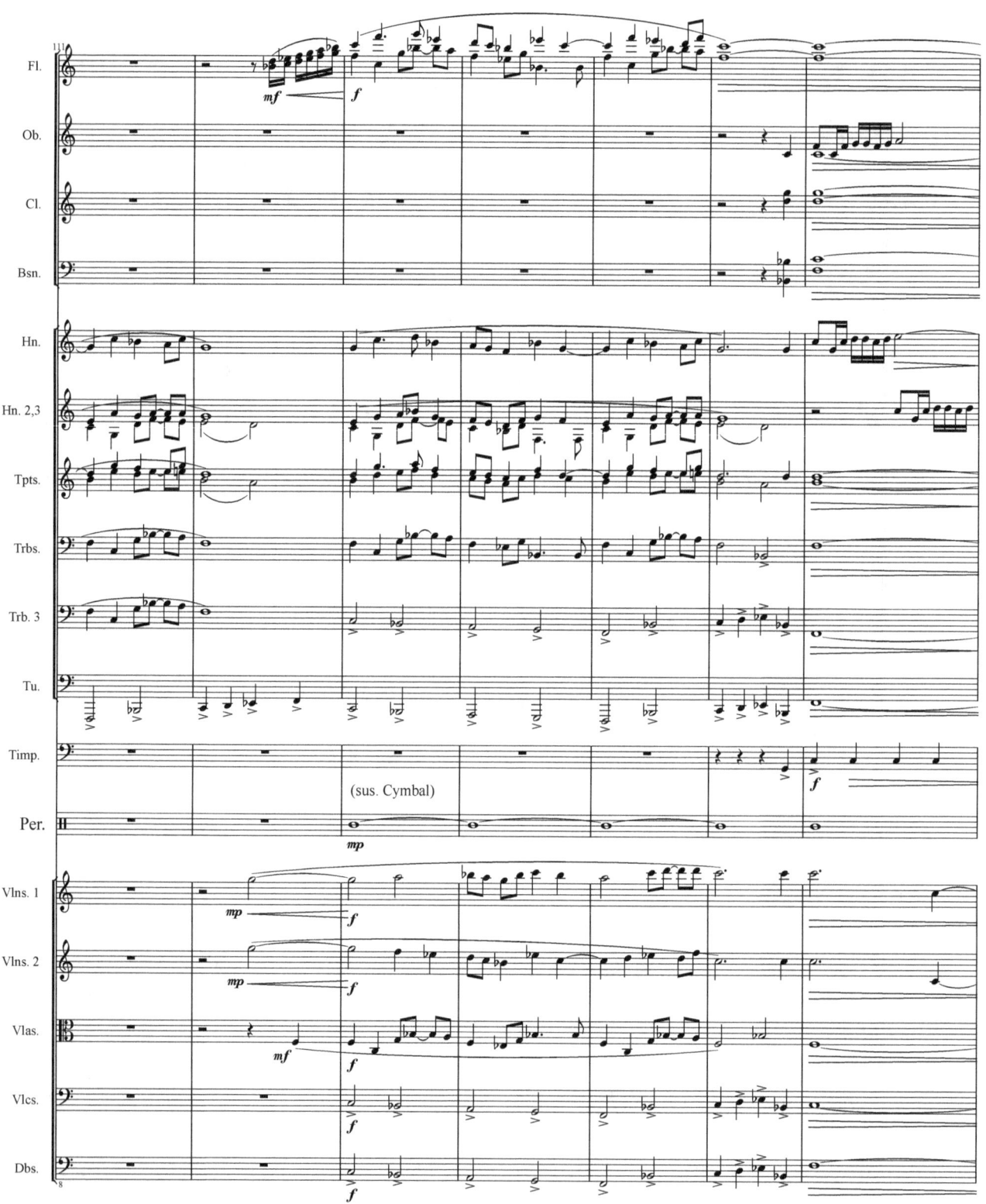

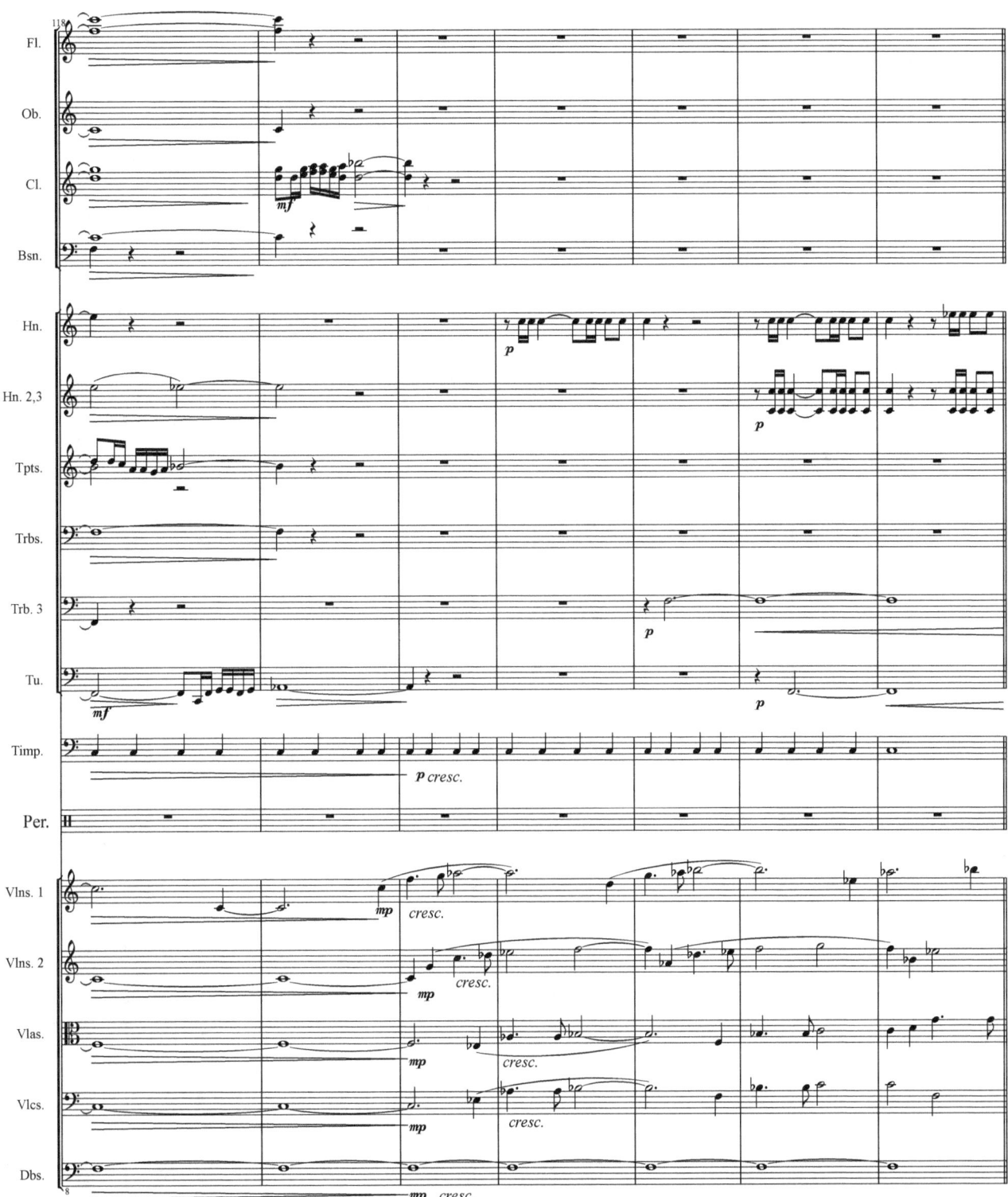

49

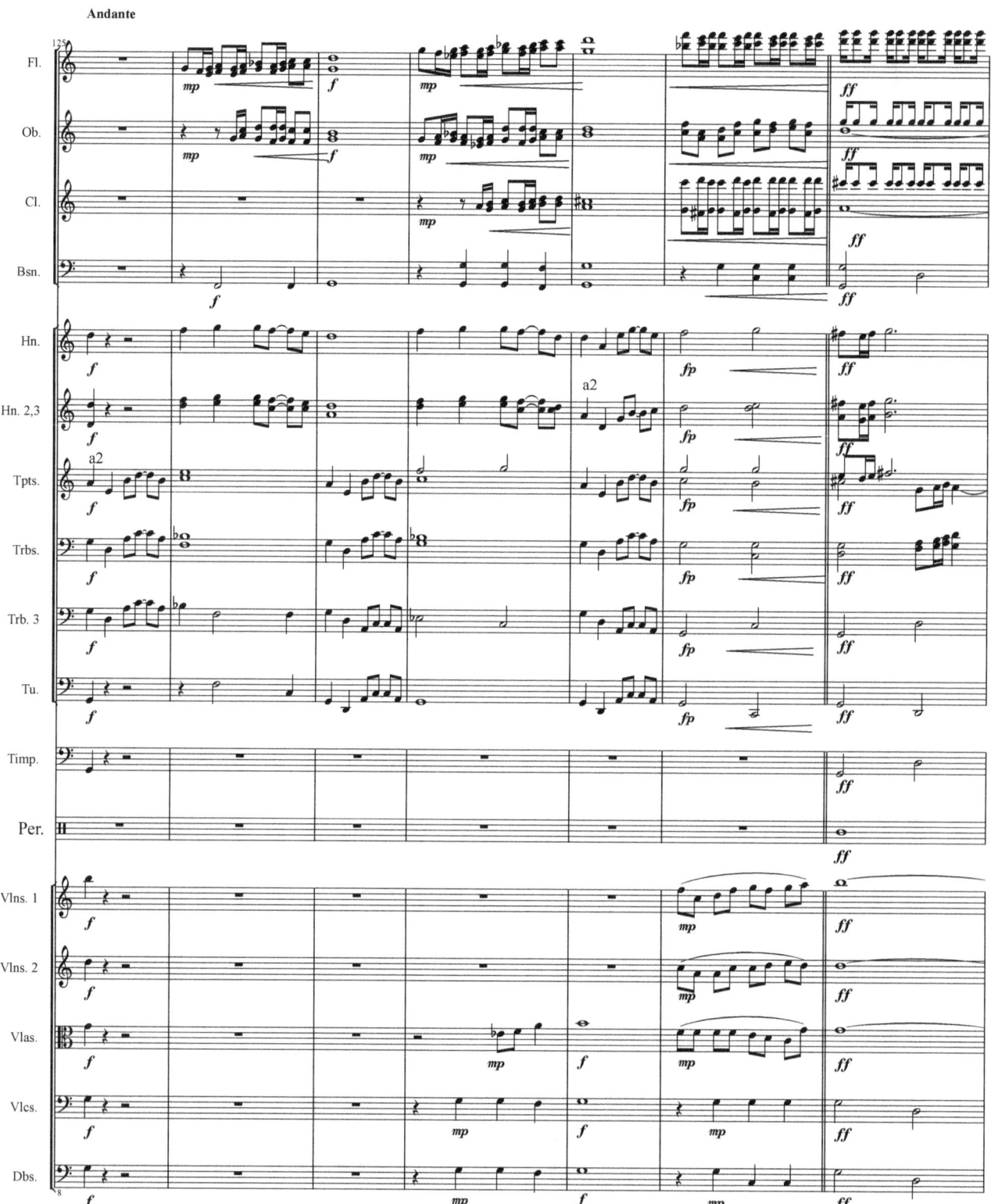

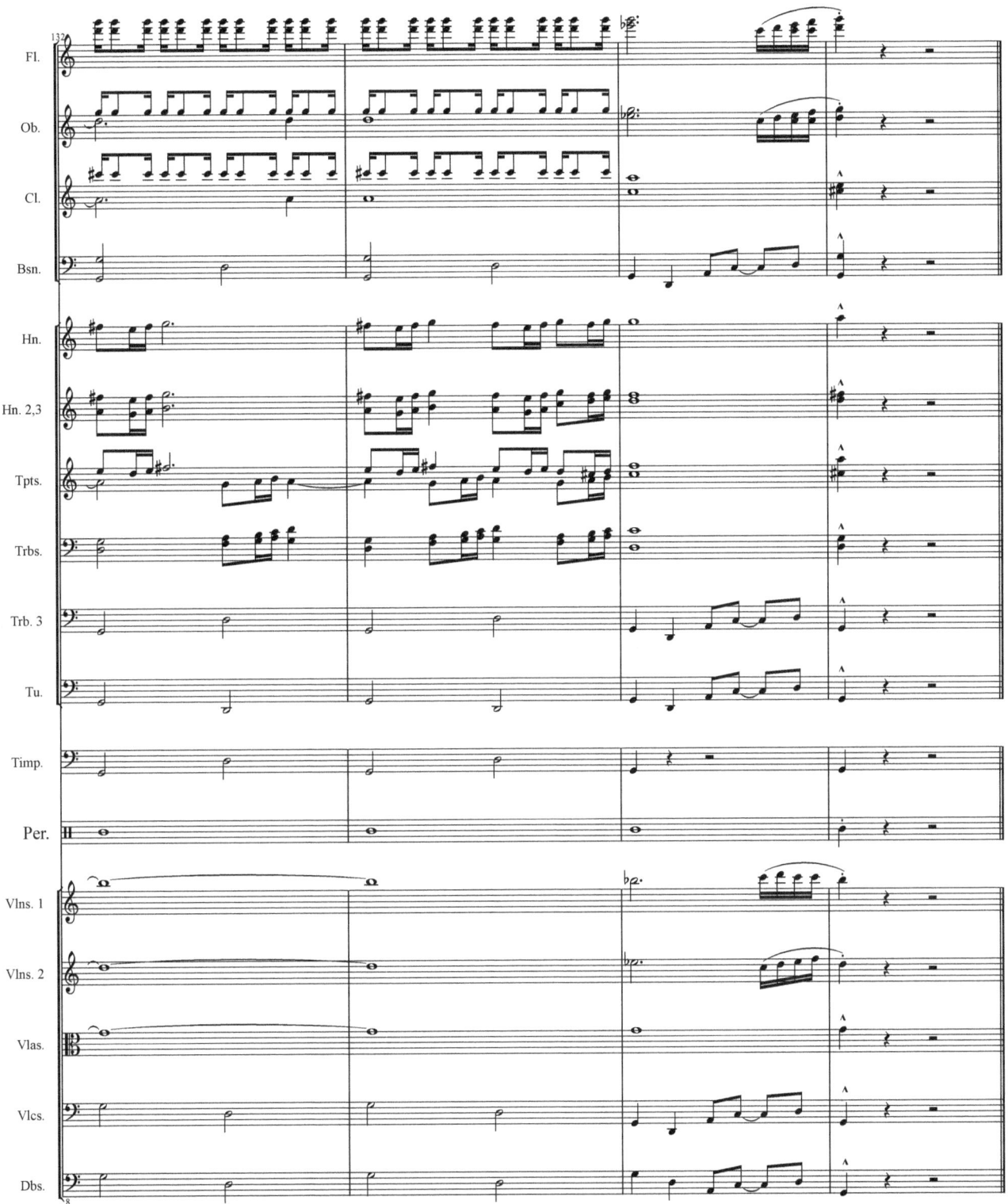

Journey Up Star Mountain
for the Eurydice Community Orchestra of Roanoke, VA.

Ken Langer

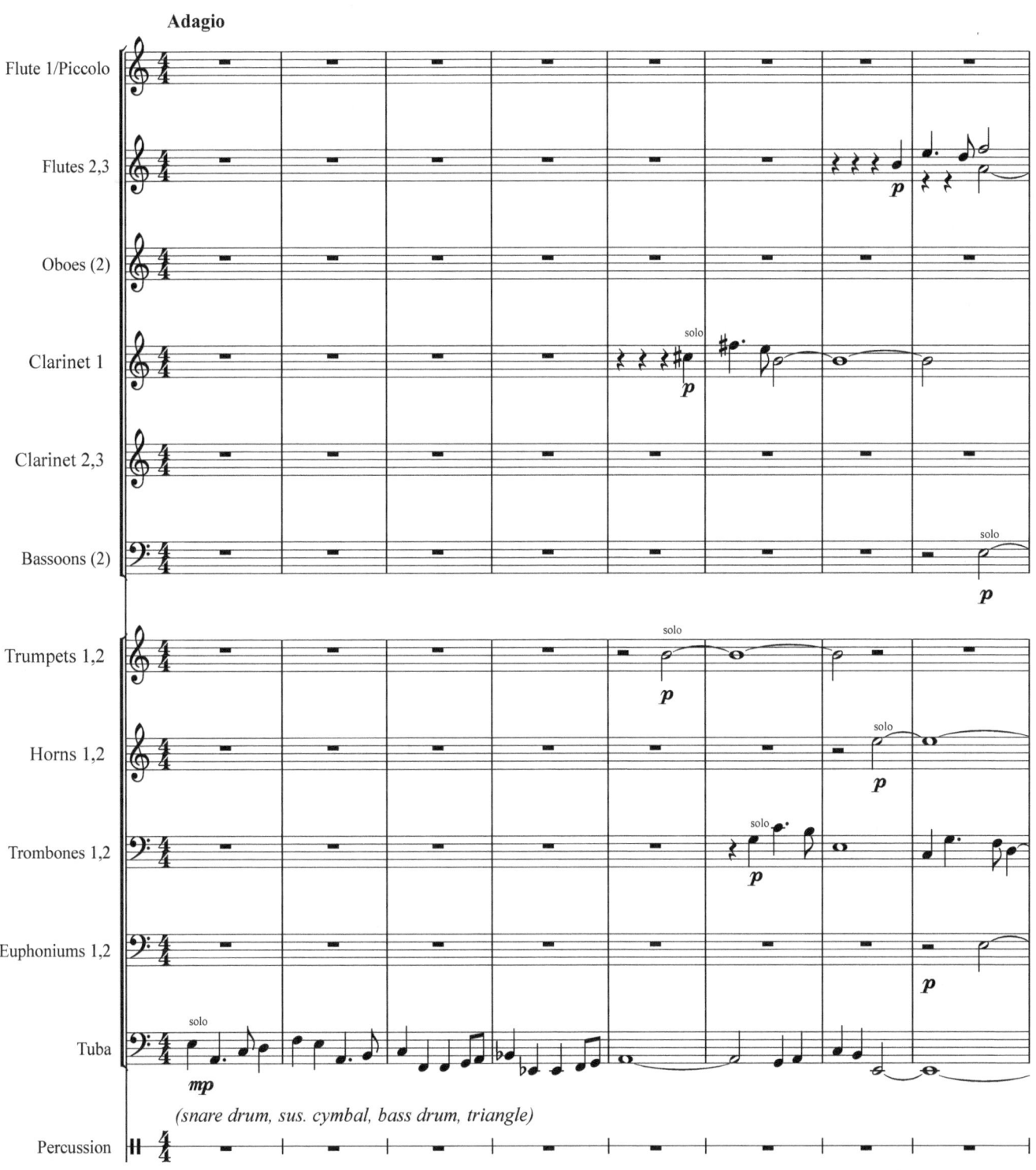

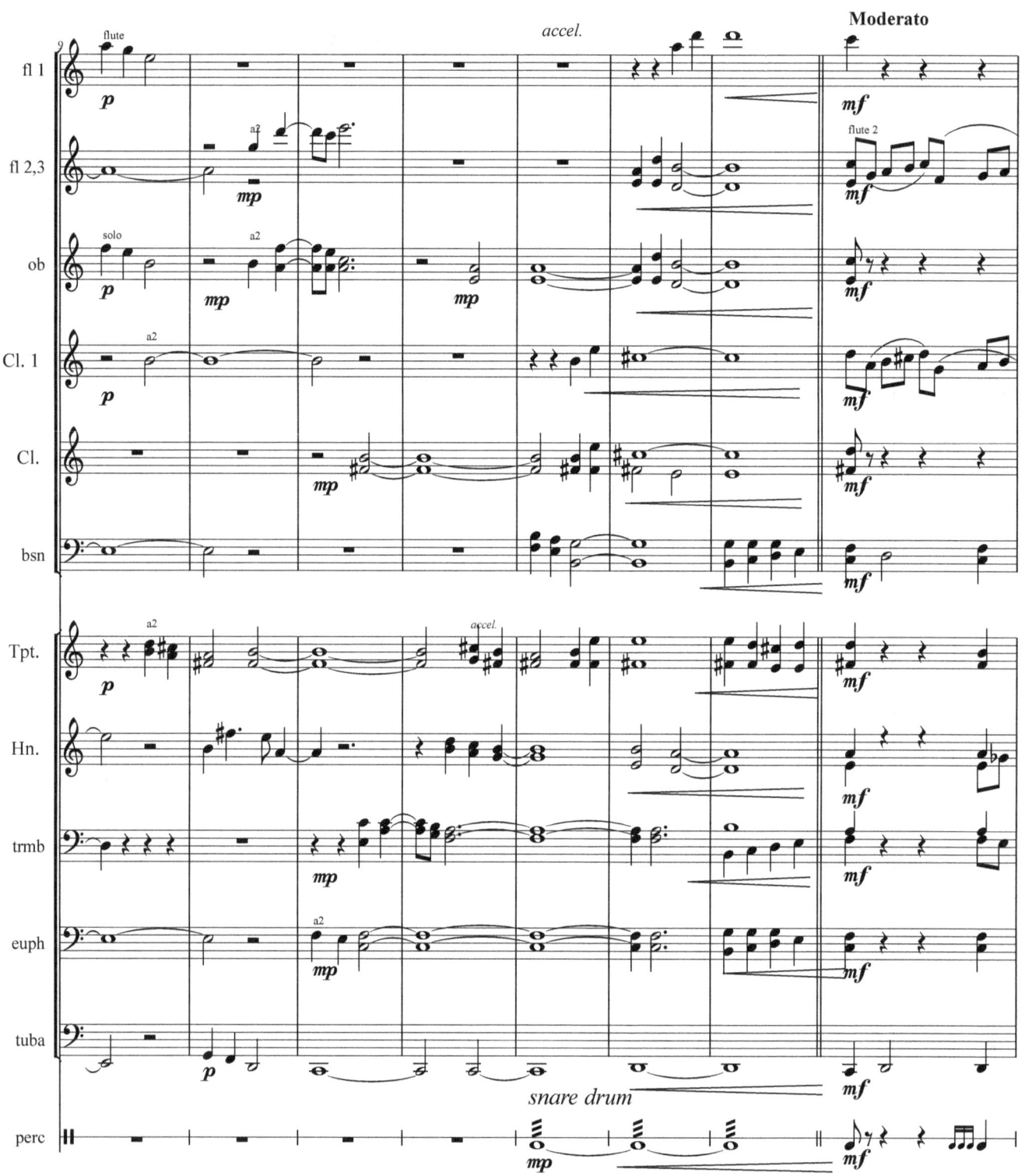

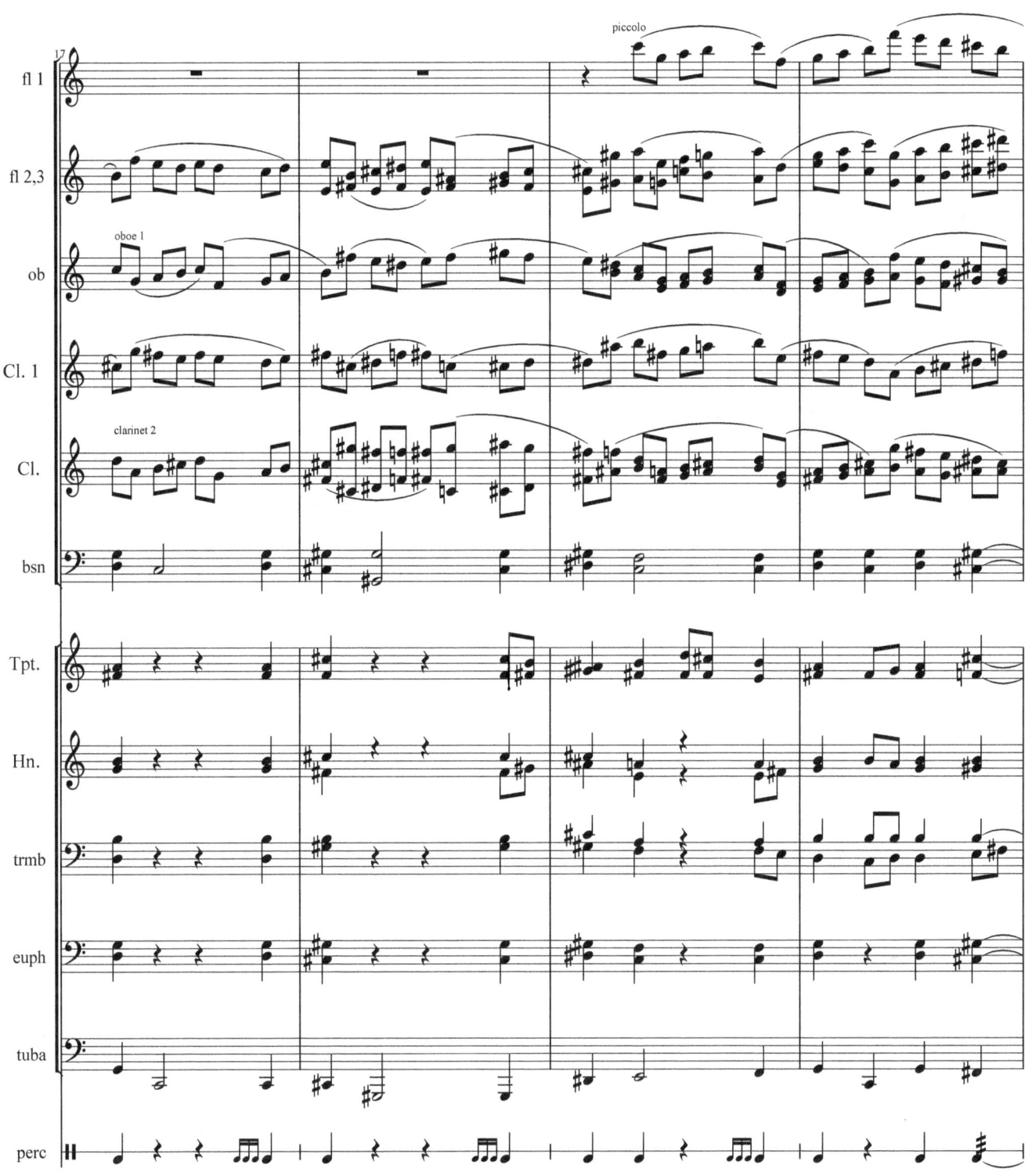

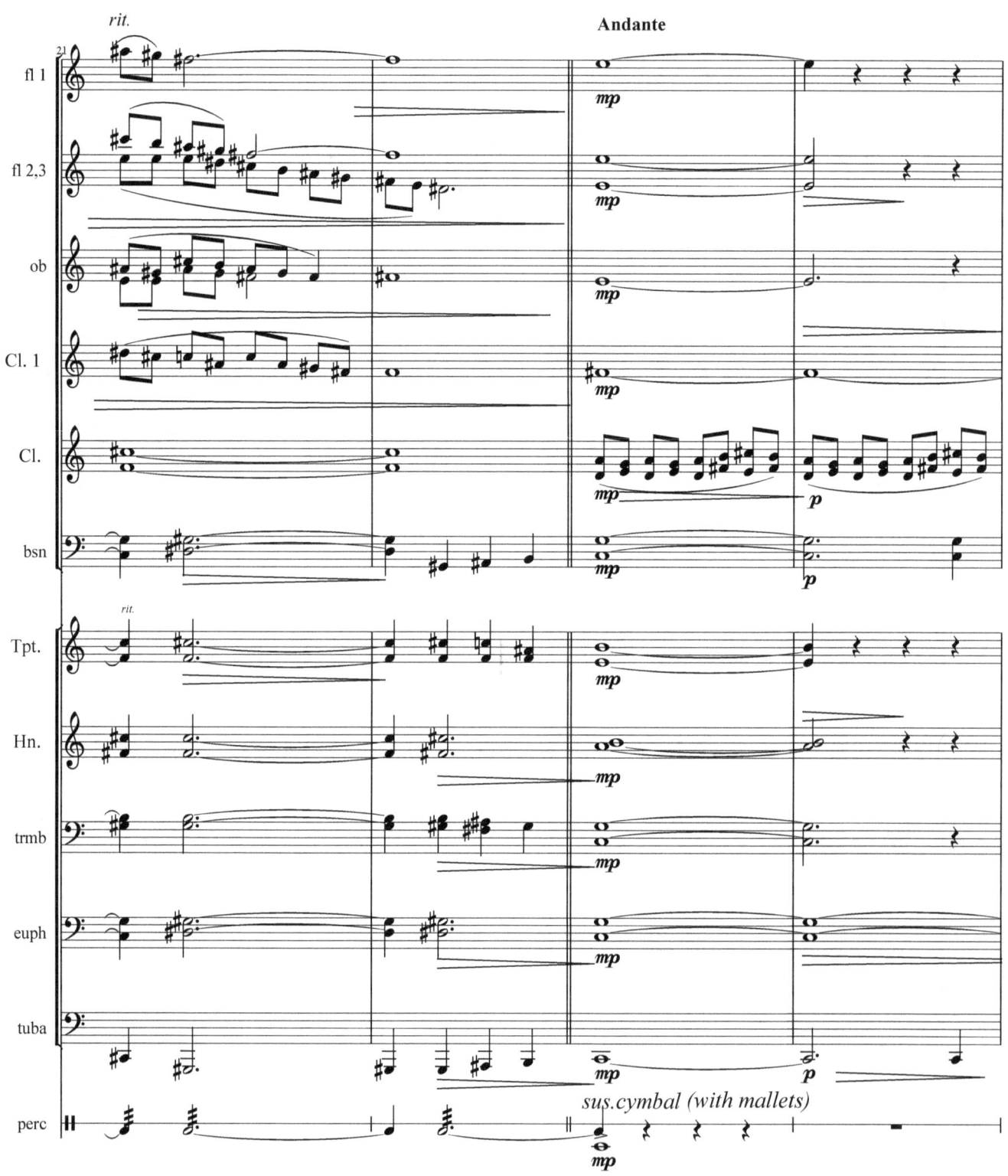

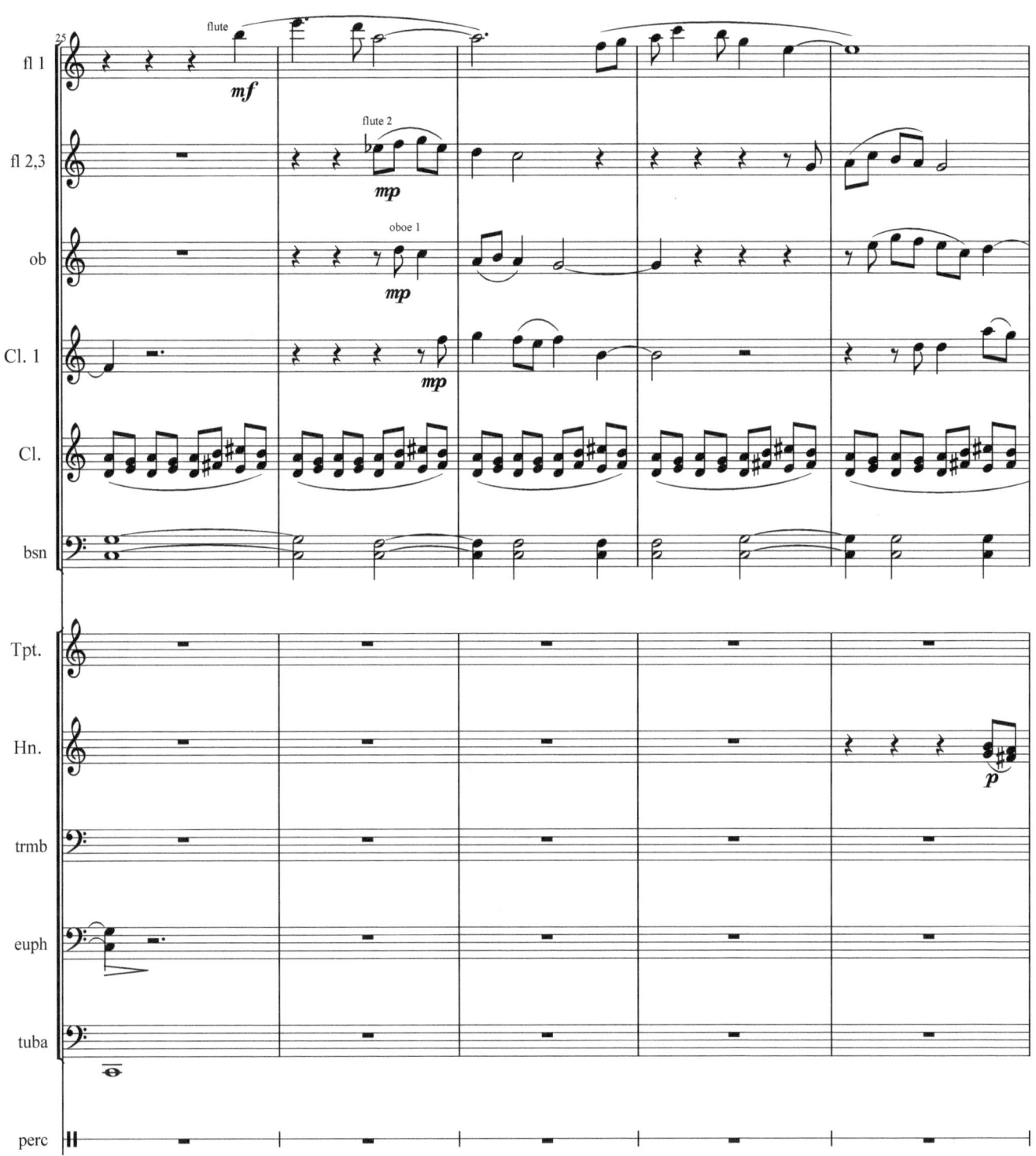

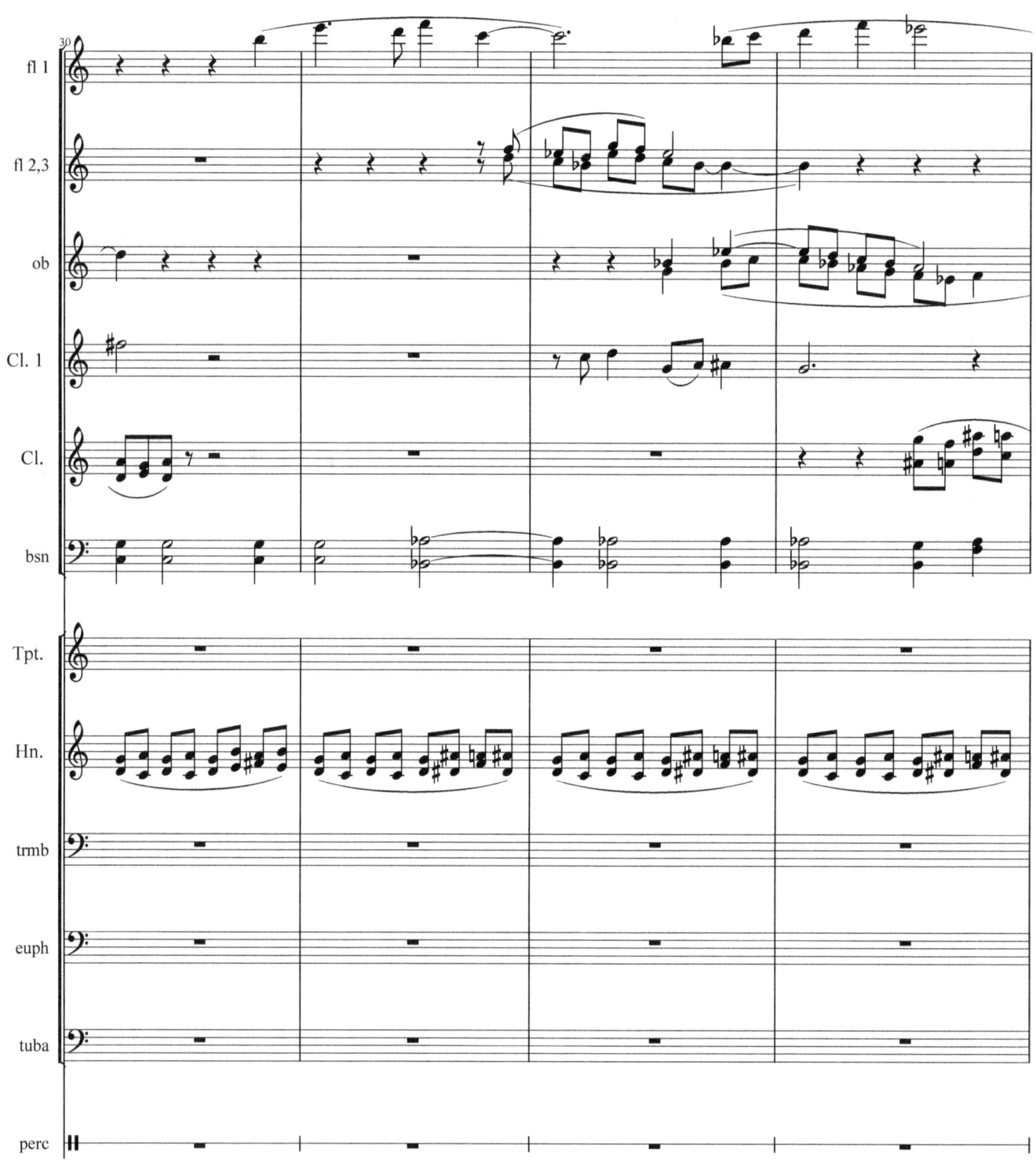

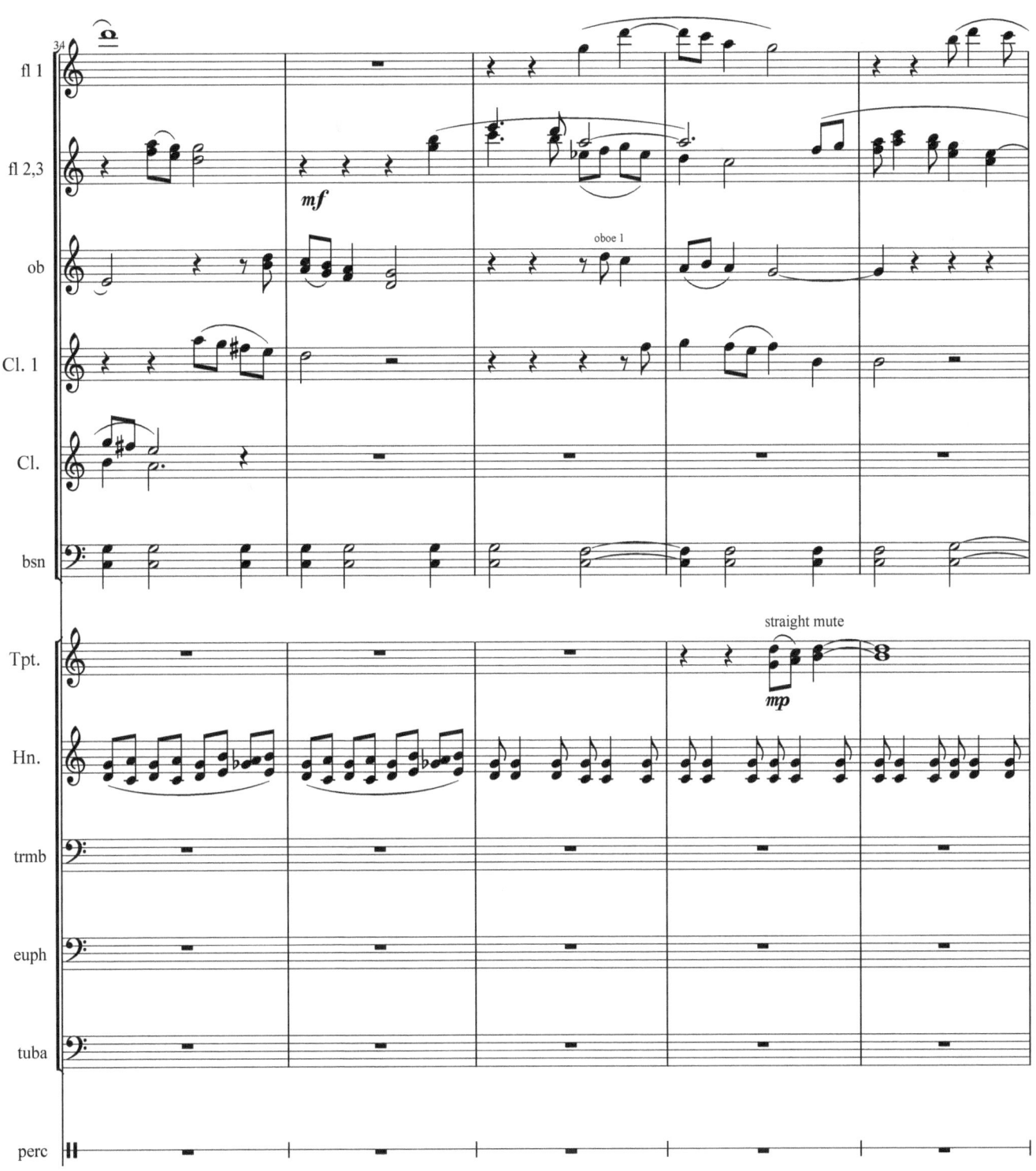

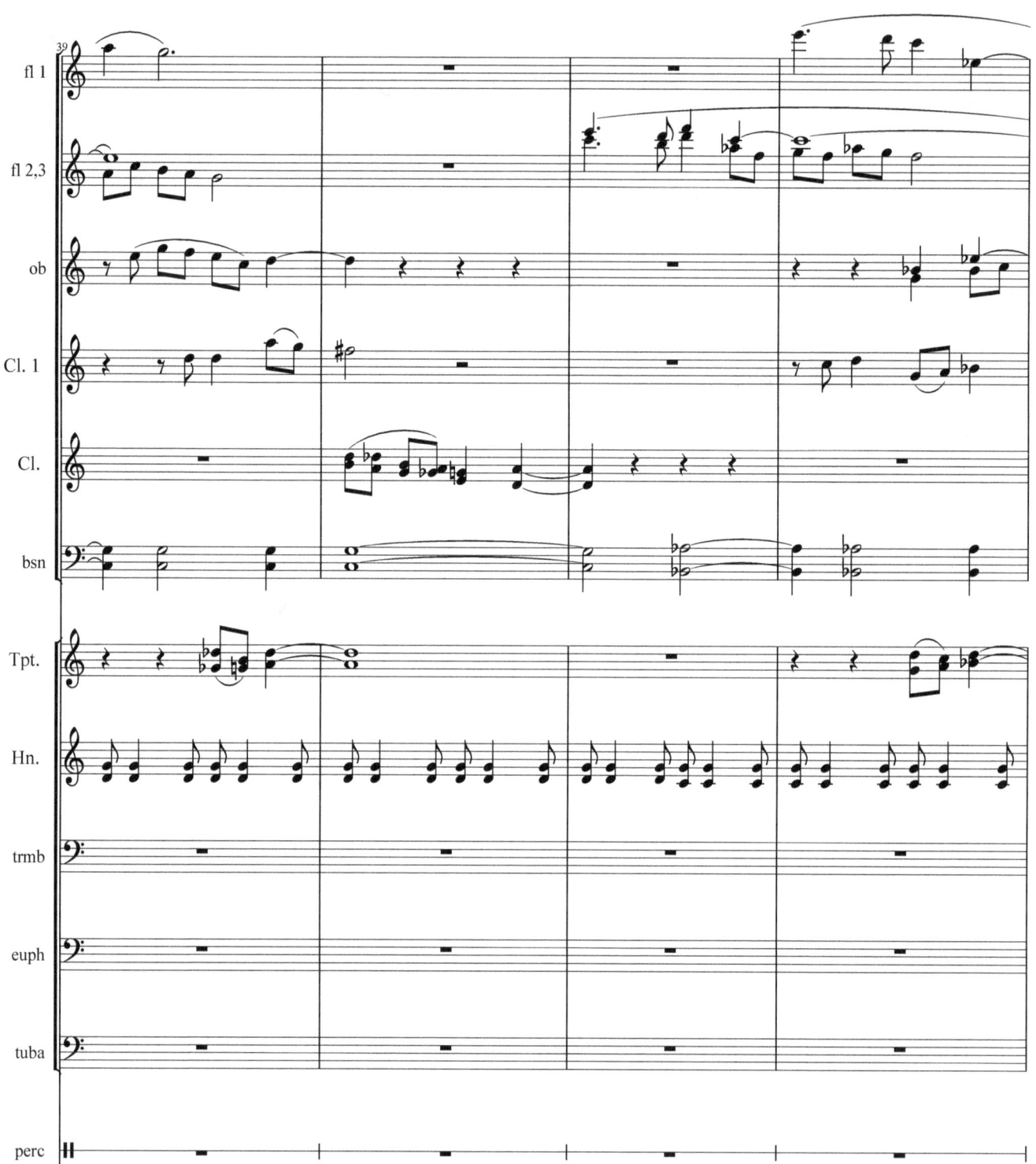

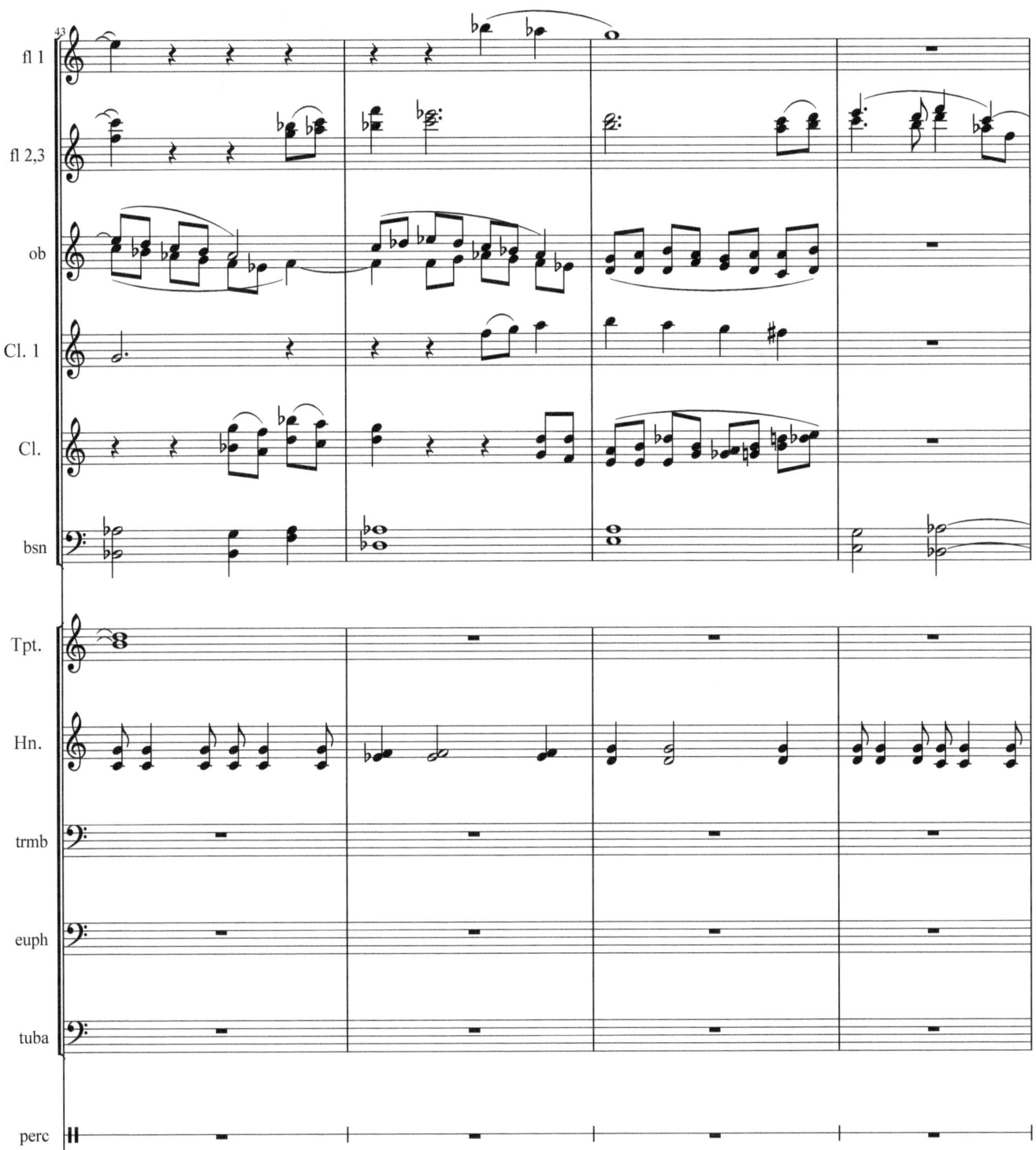

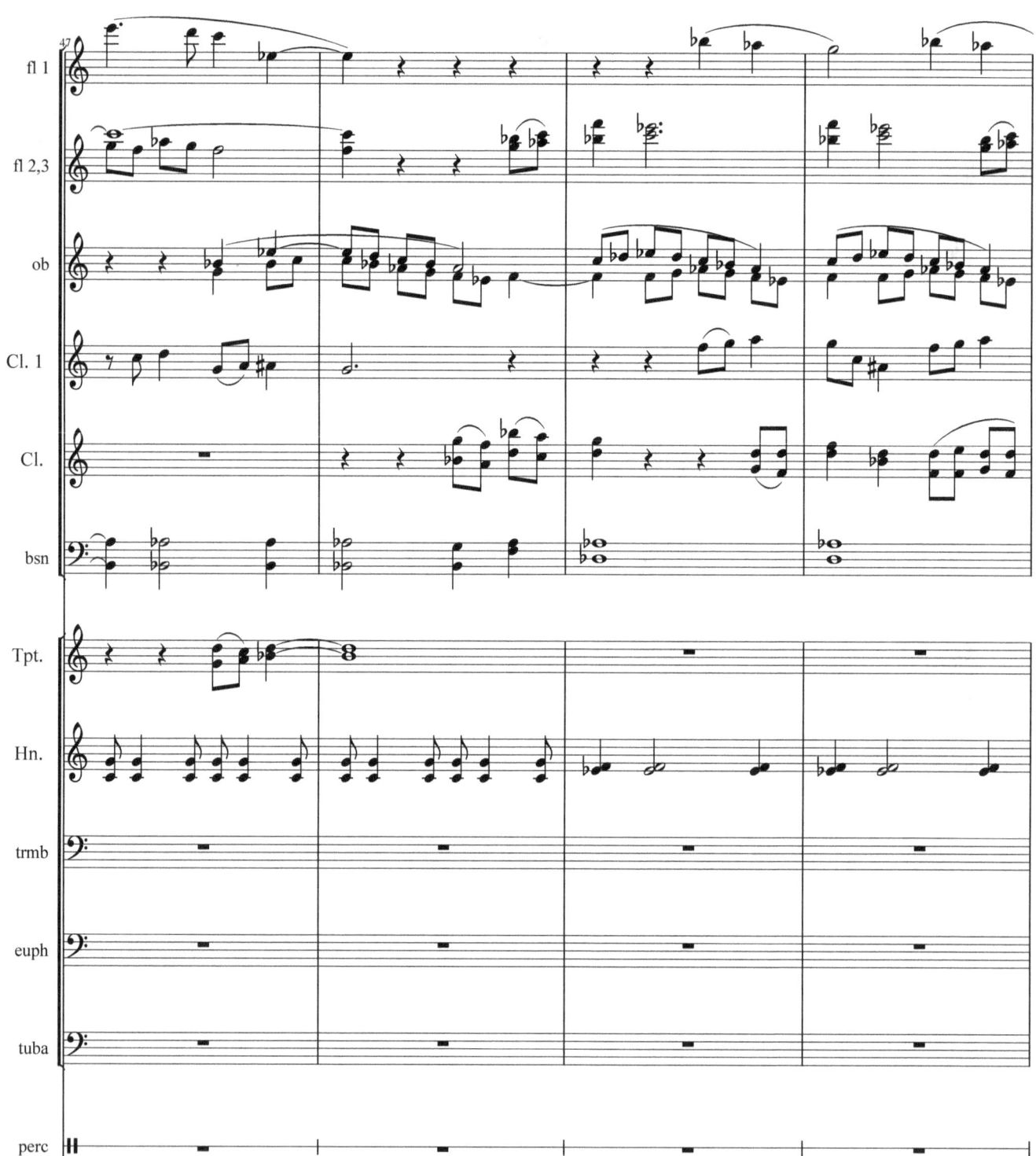

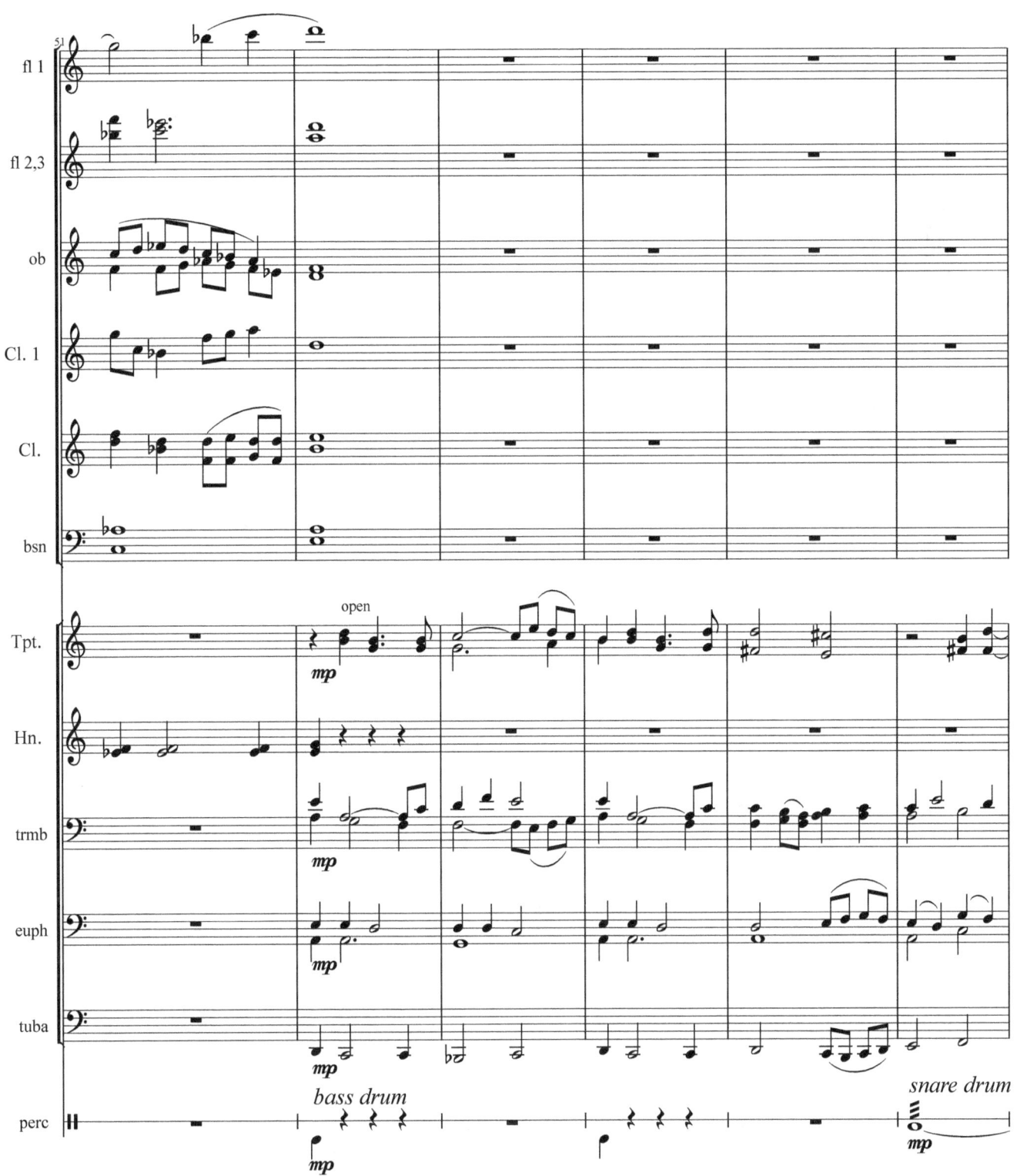

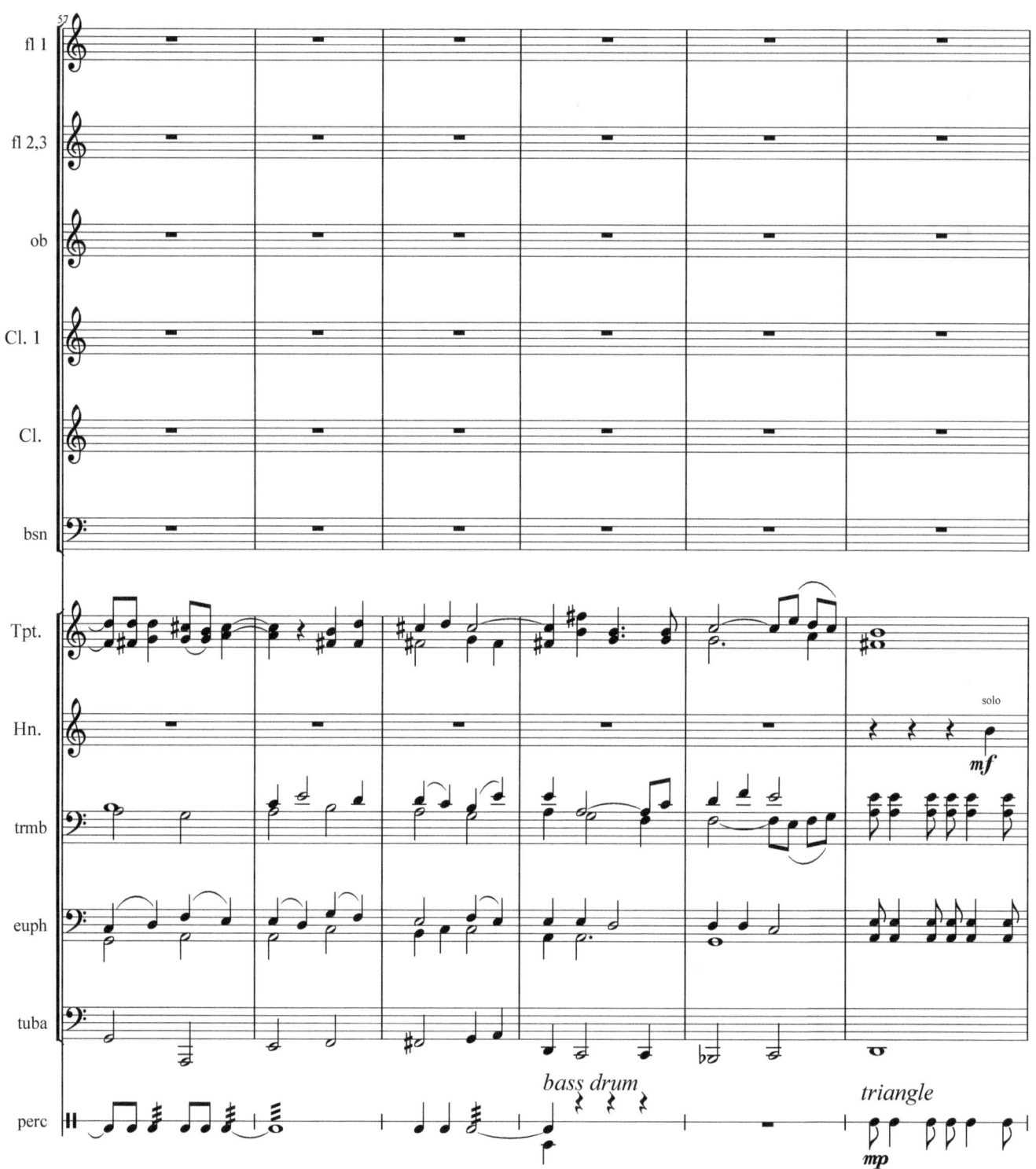

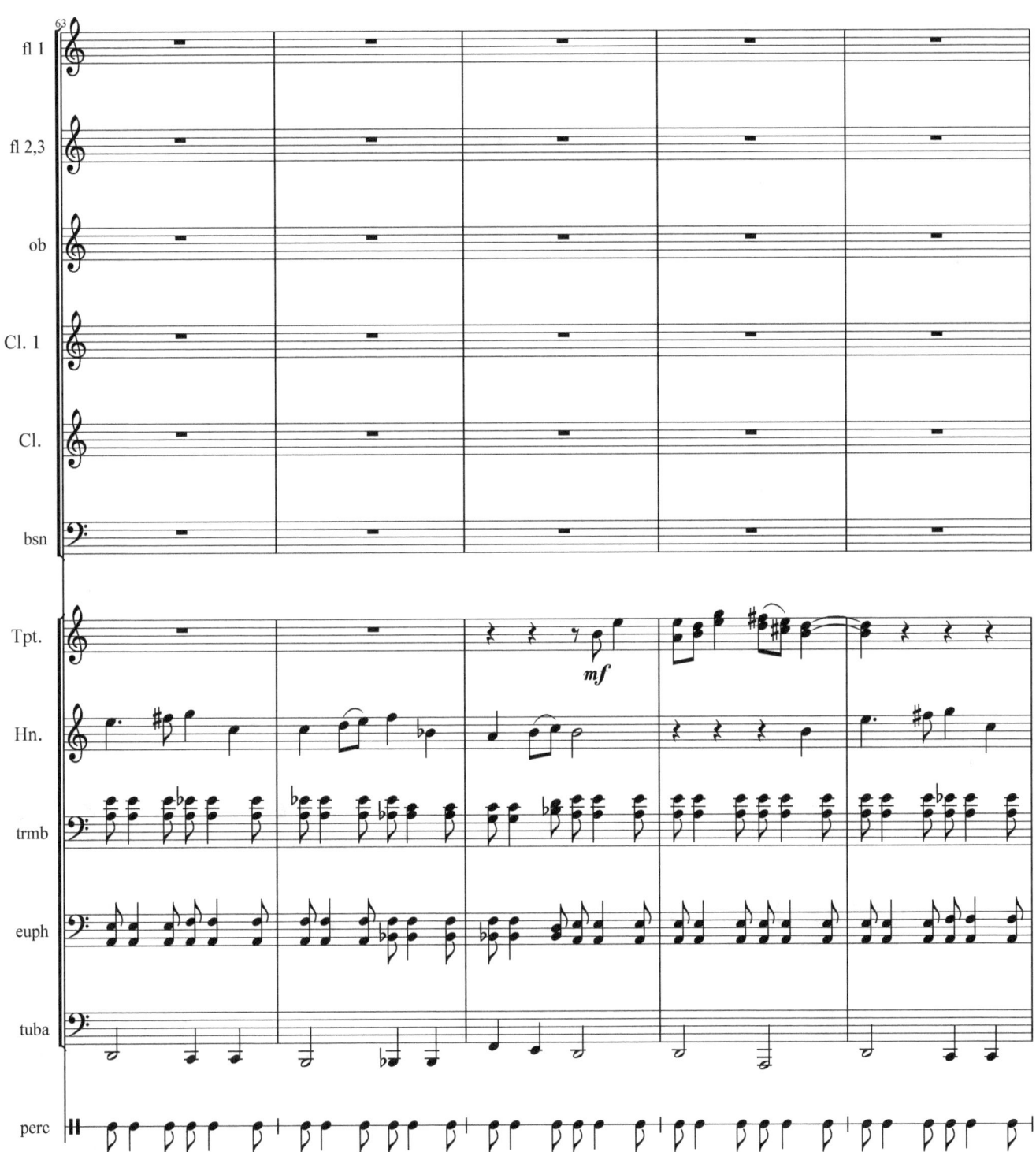

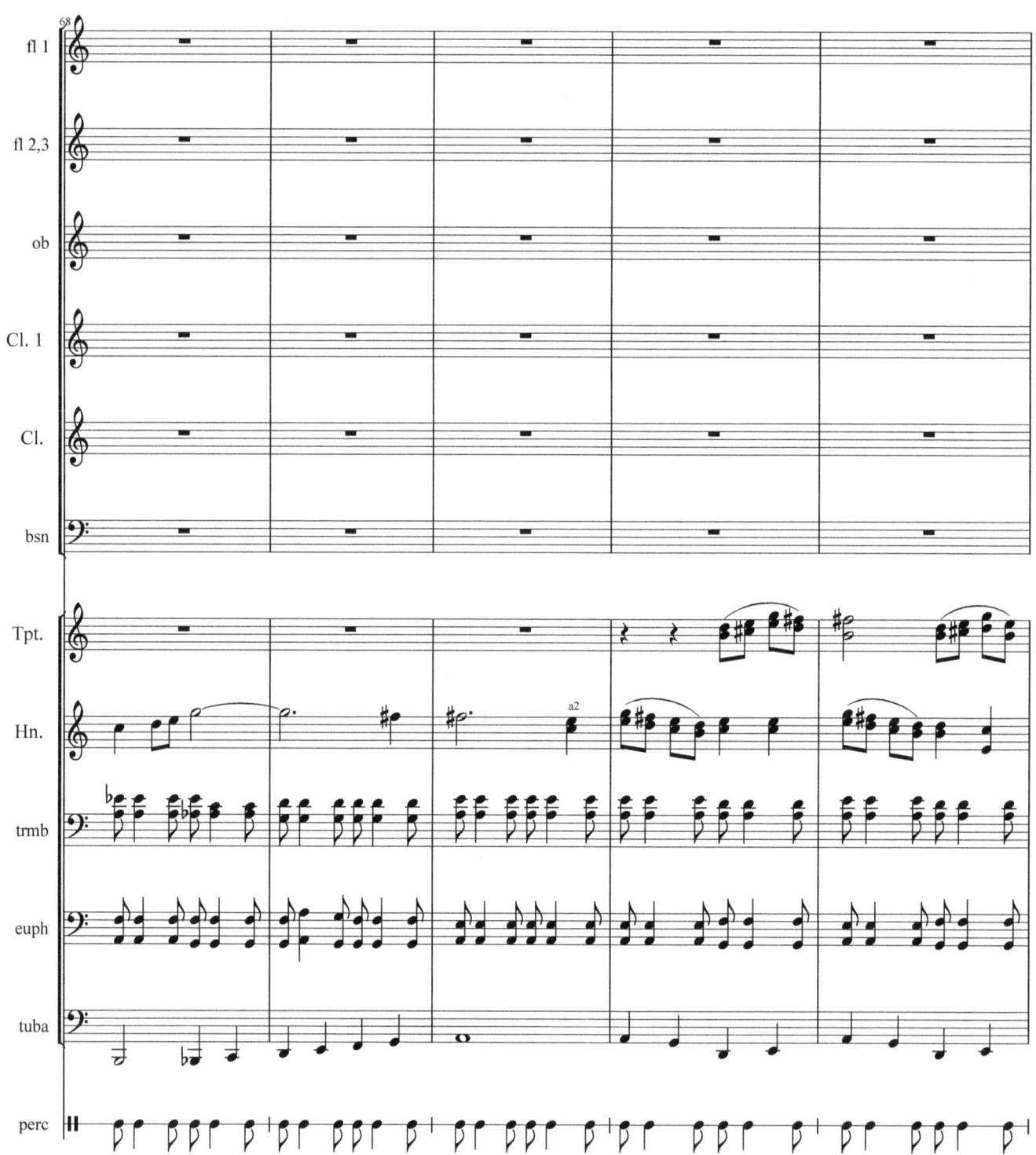

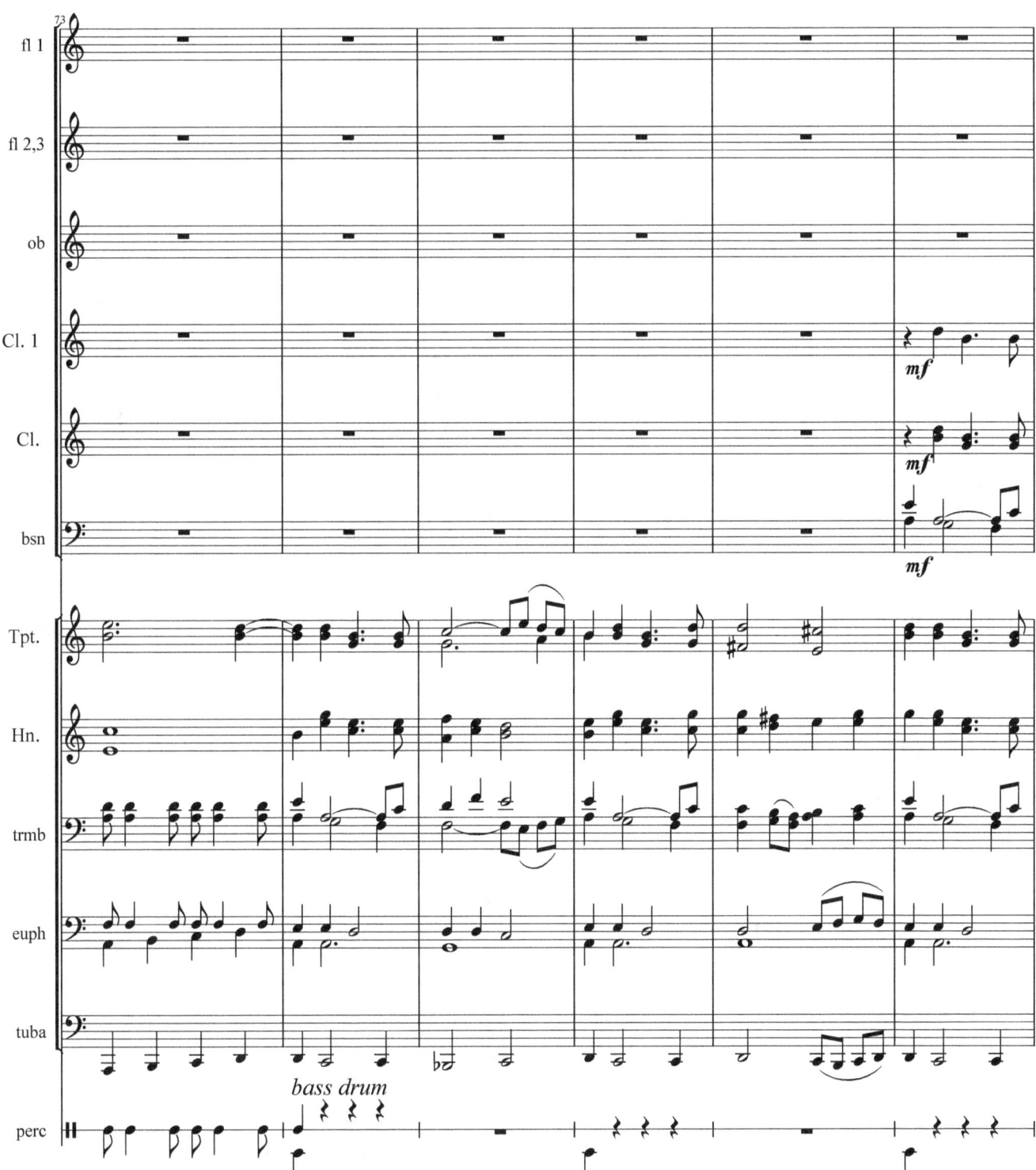

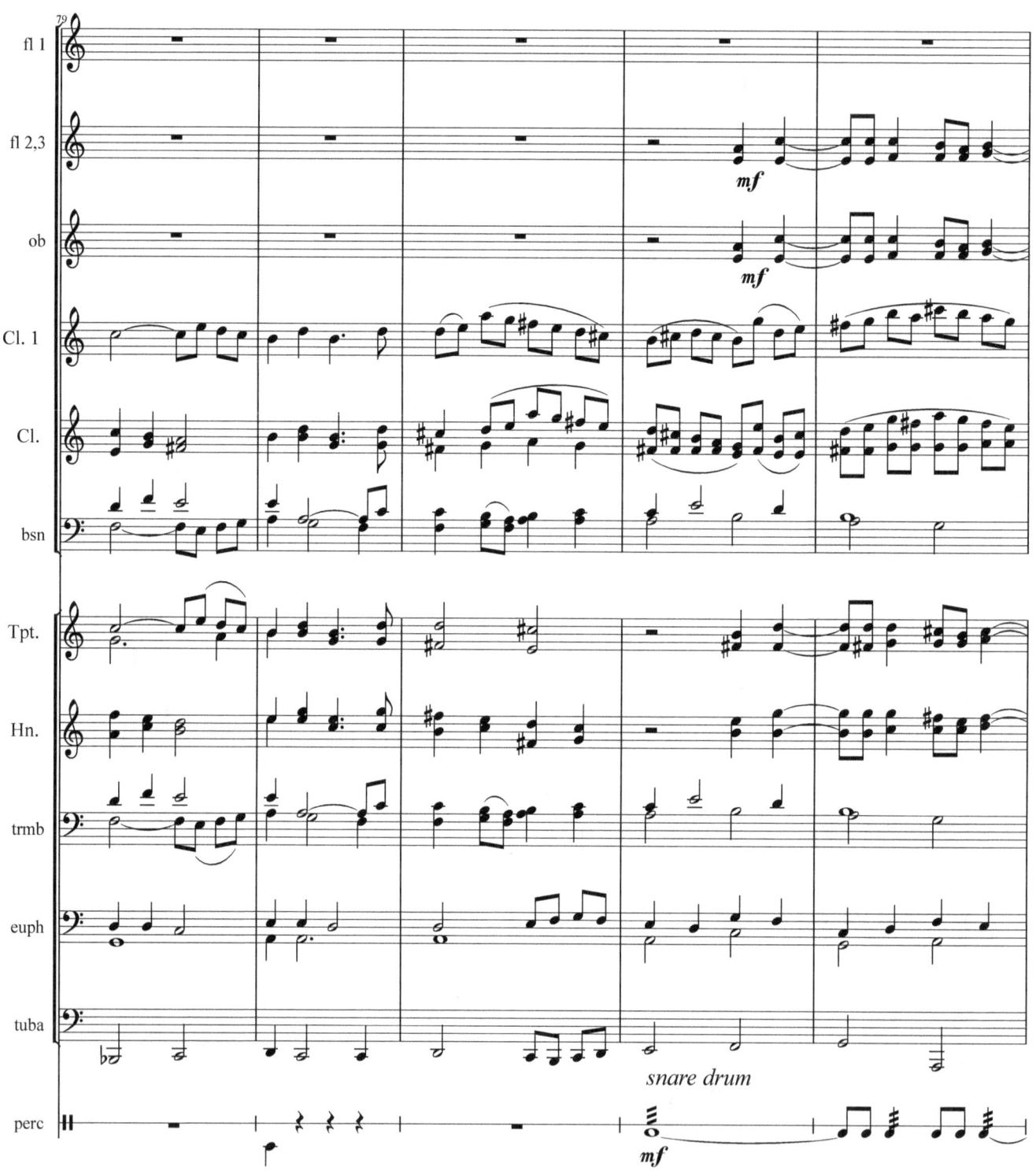

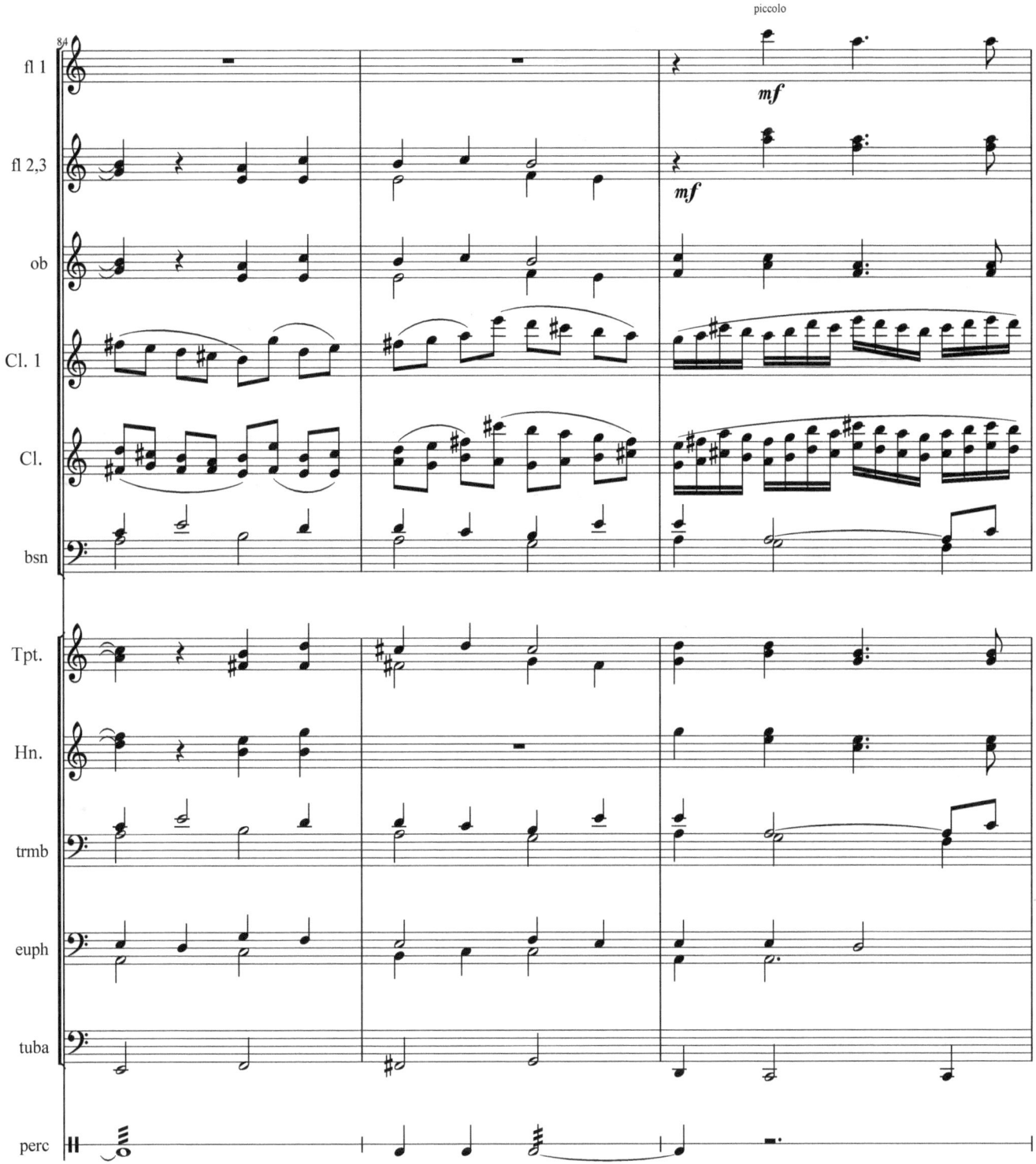

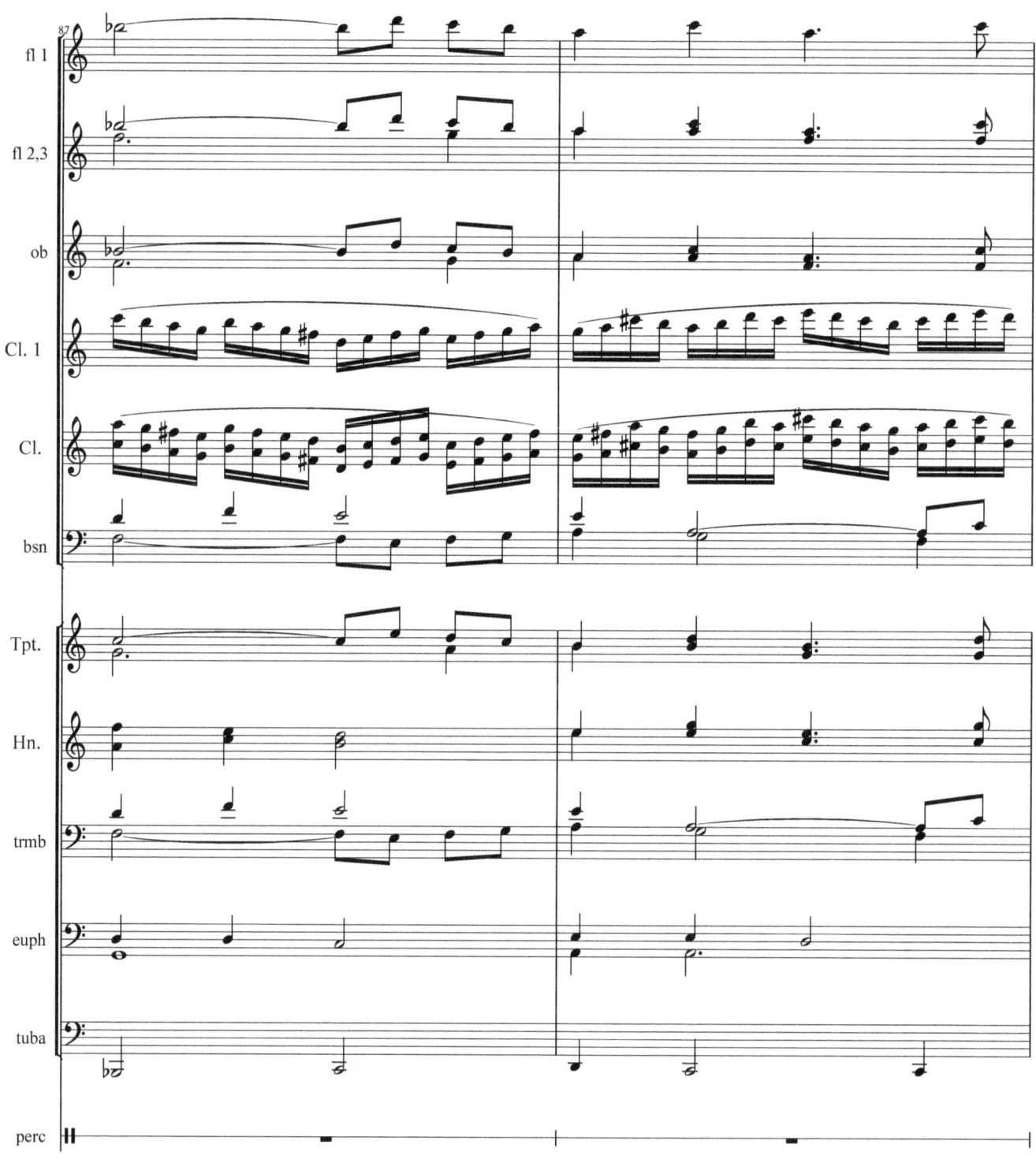

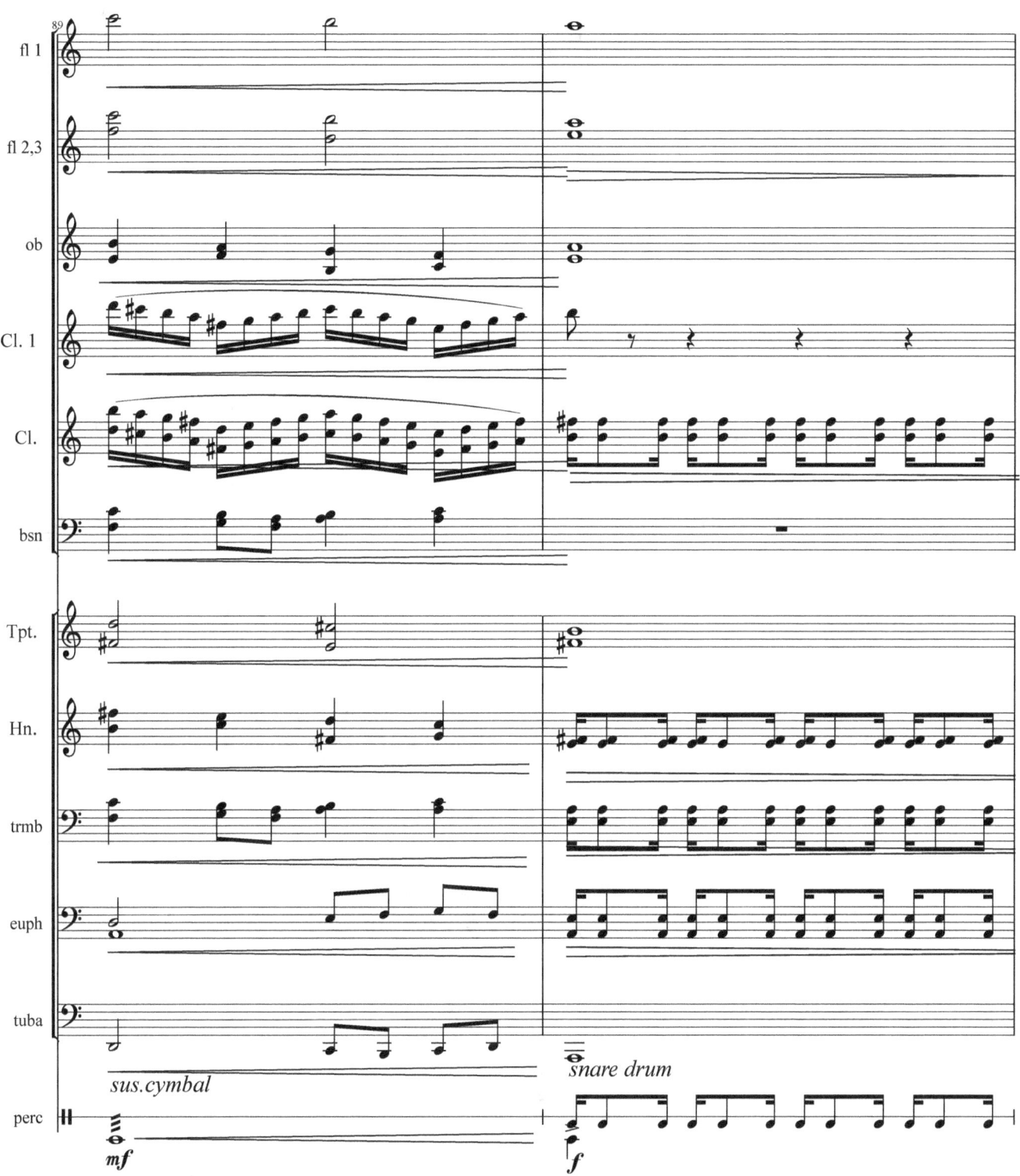

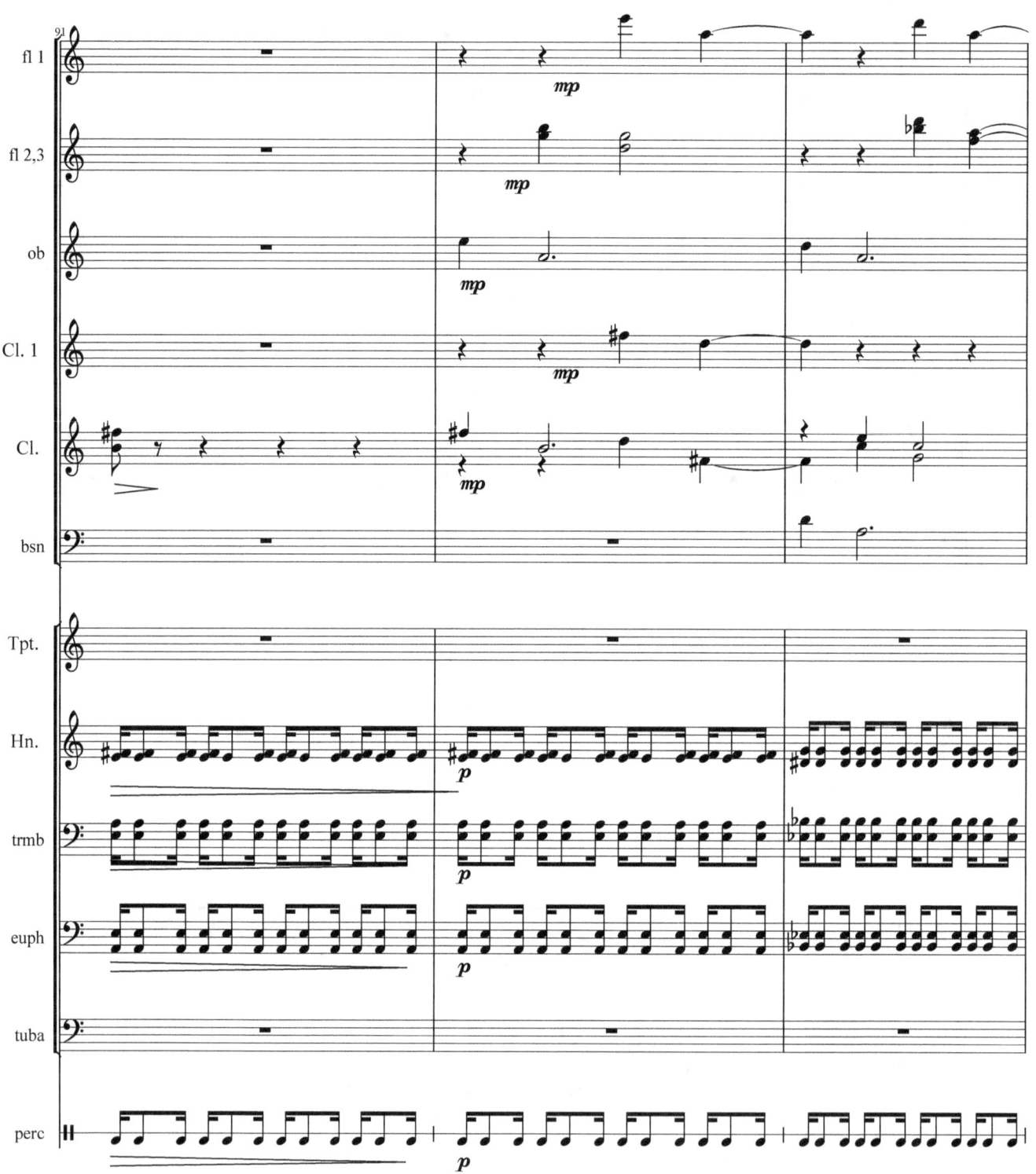

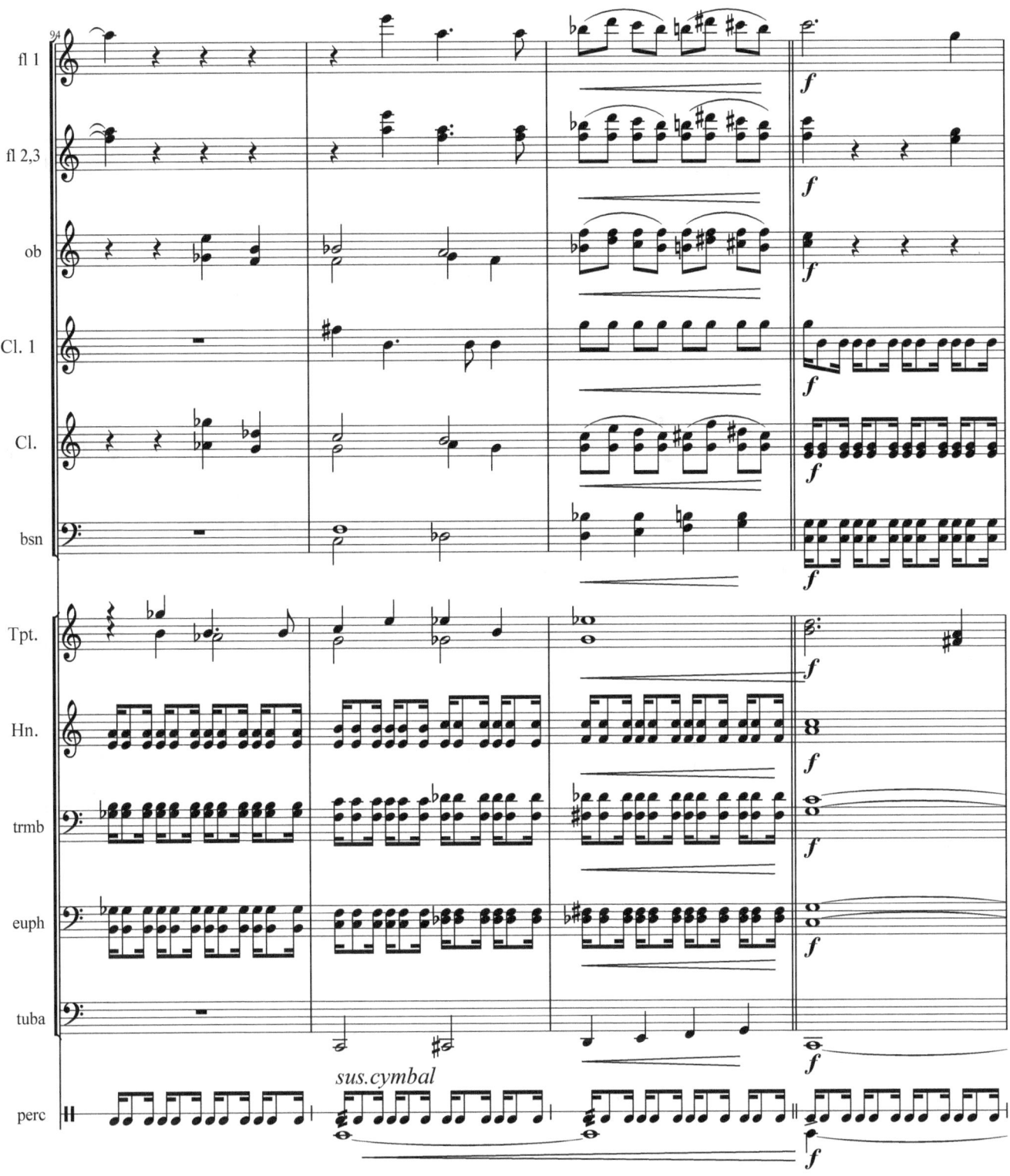

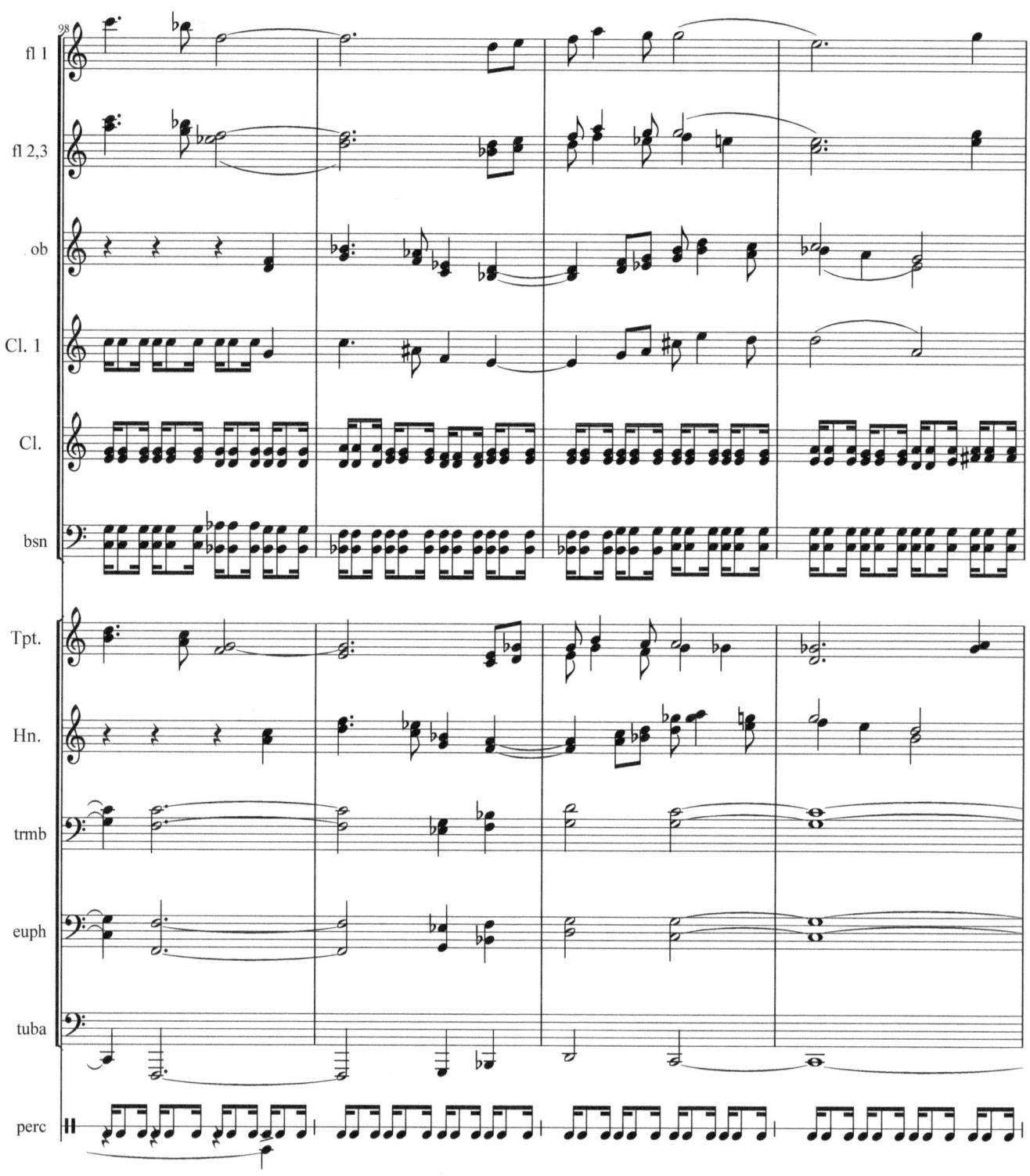

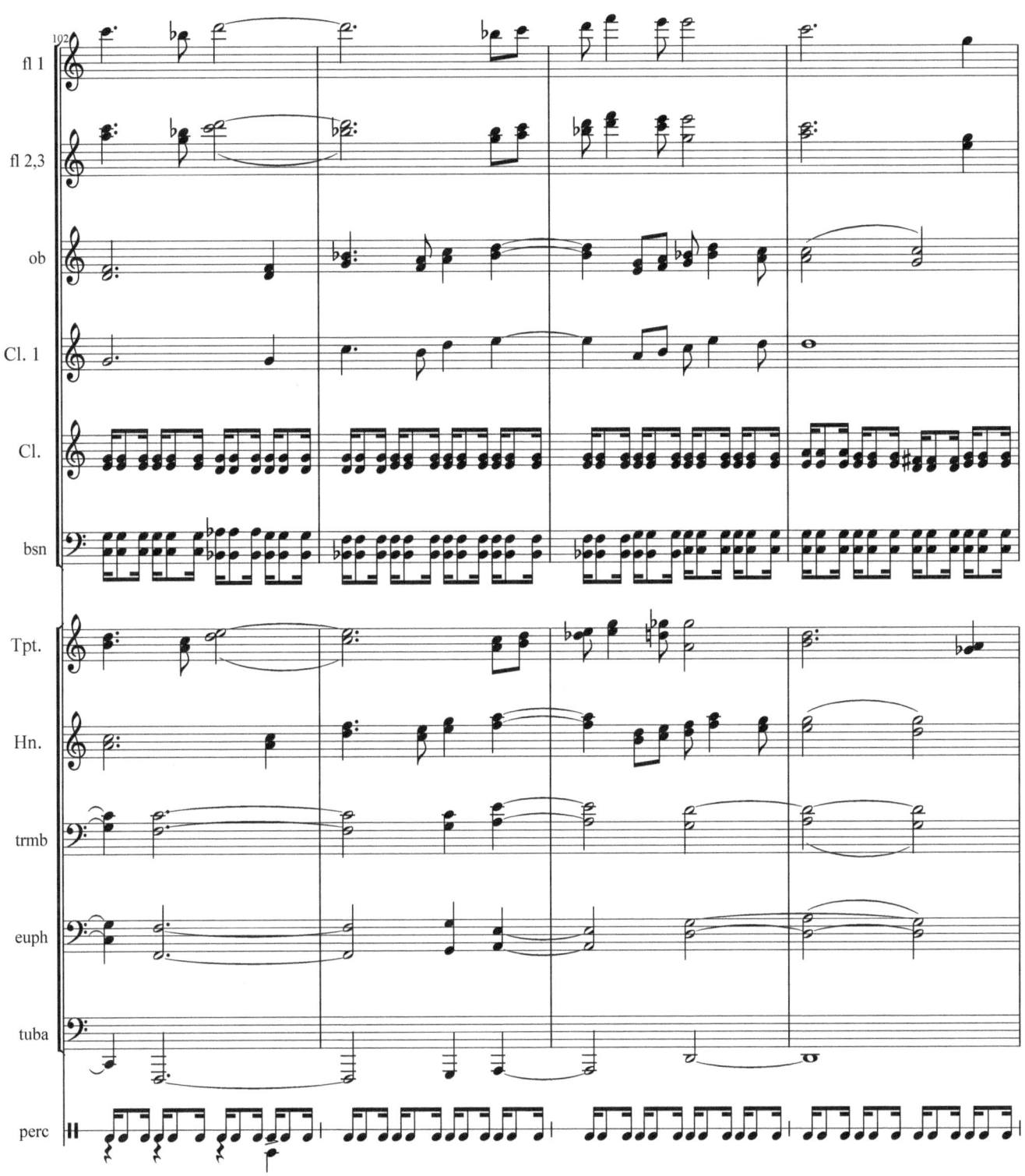

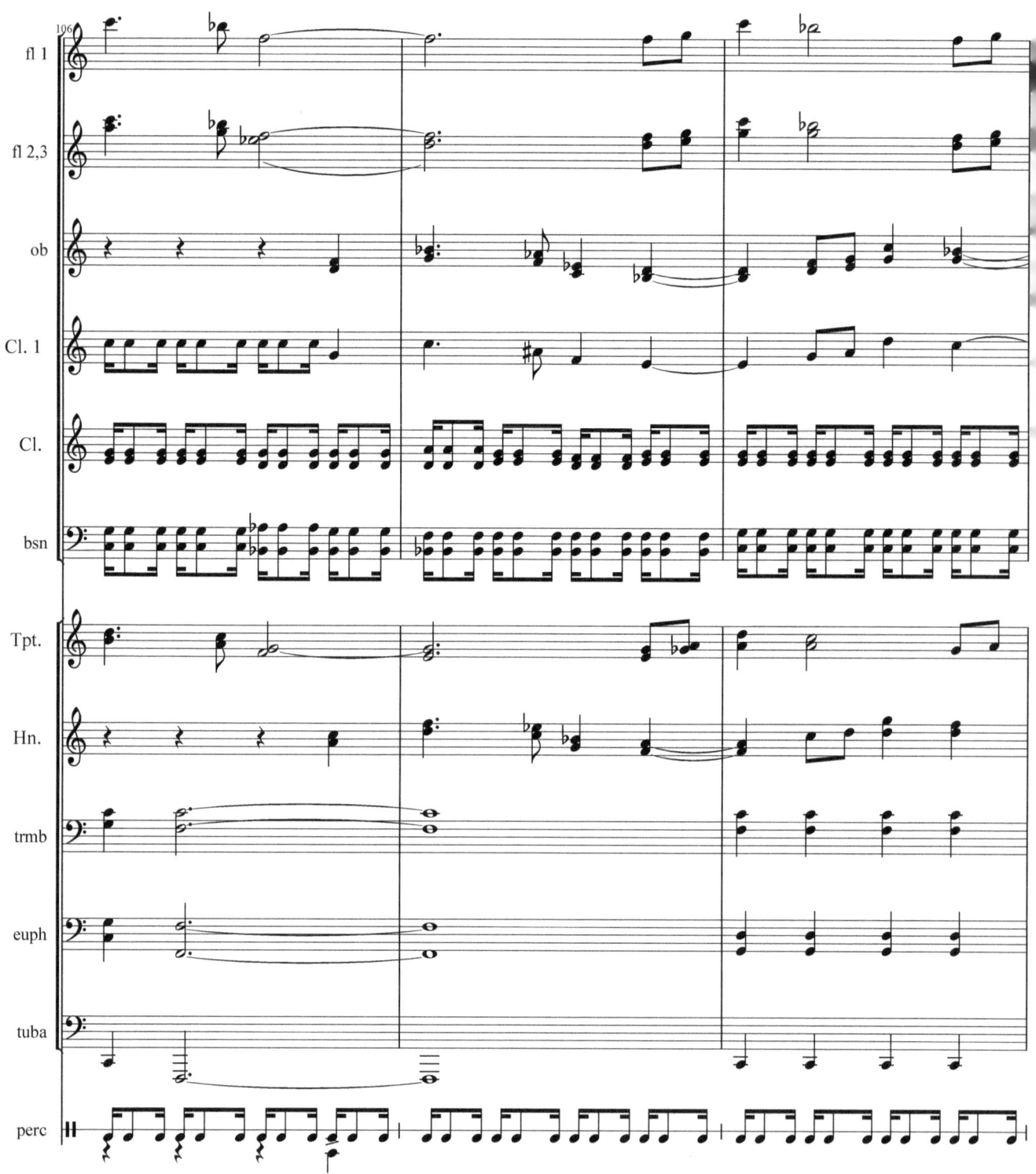

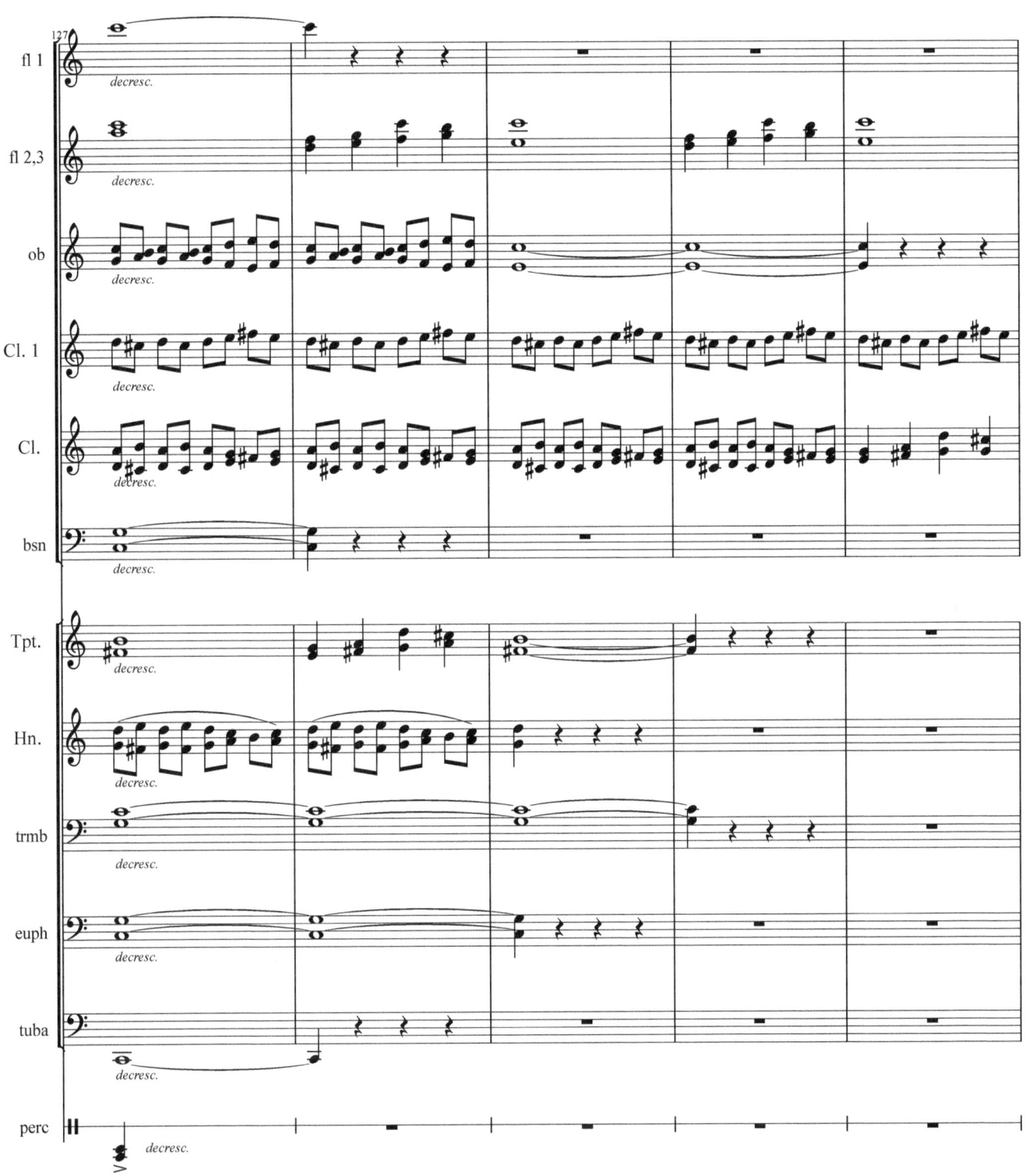

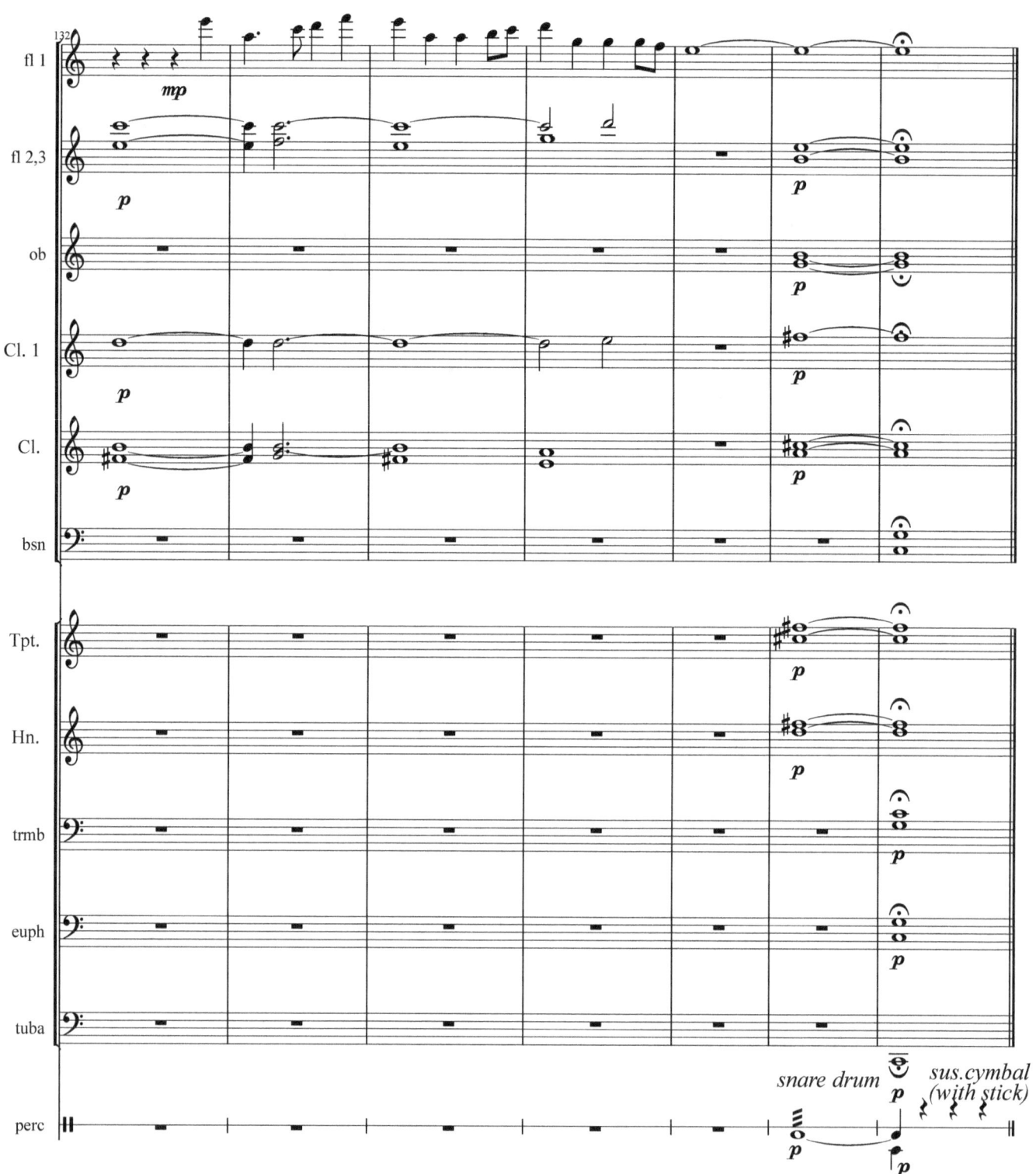

Voices of 1918

Commissioned for the Vermont Symphony Orchestra's 2000 "Made In Vermont" Music Series

Ken Langer

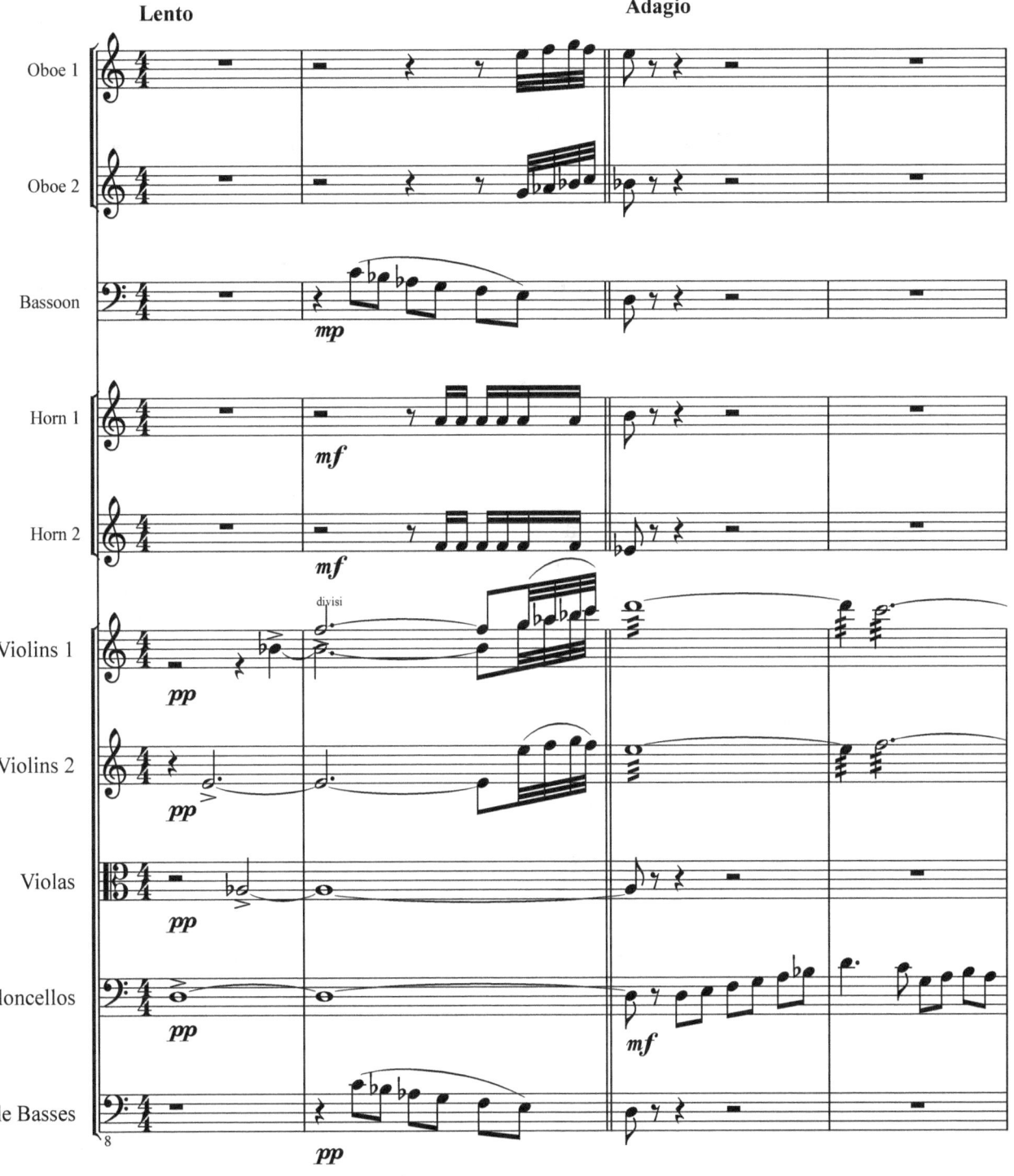

83

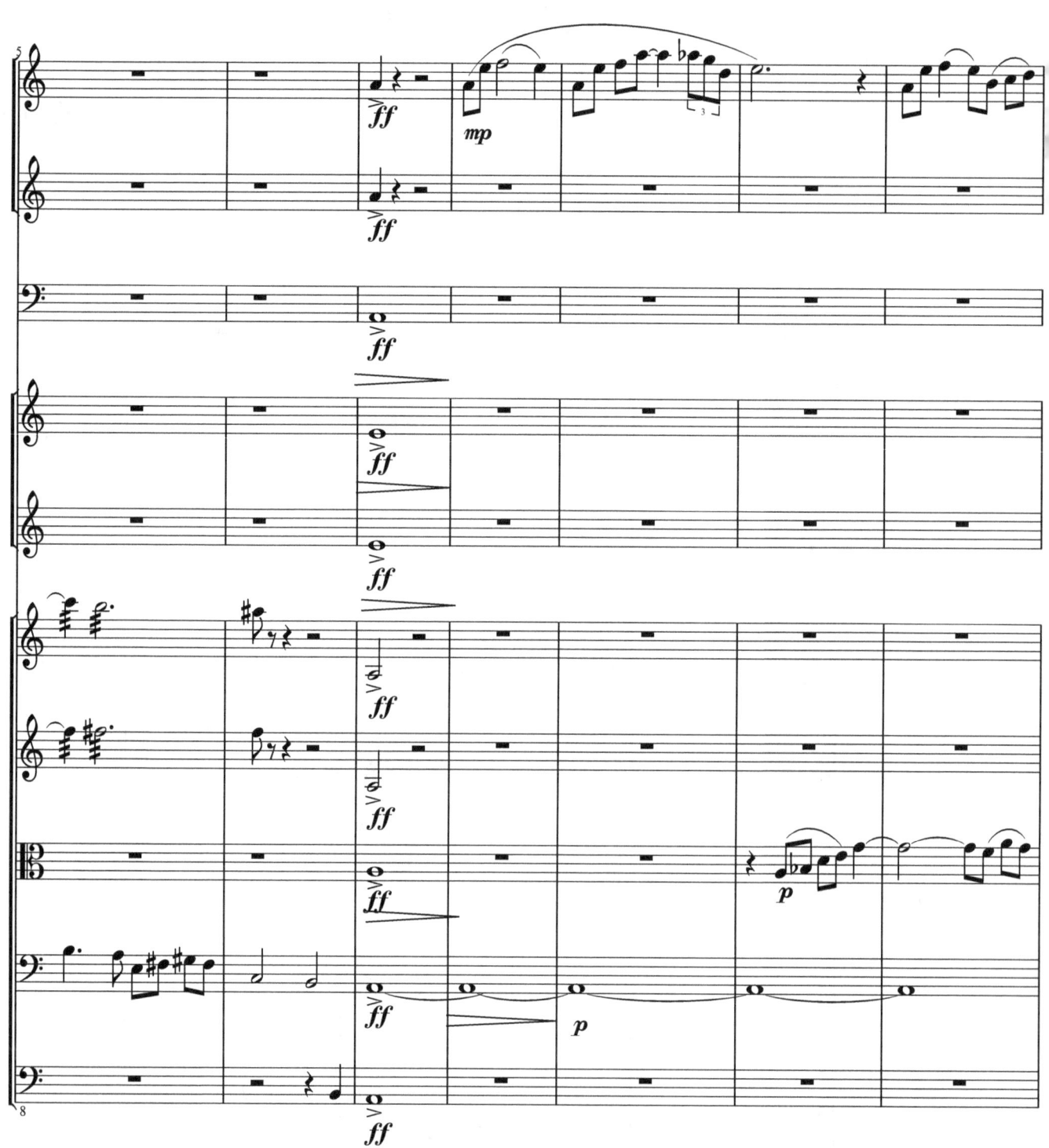

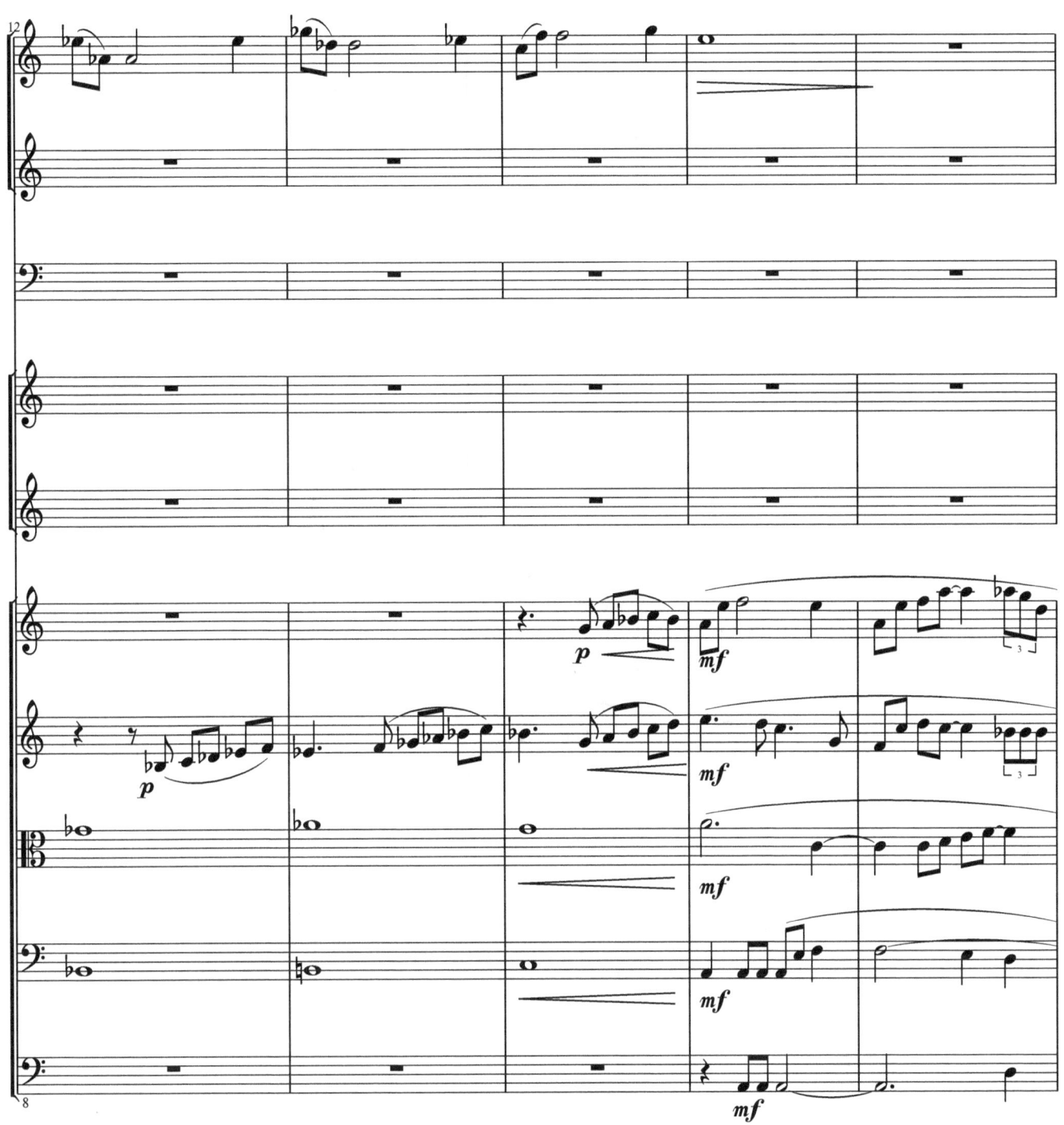

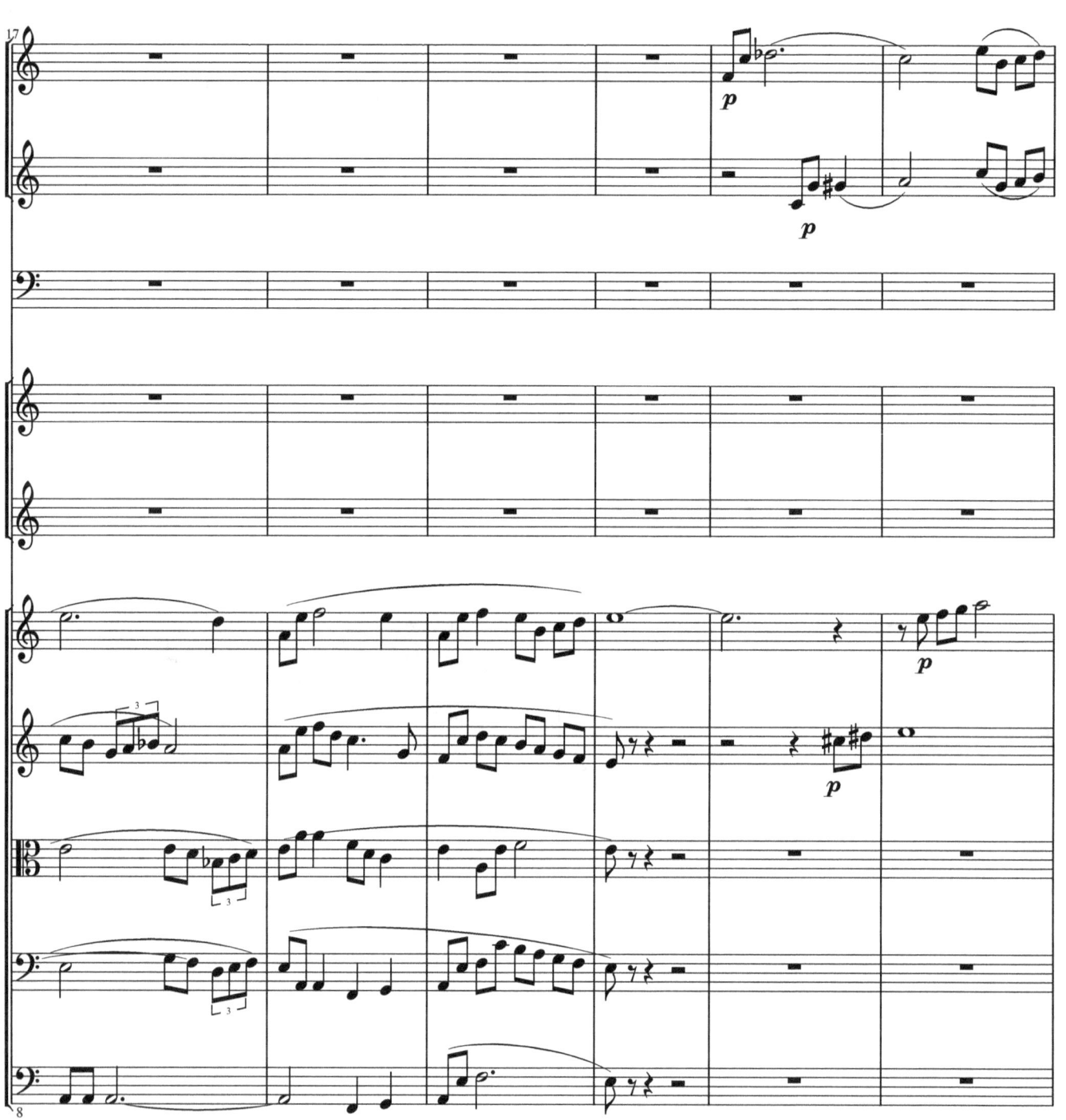

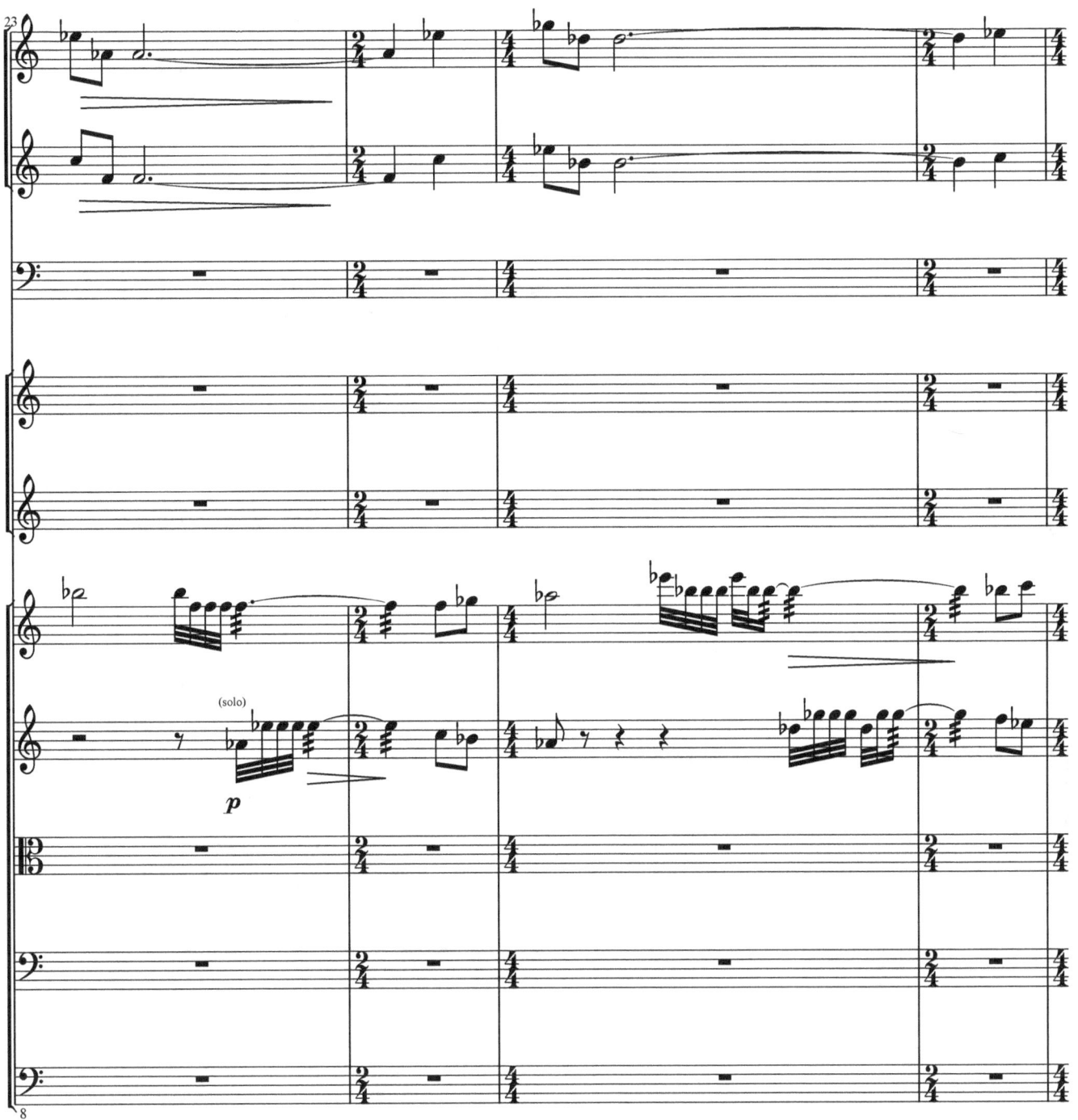

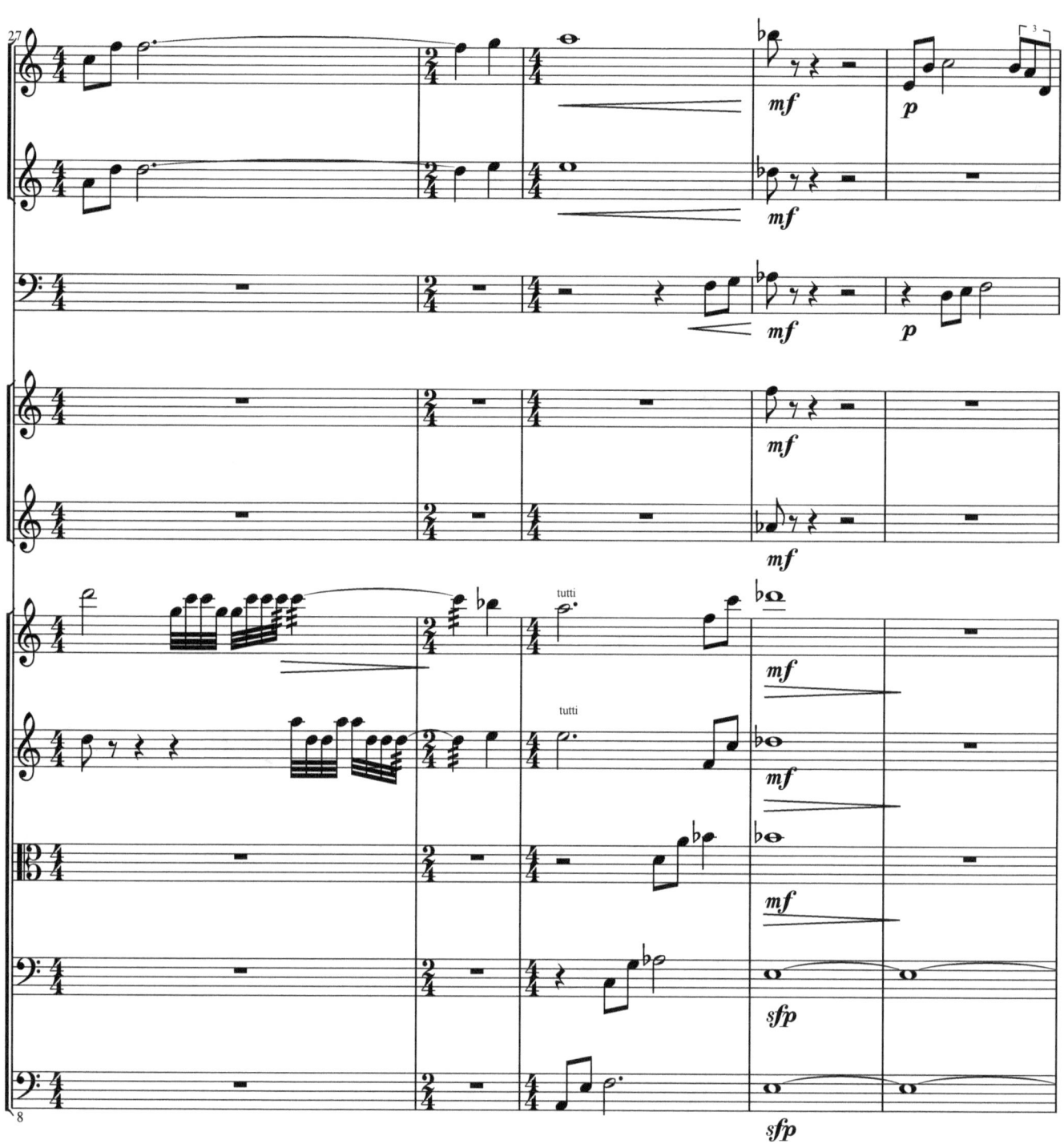

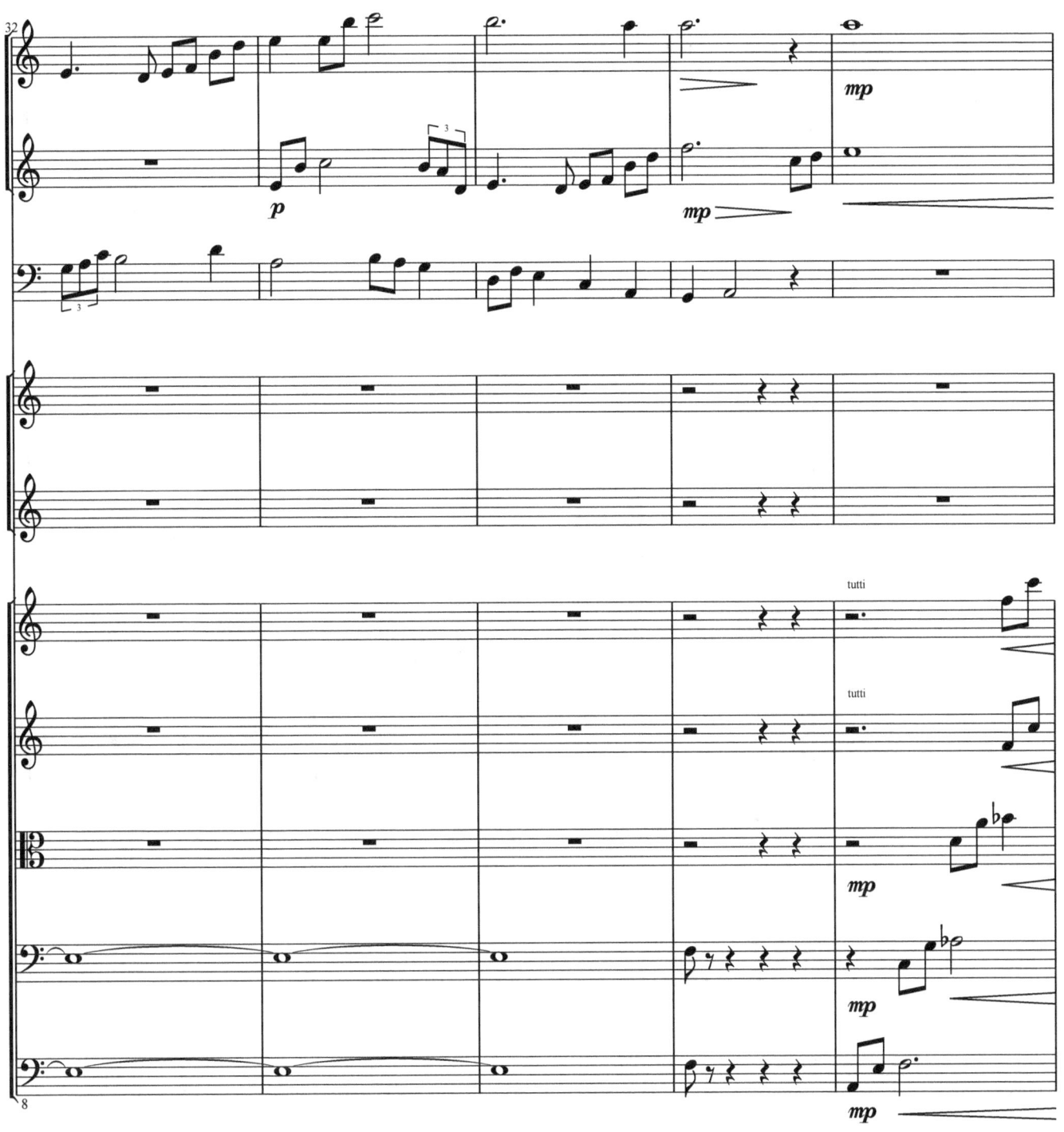

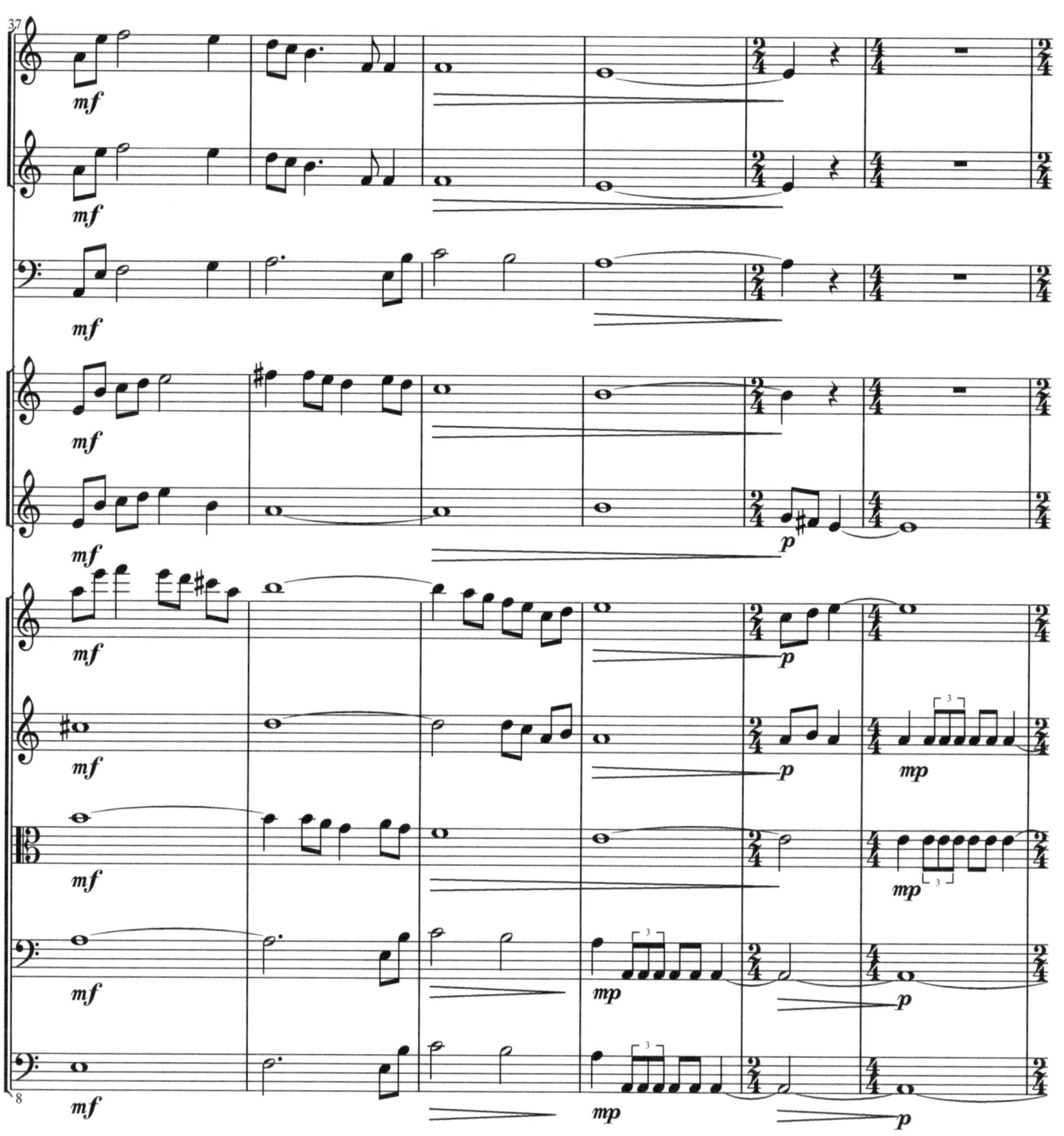

Vivace

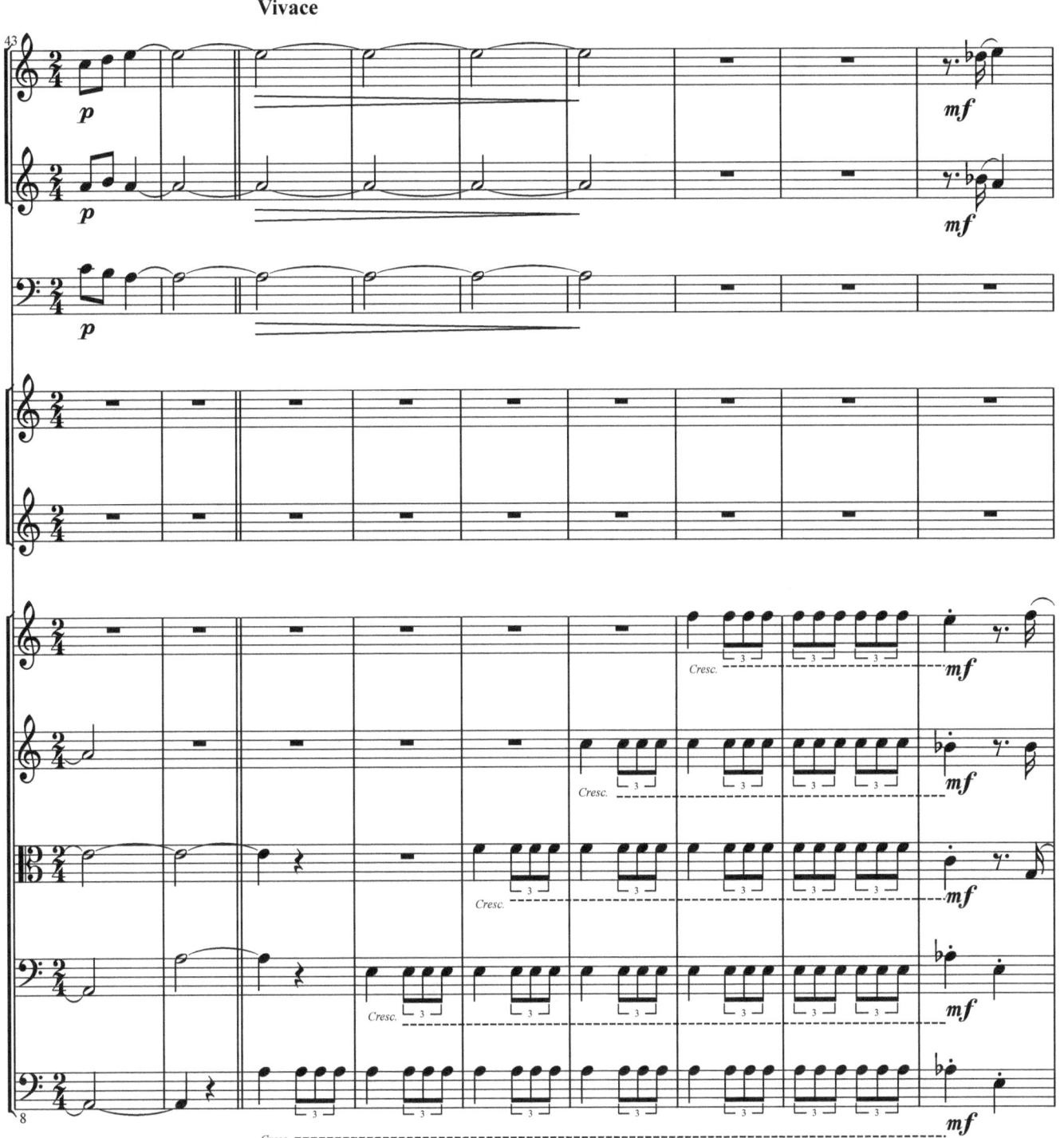

91

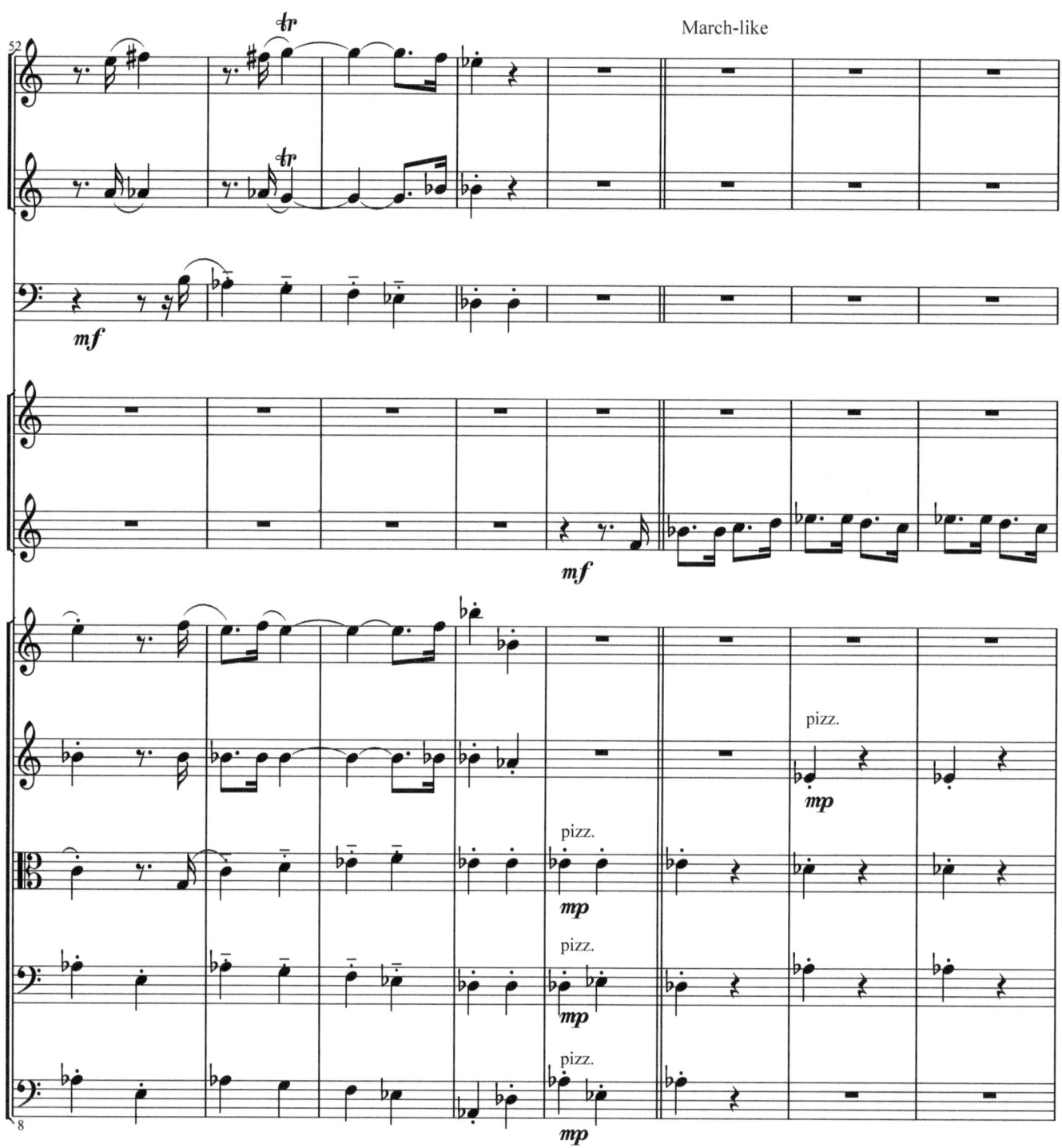

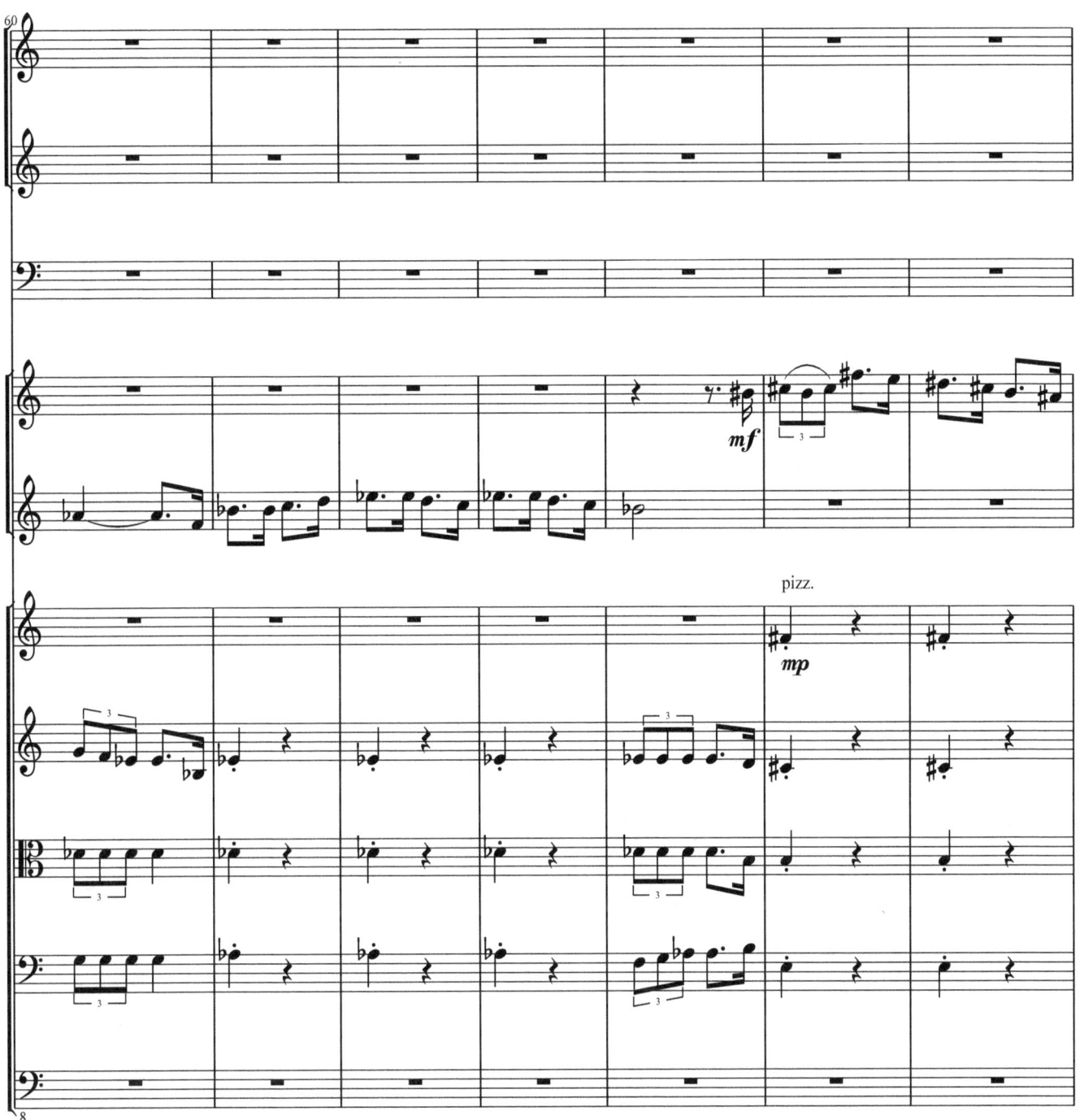

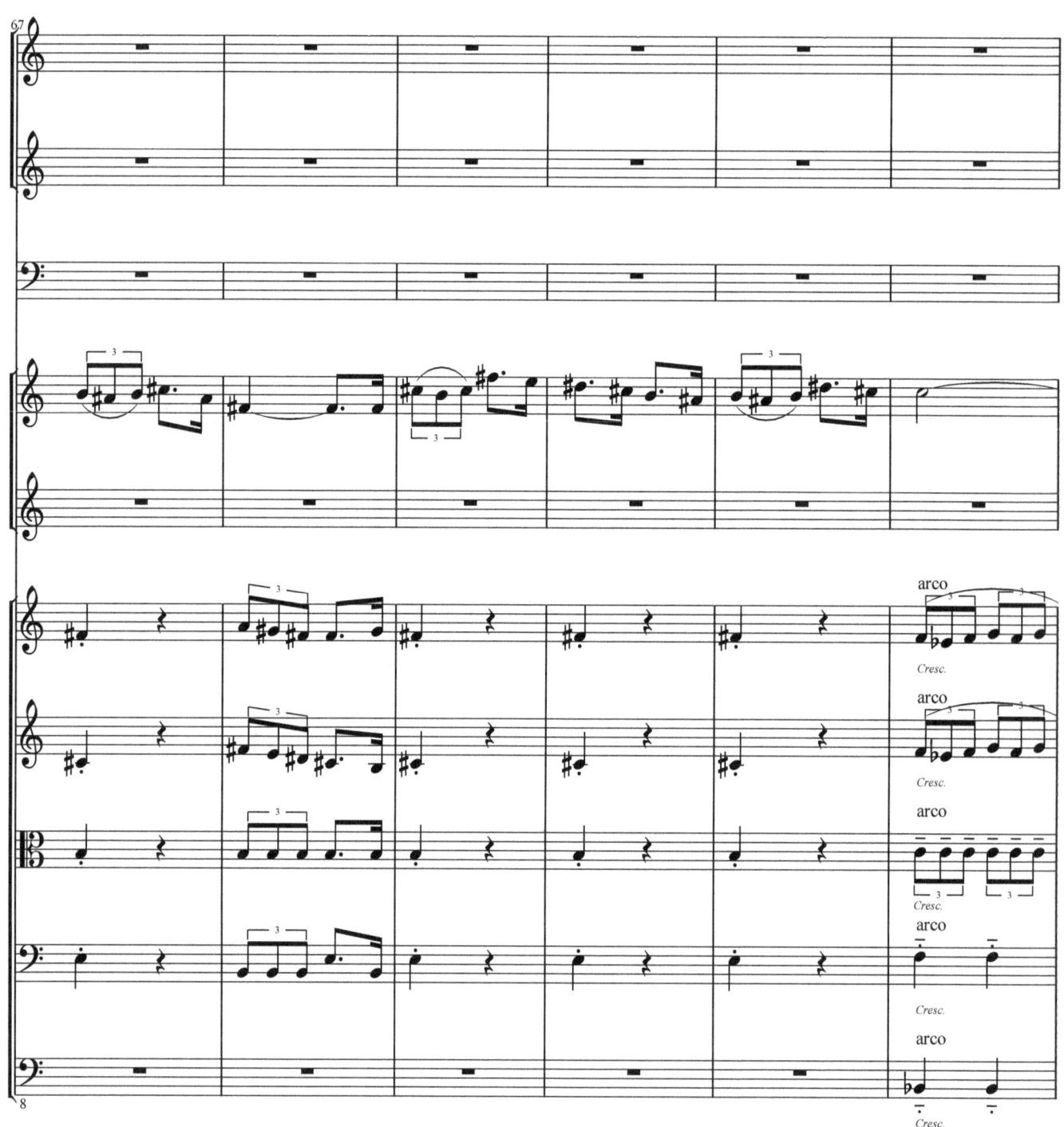

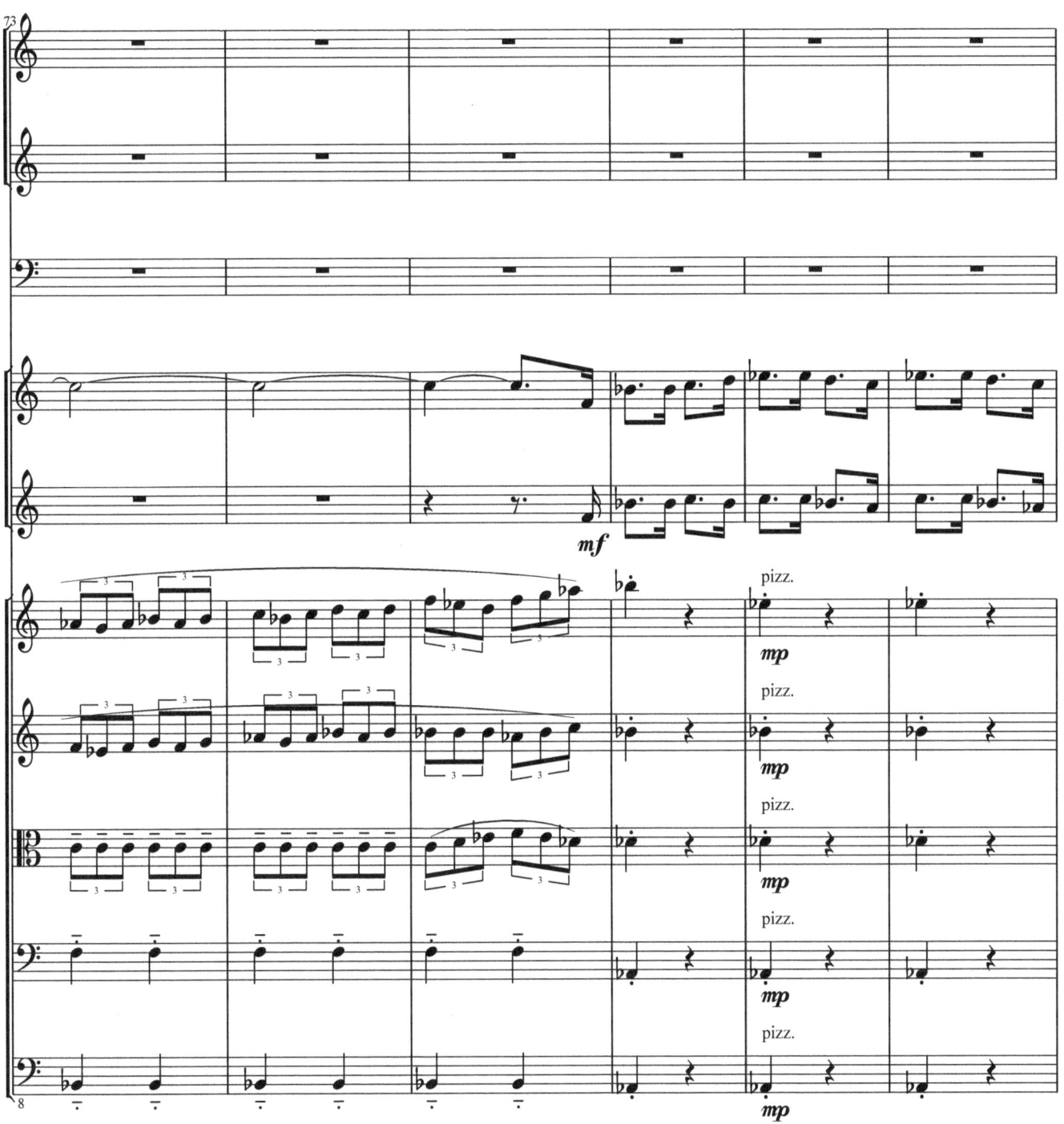

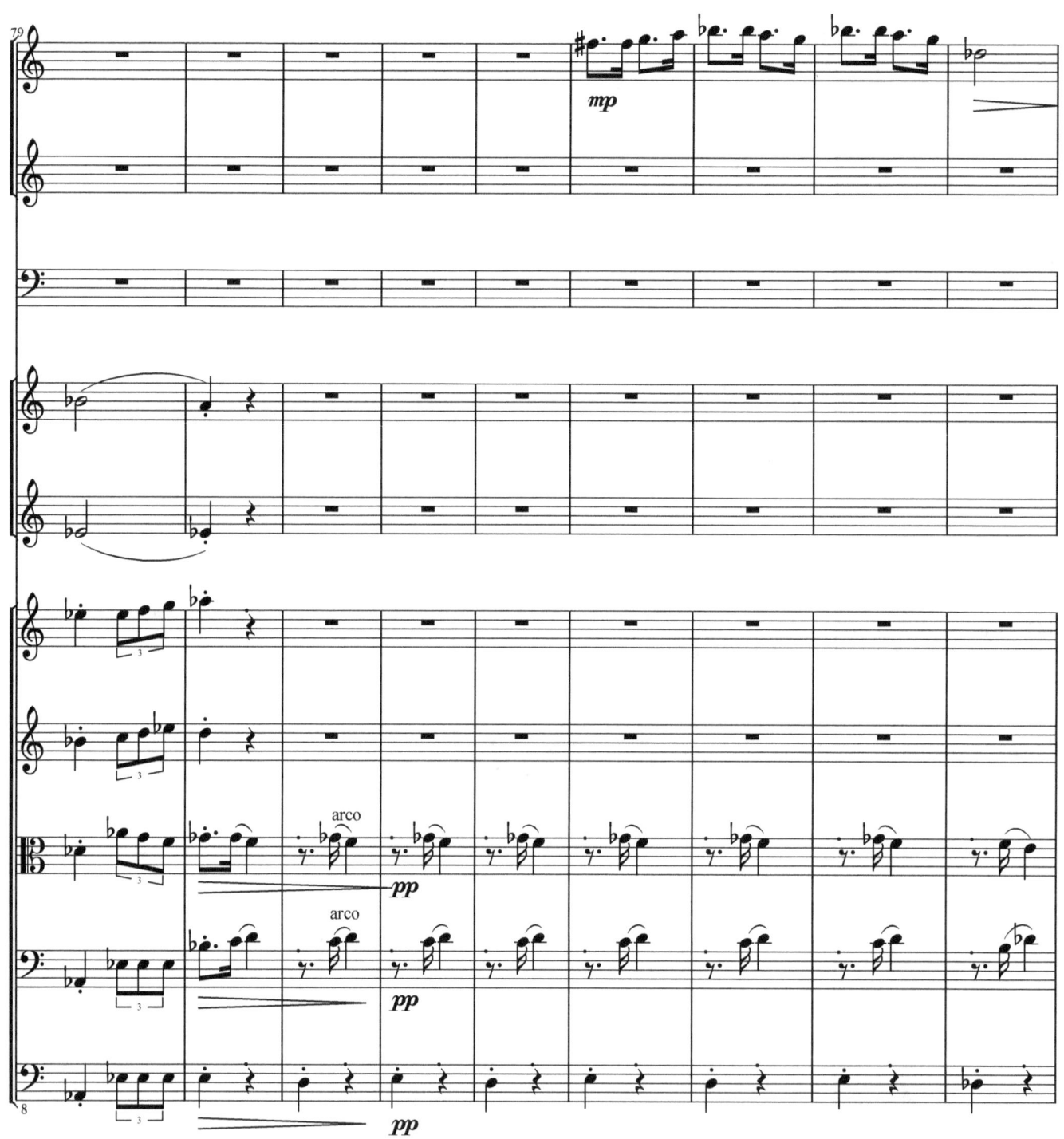

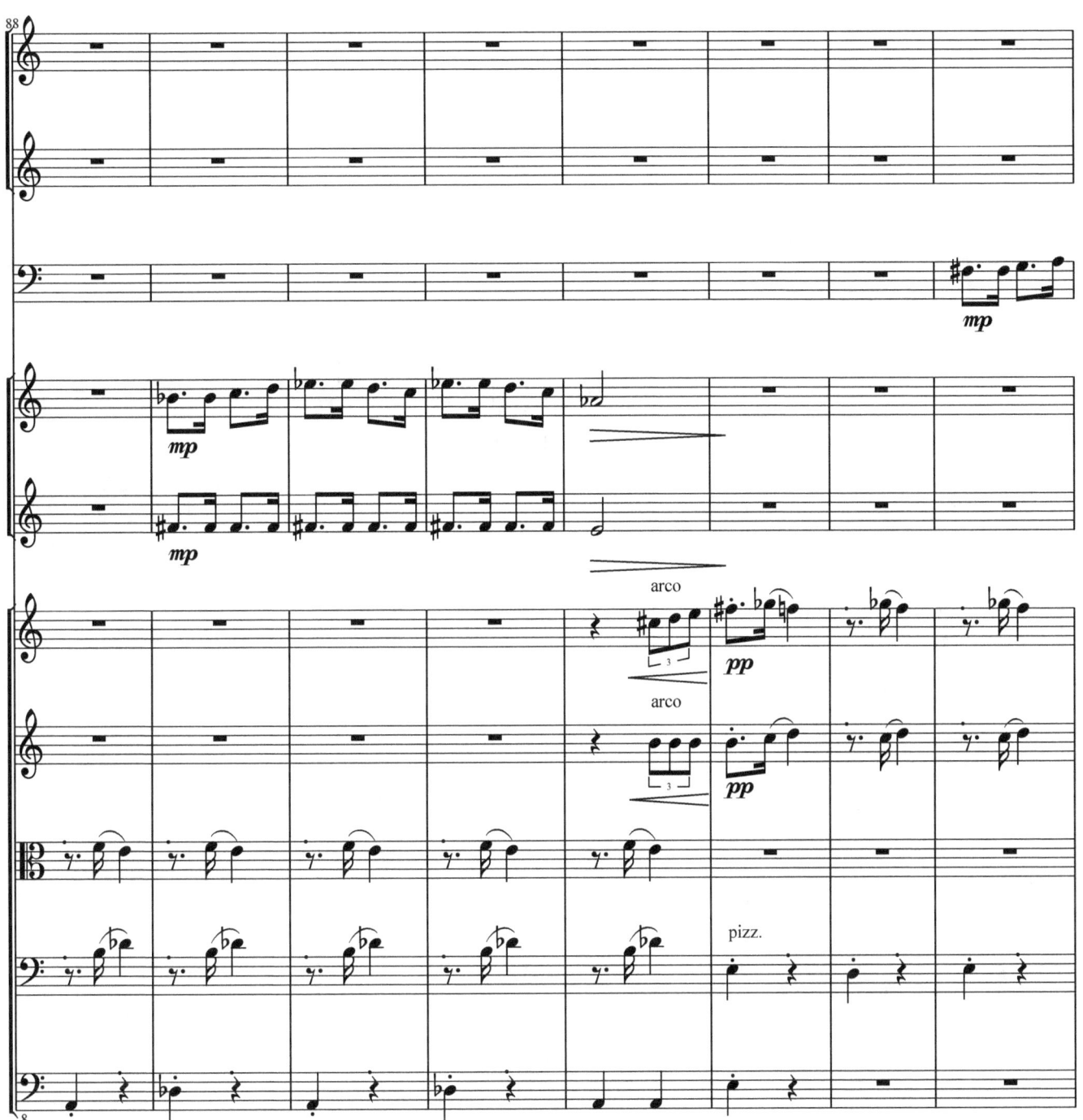

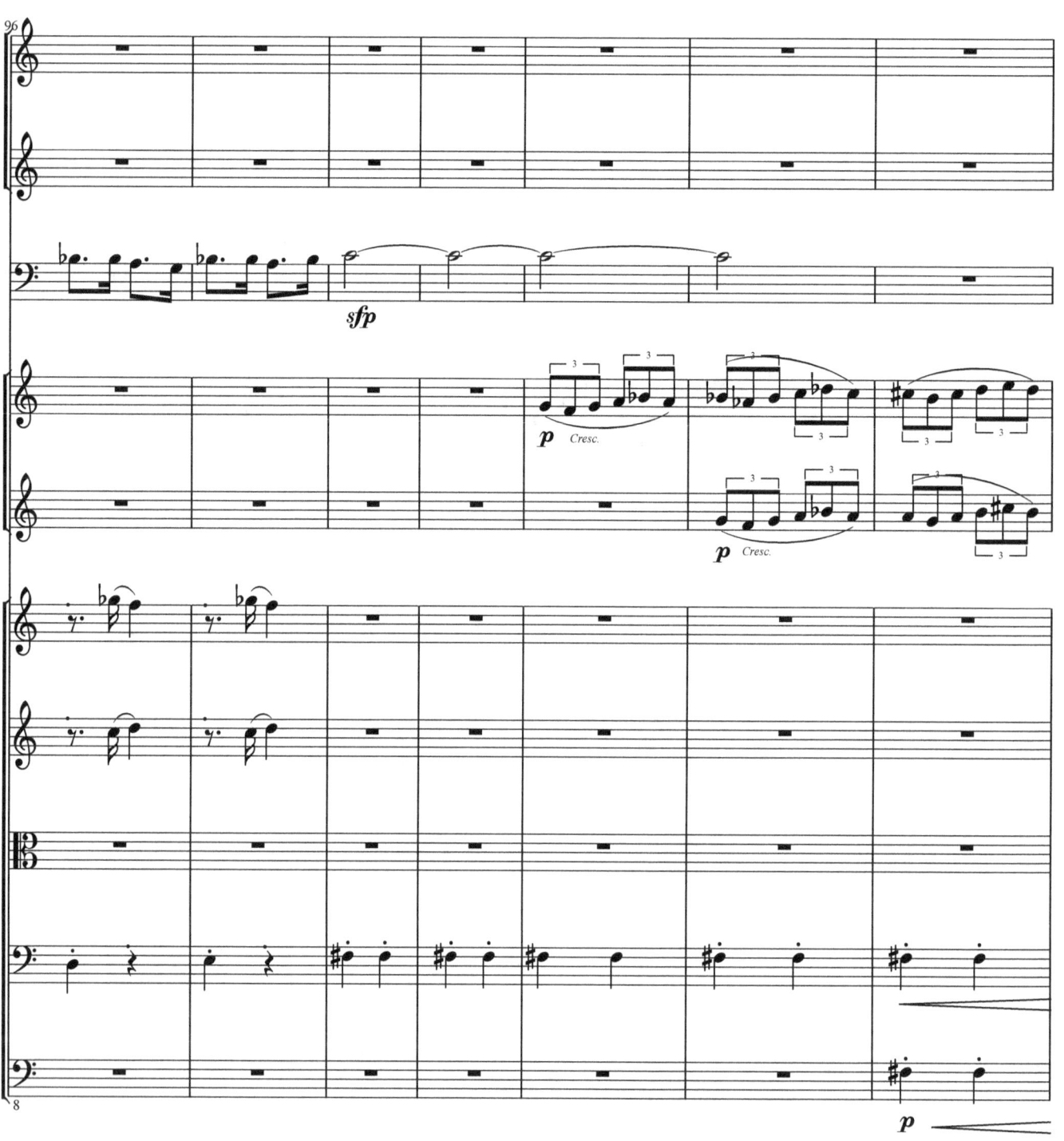

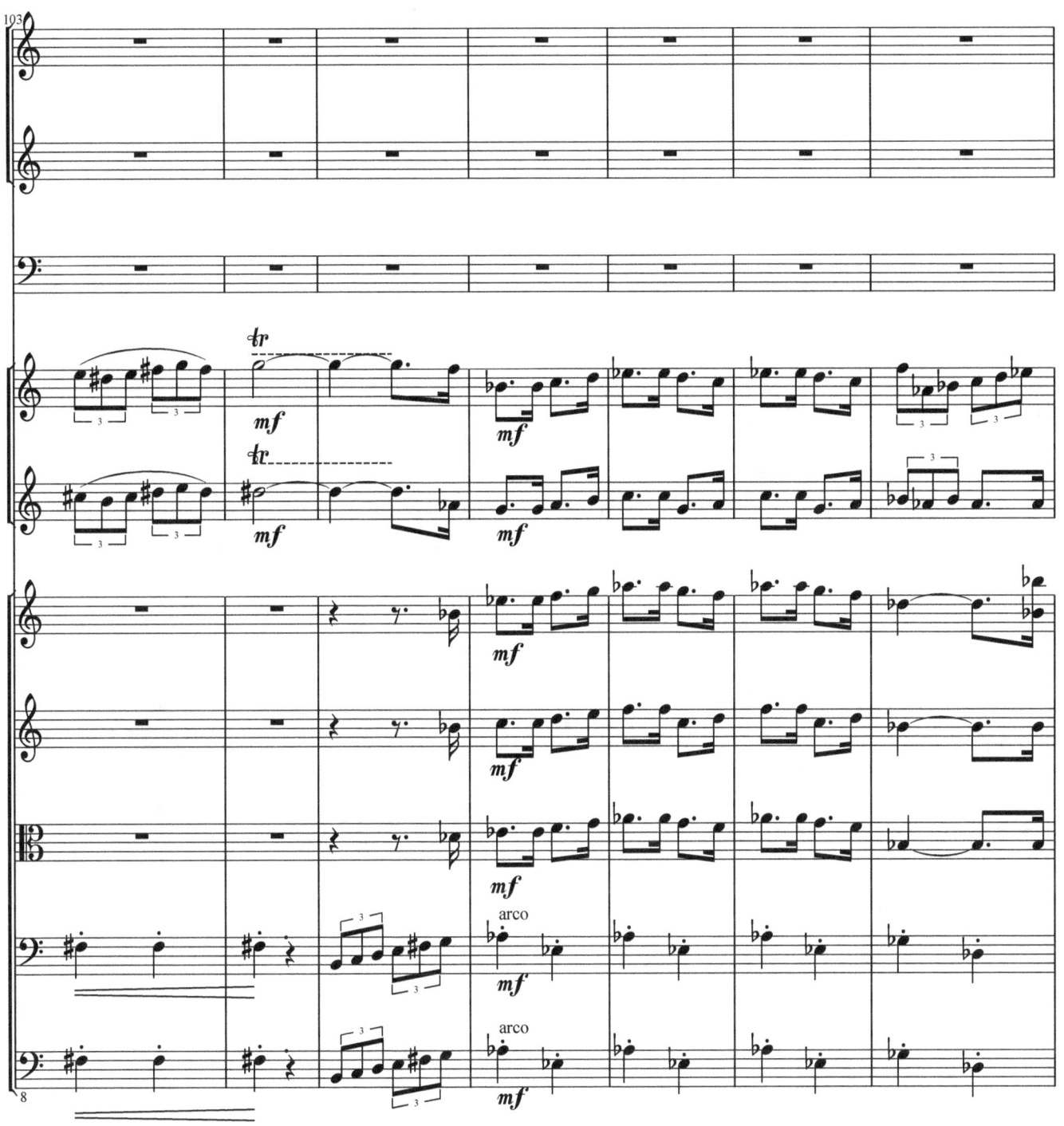

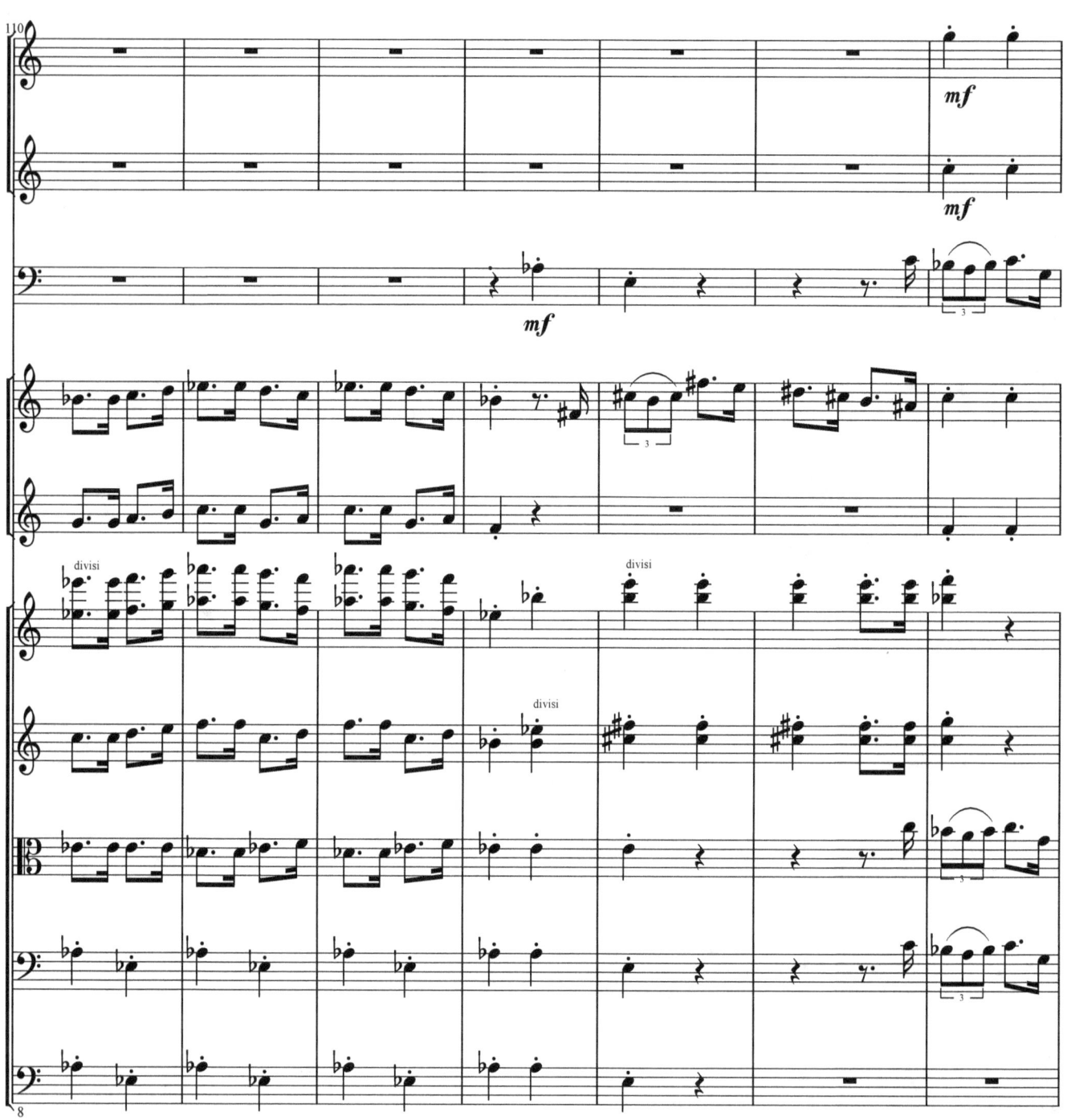

104

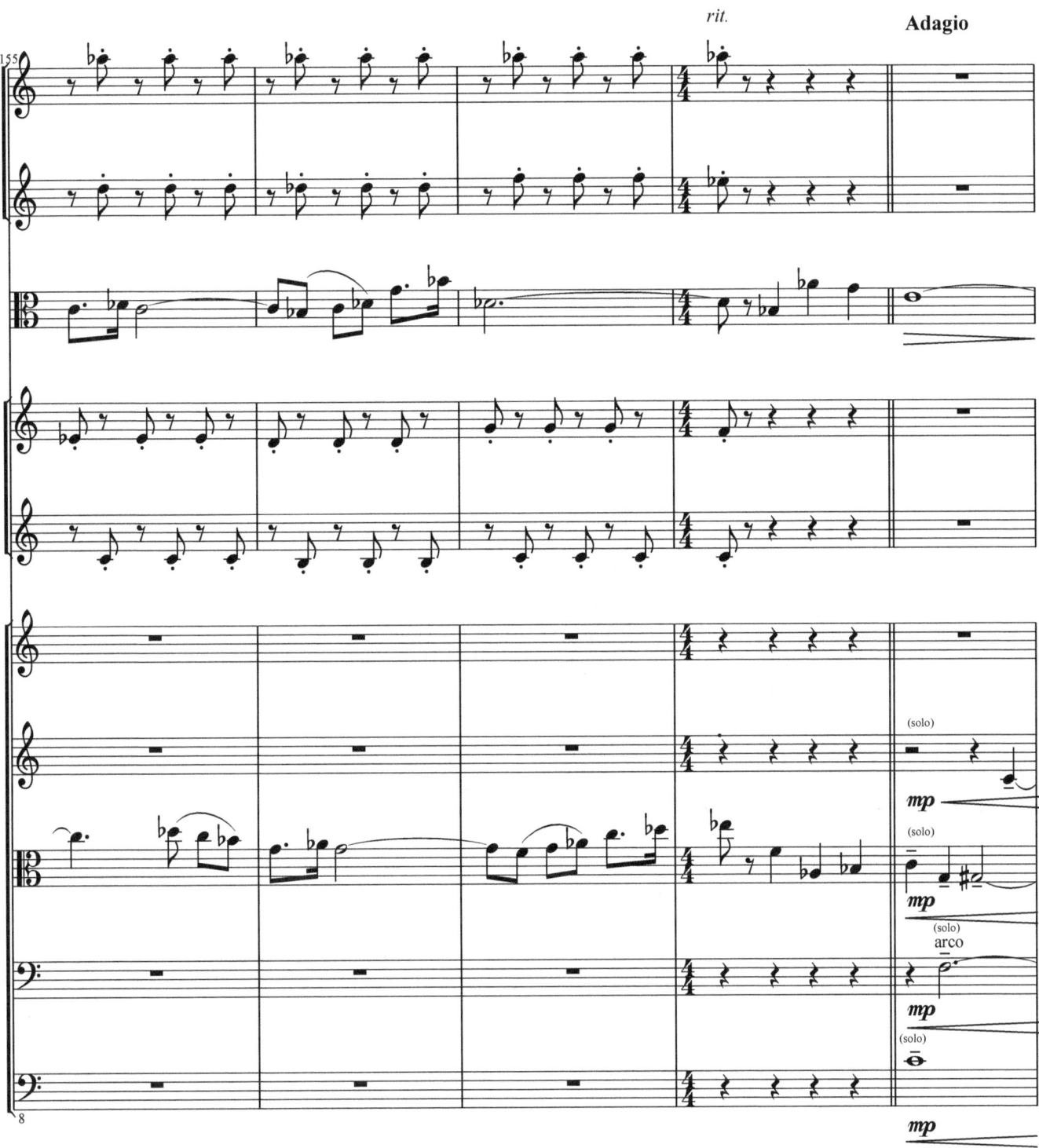

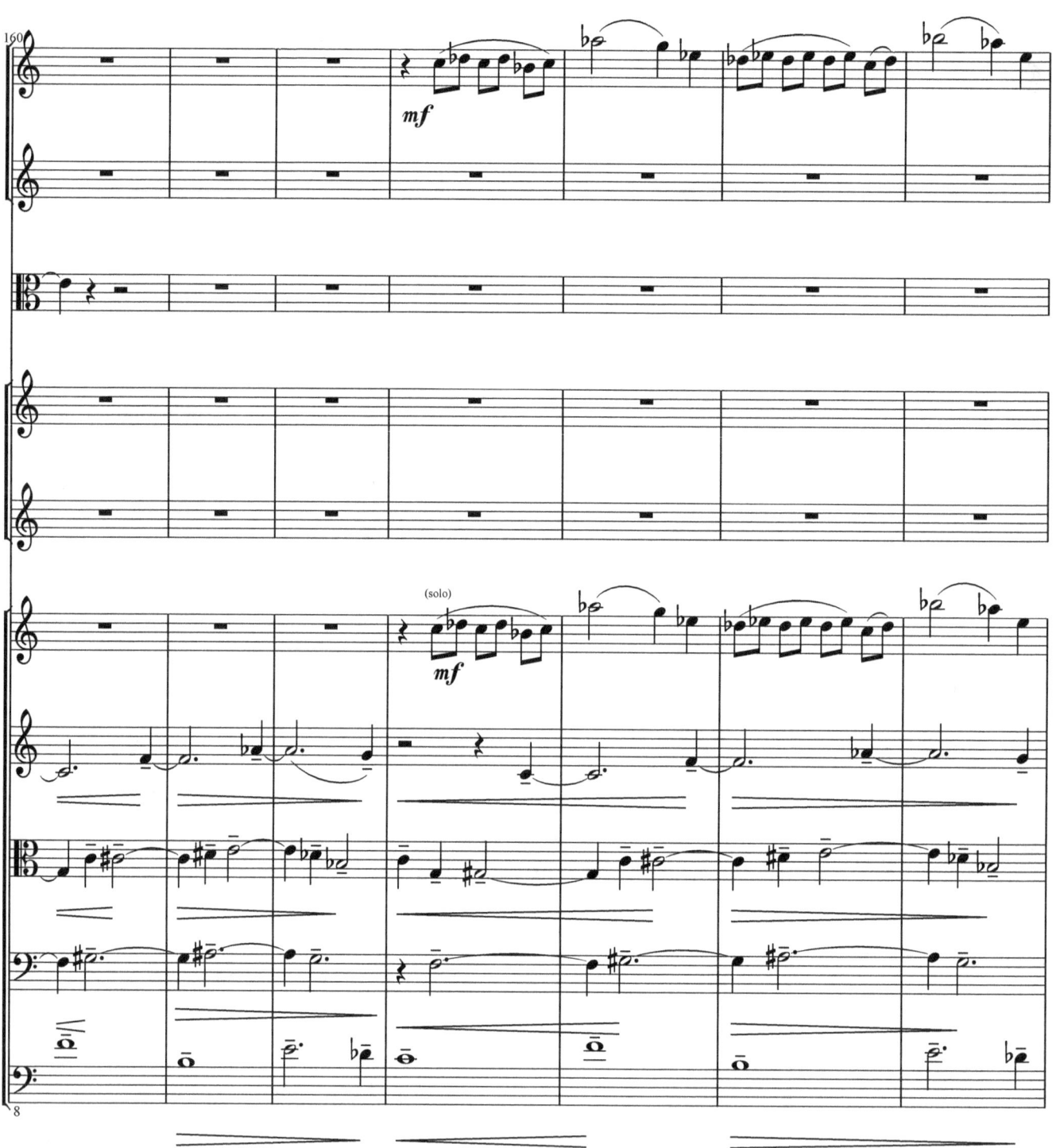

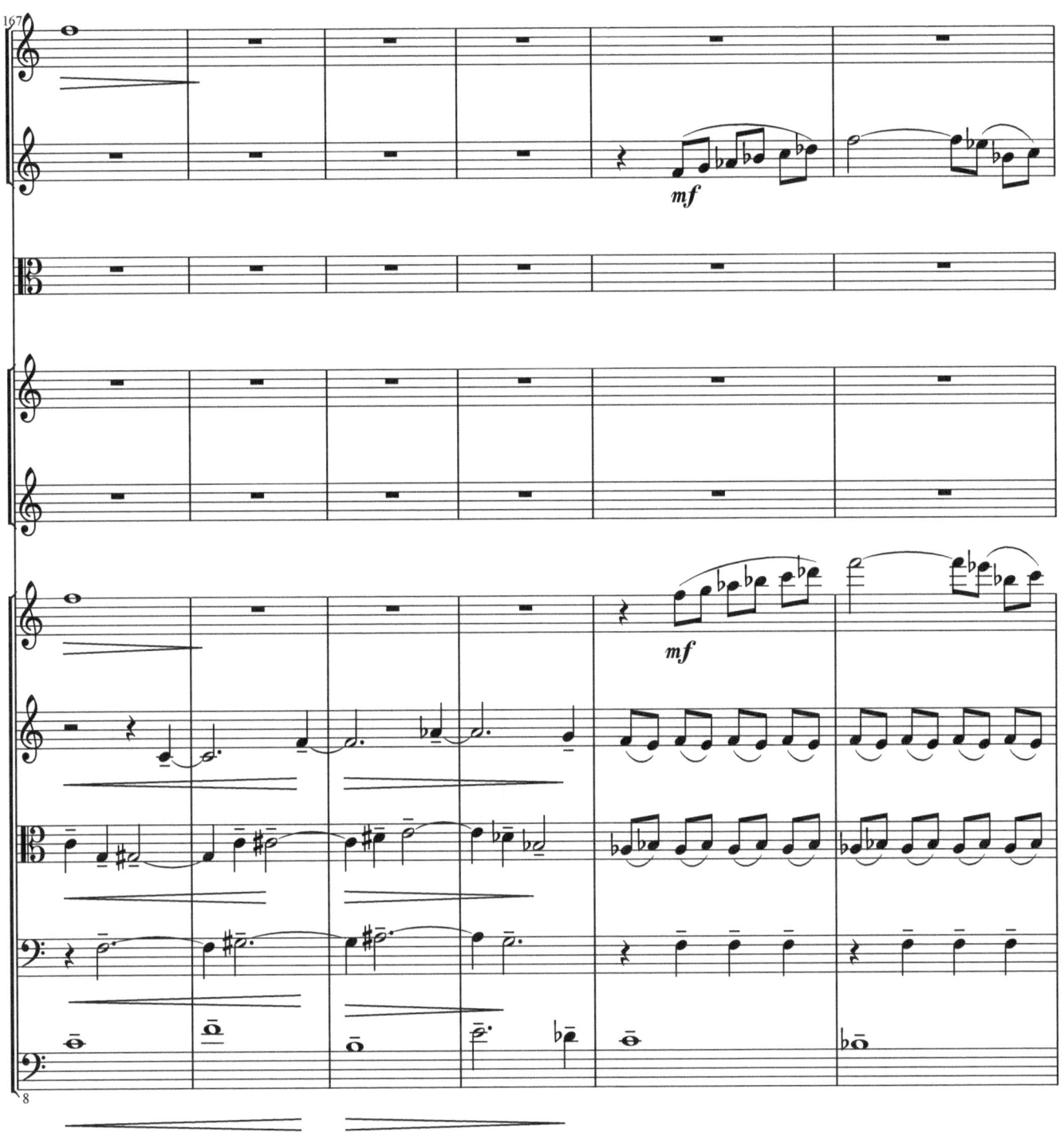

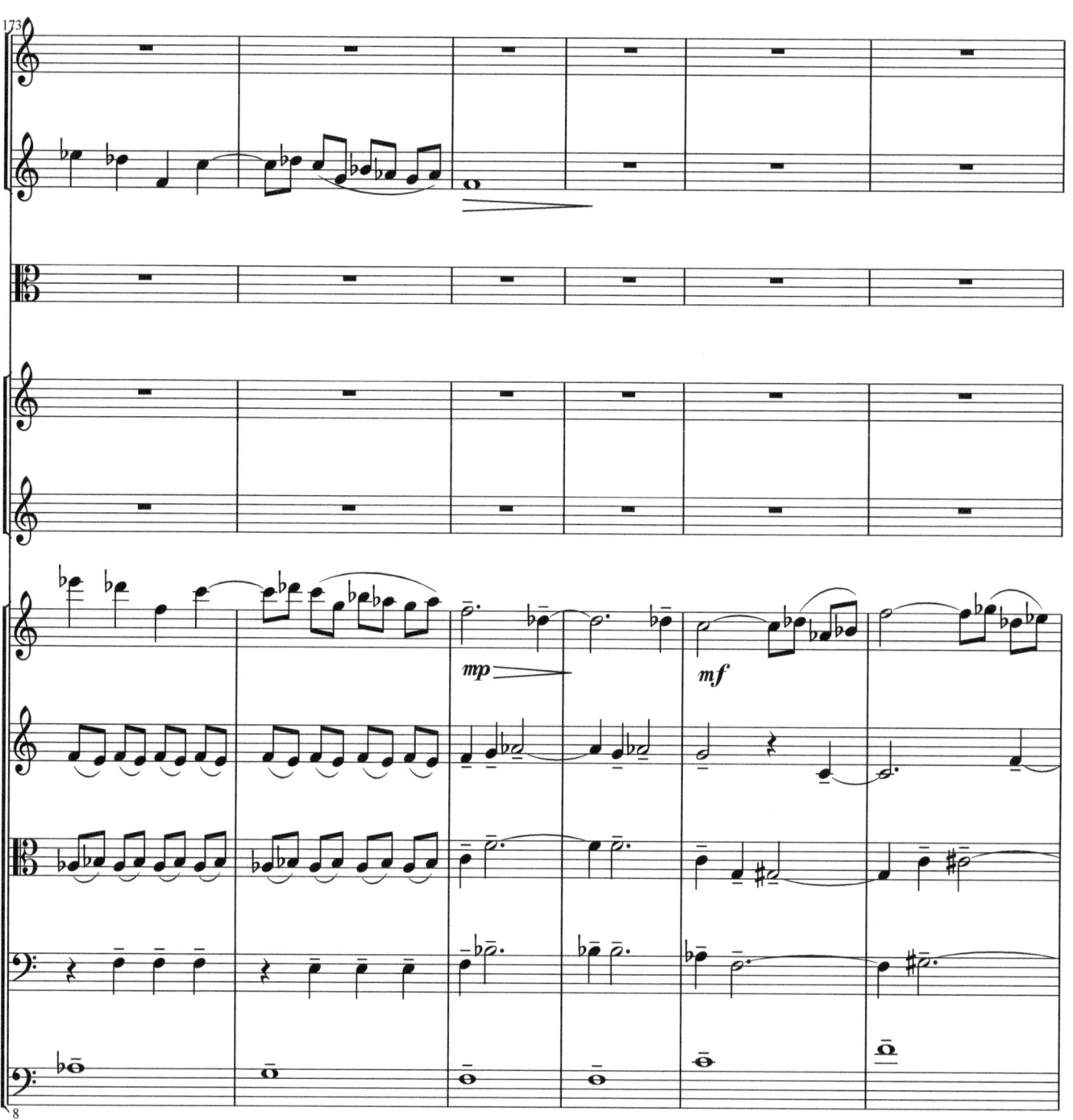

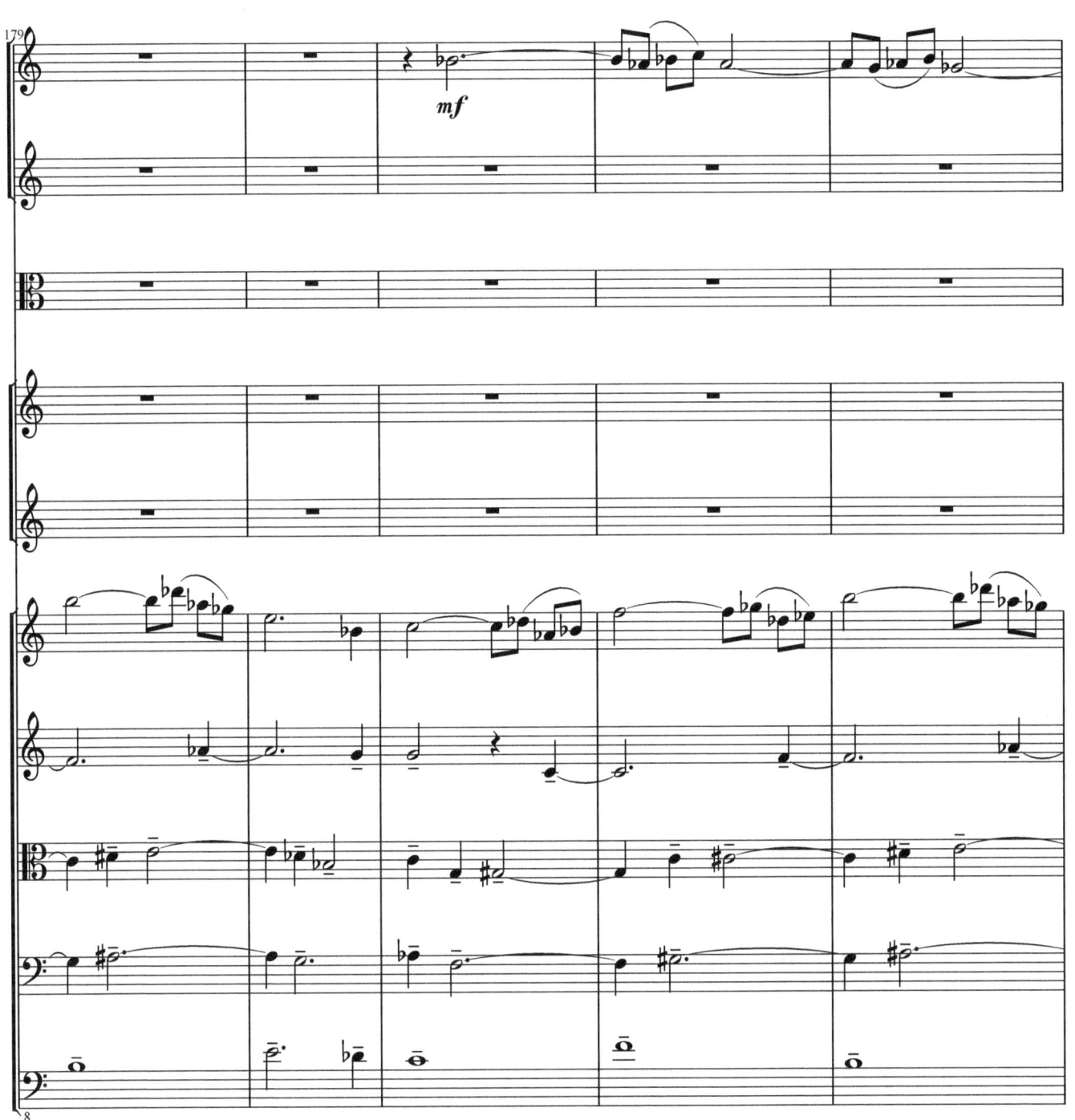

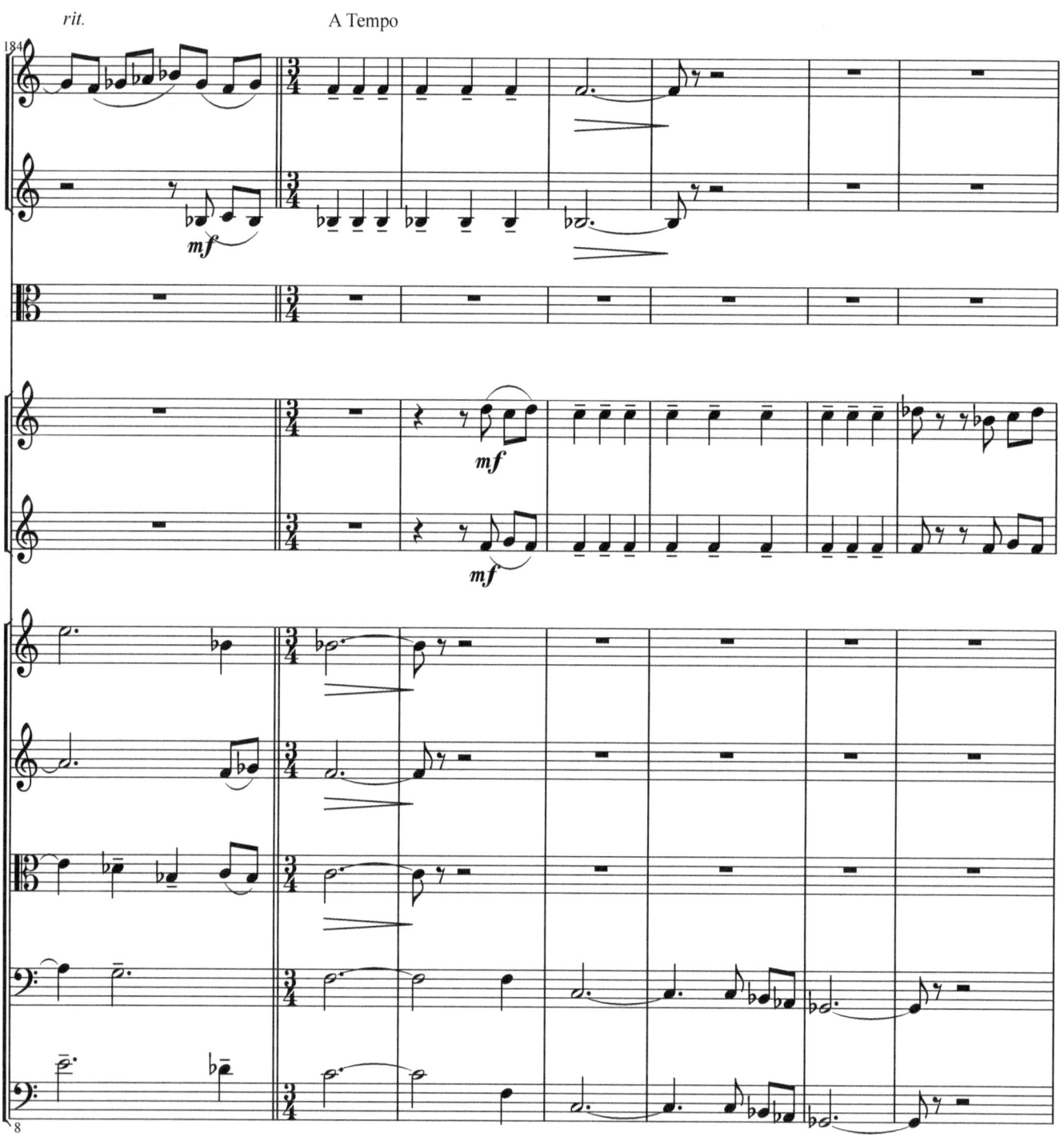

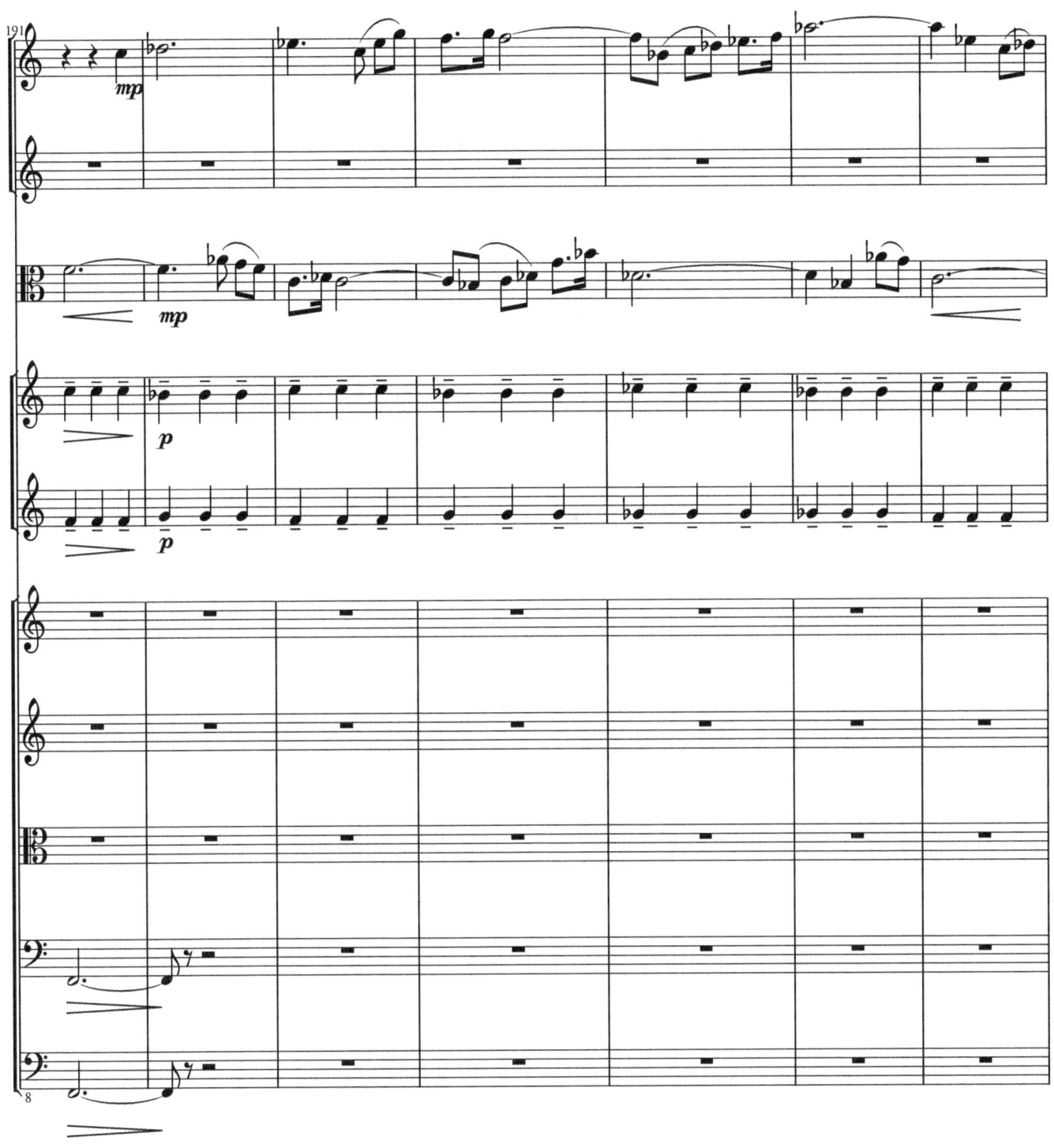

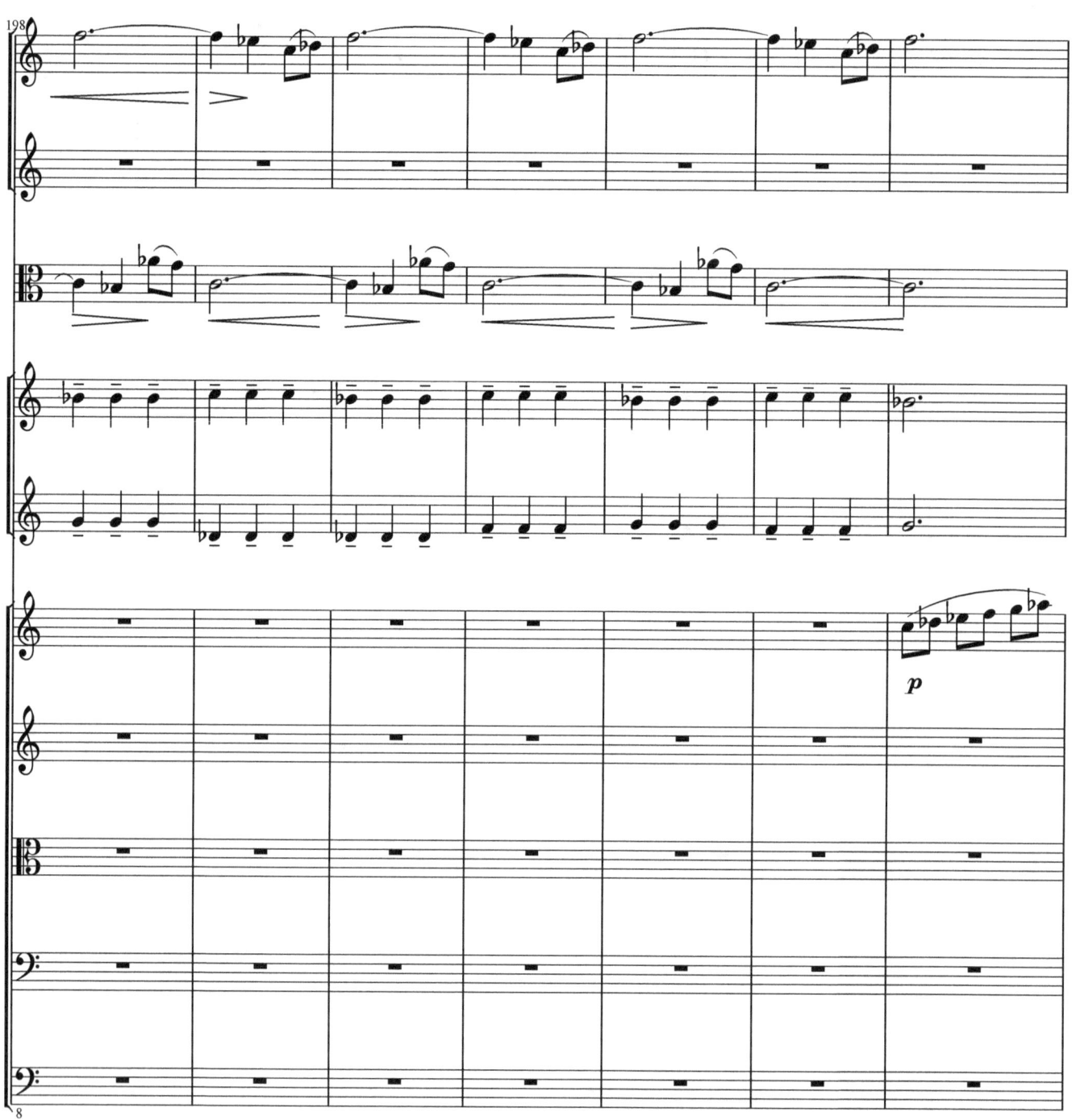

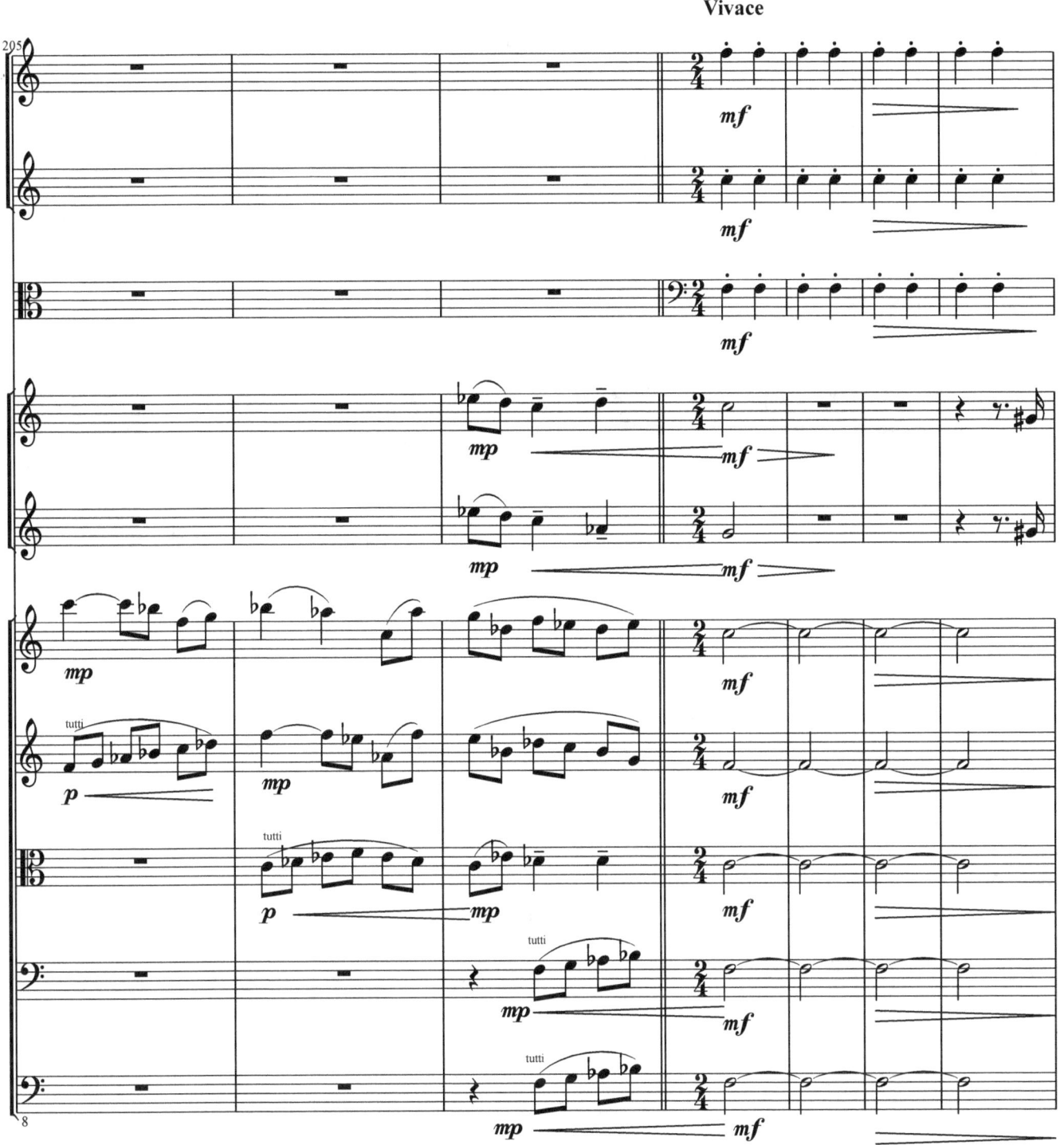

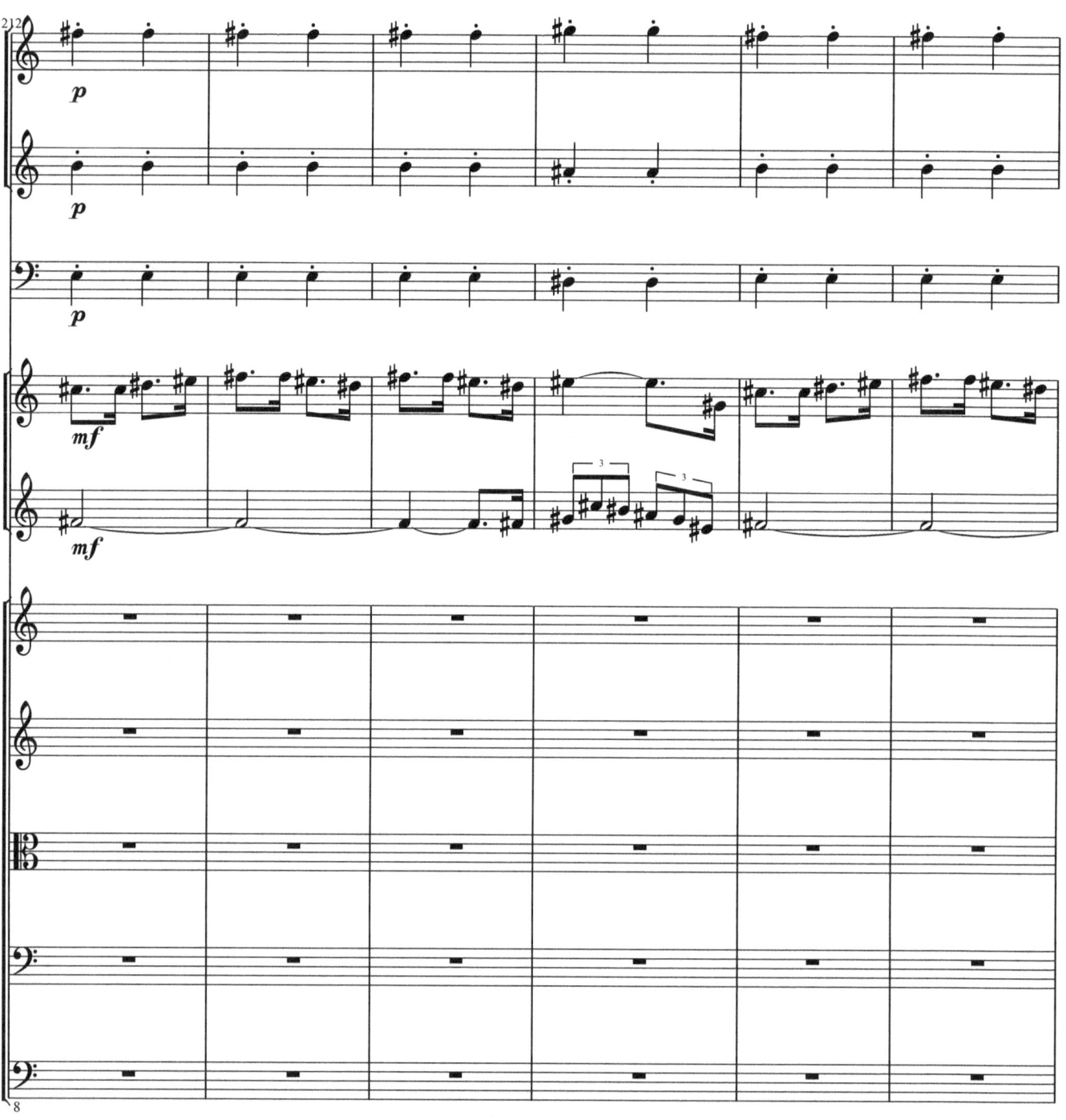

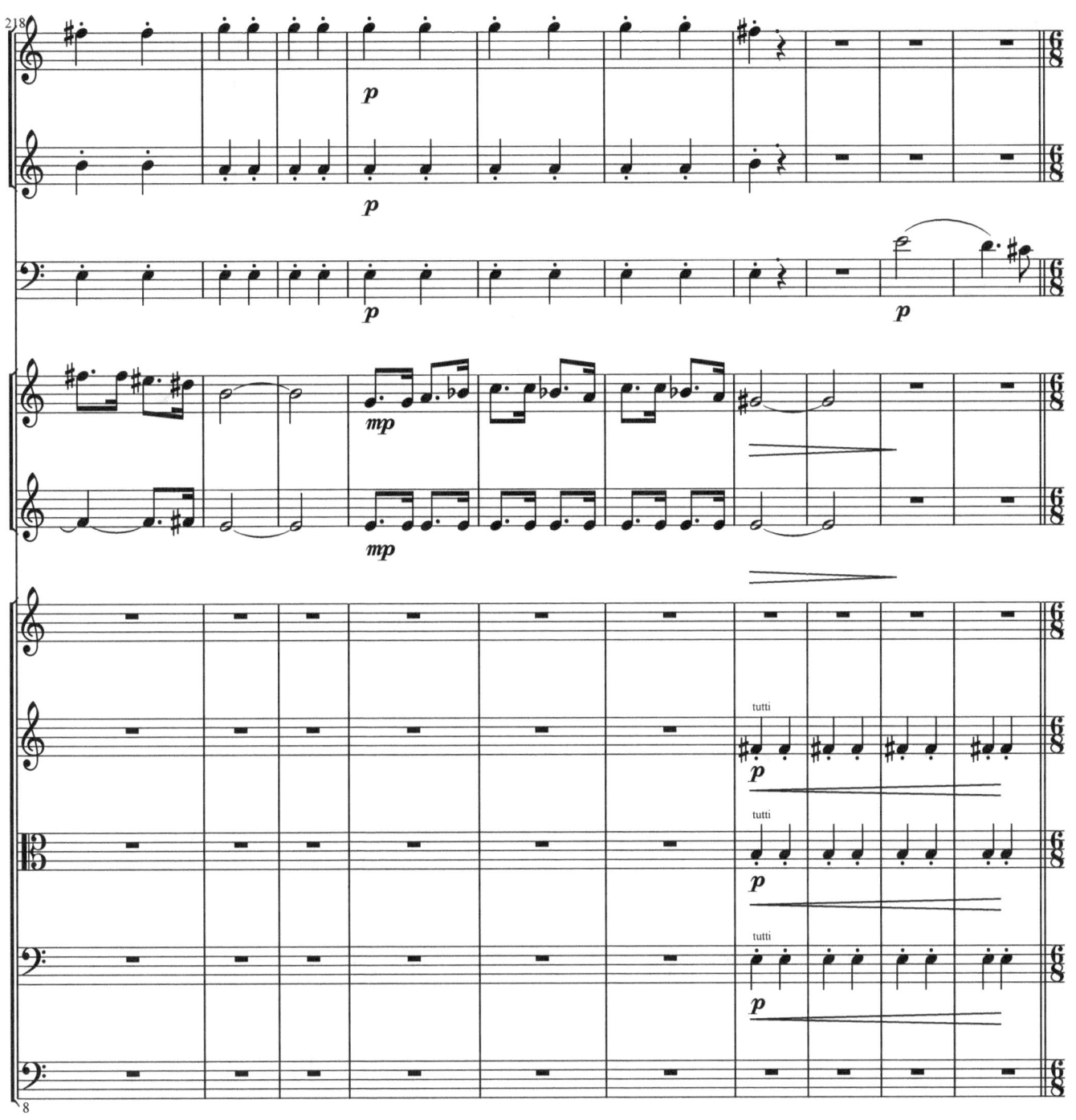

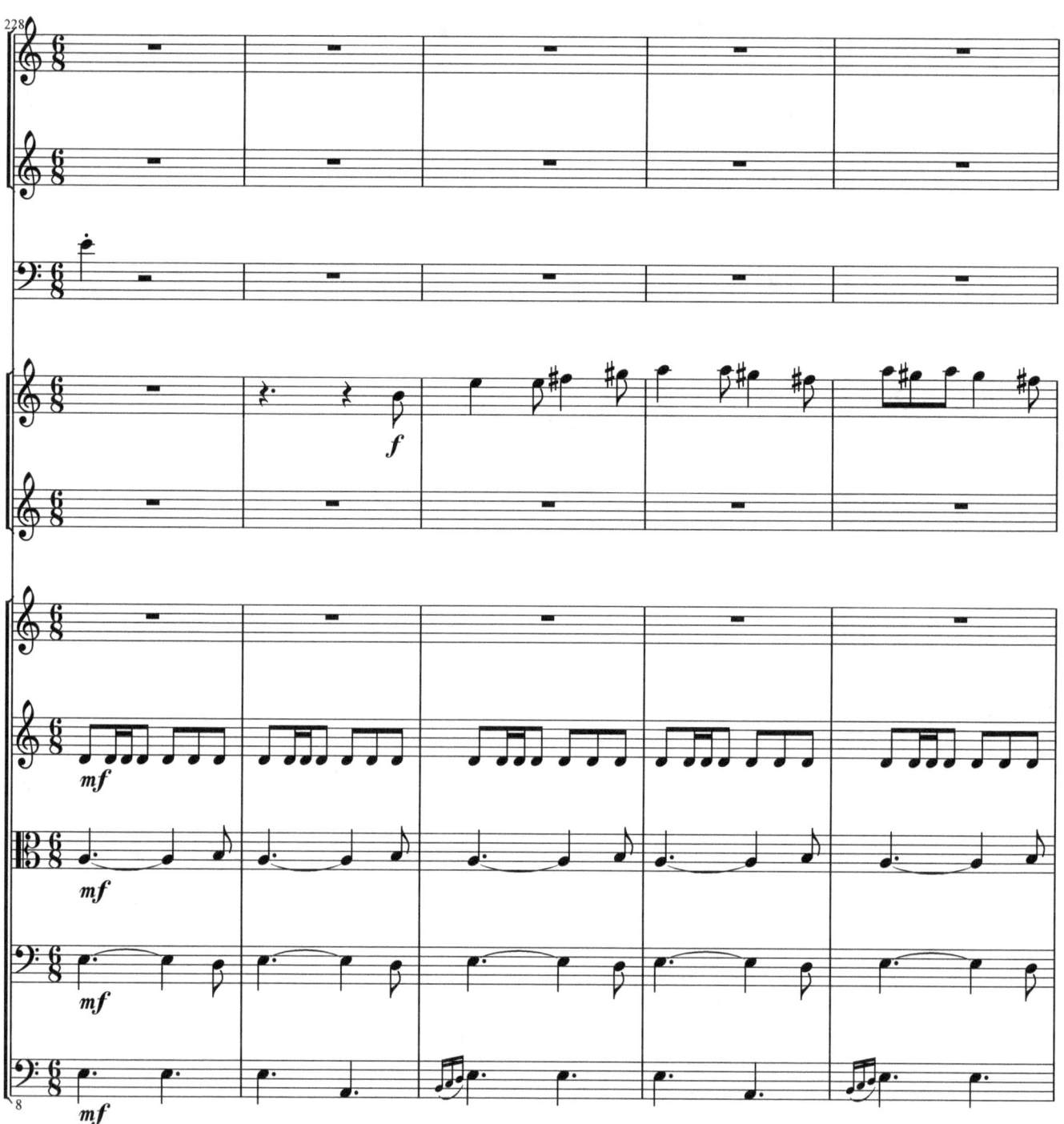

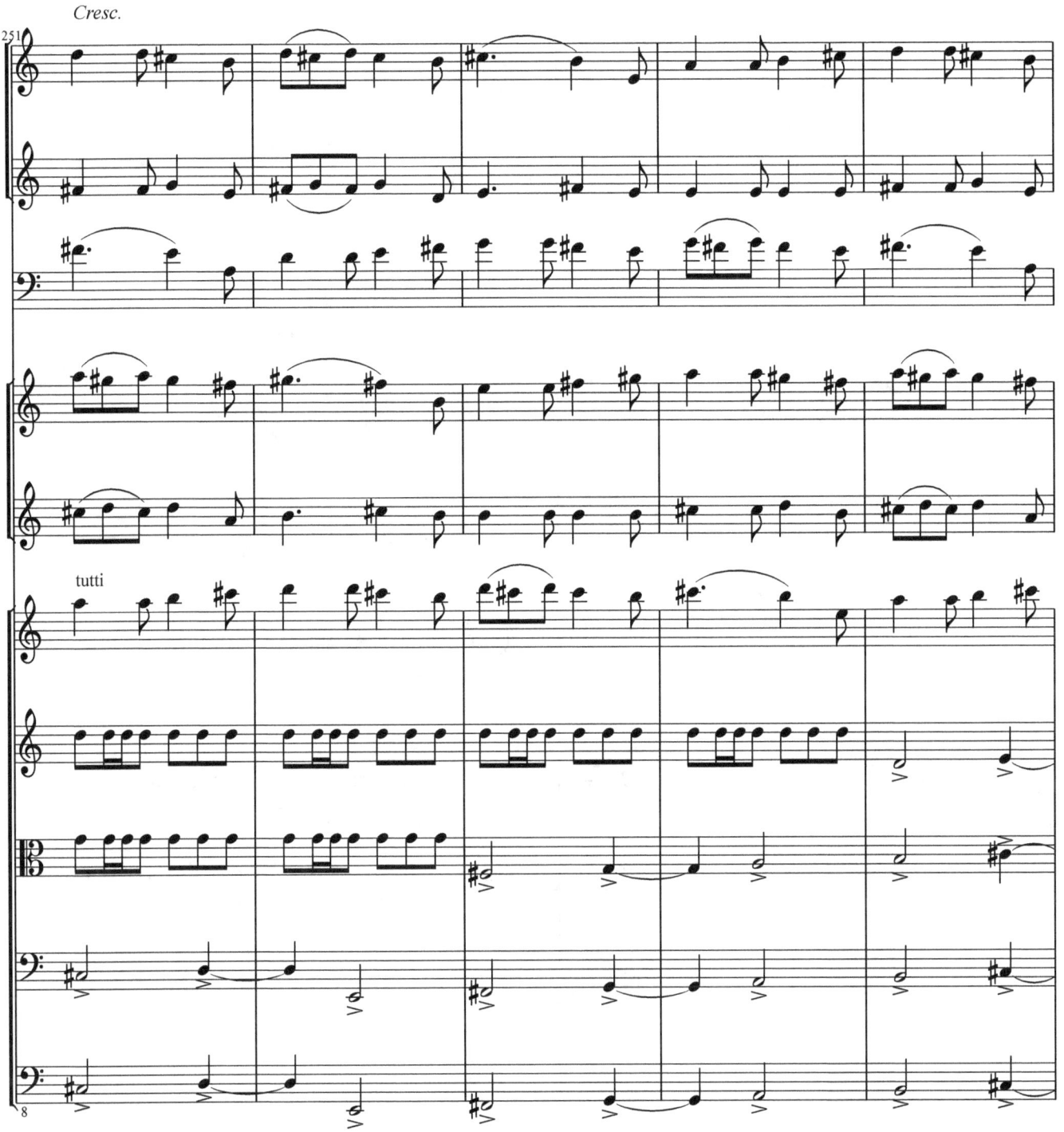

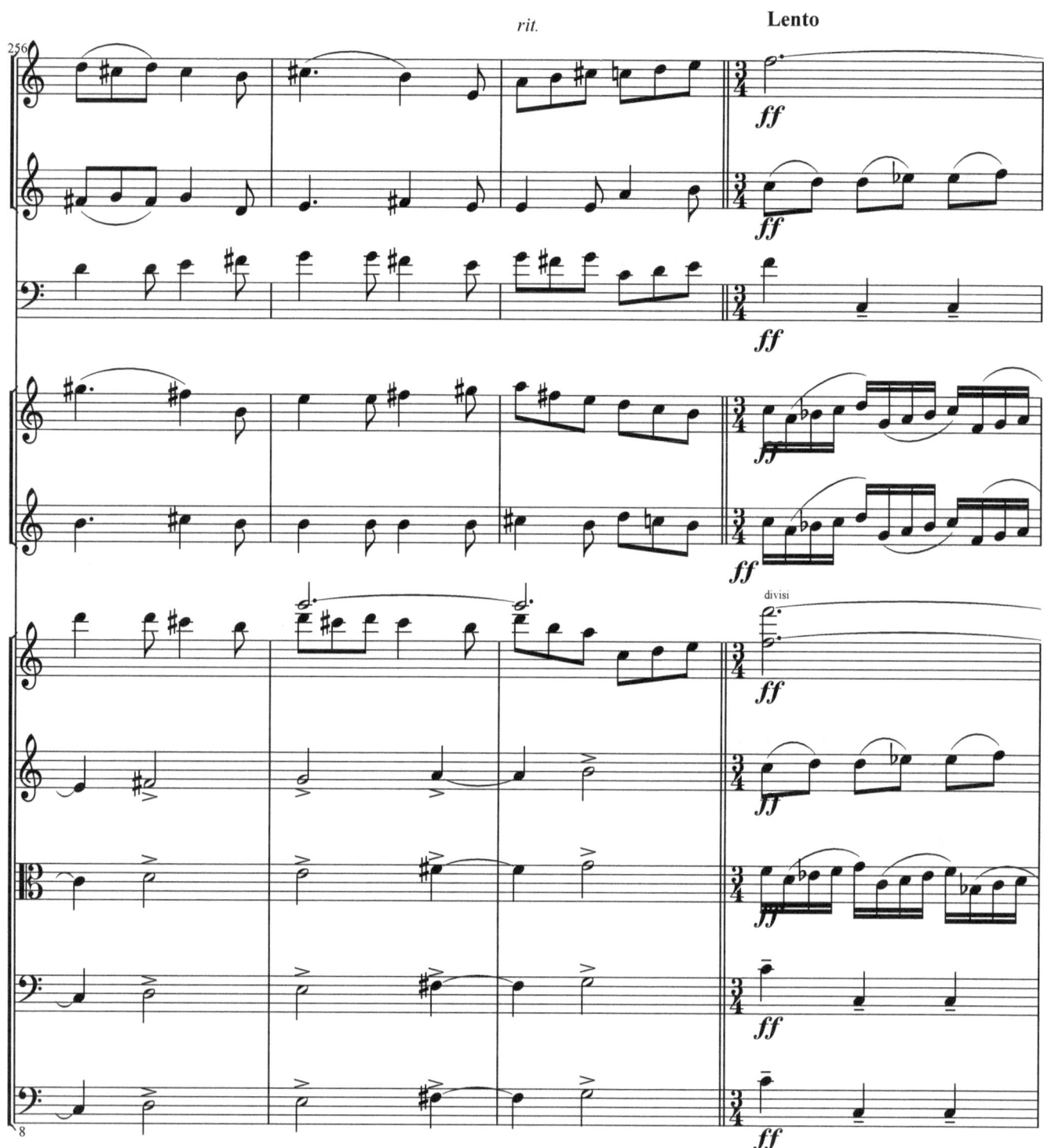

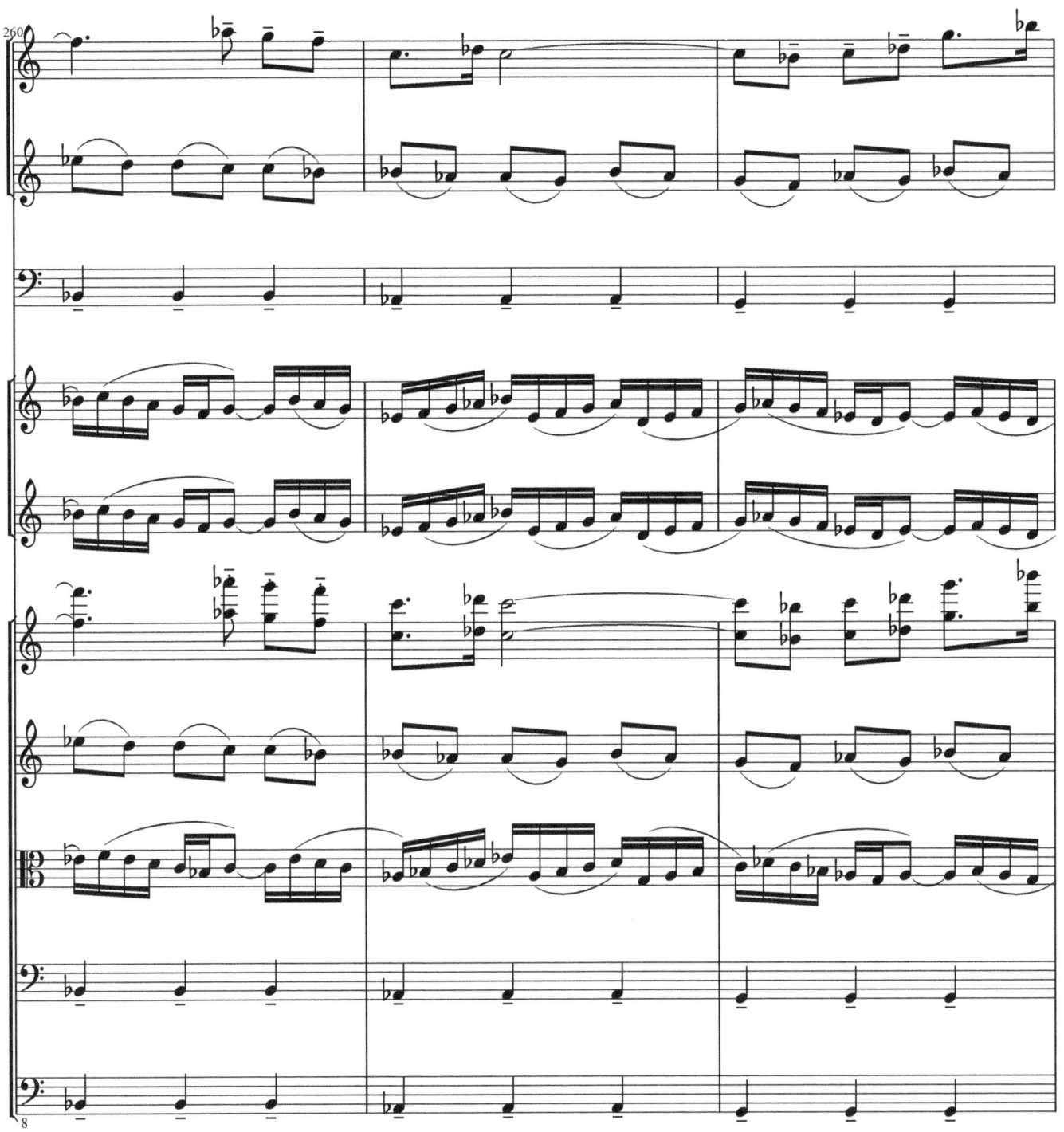

Adagio

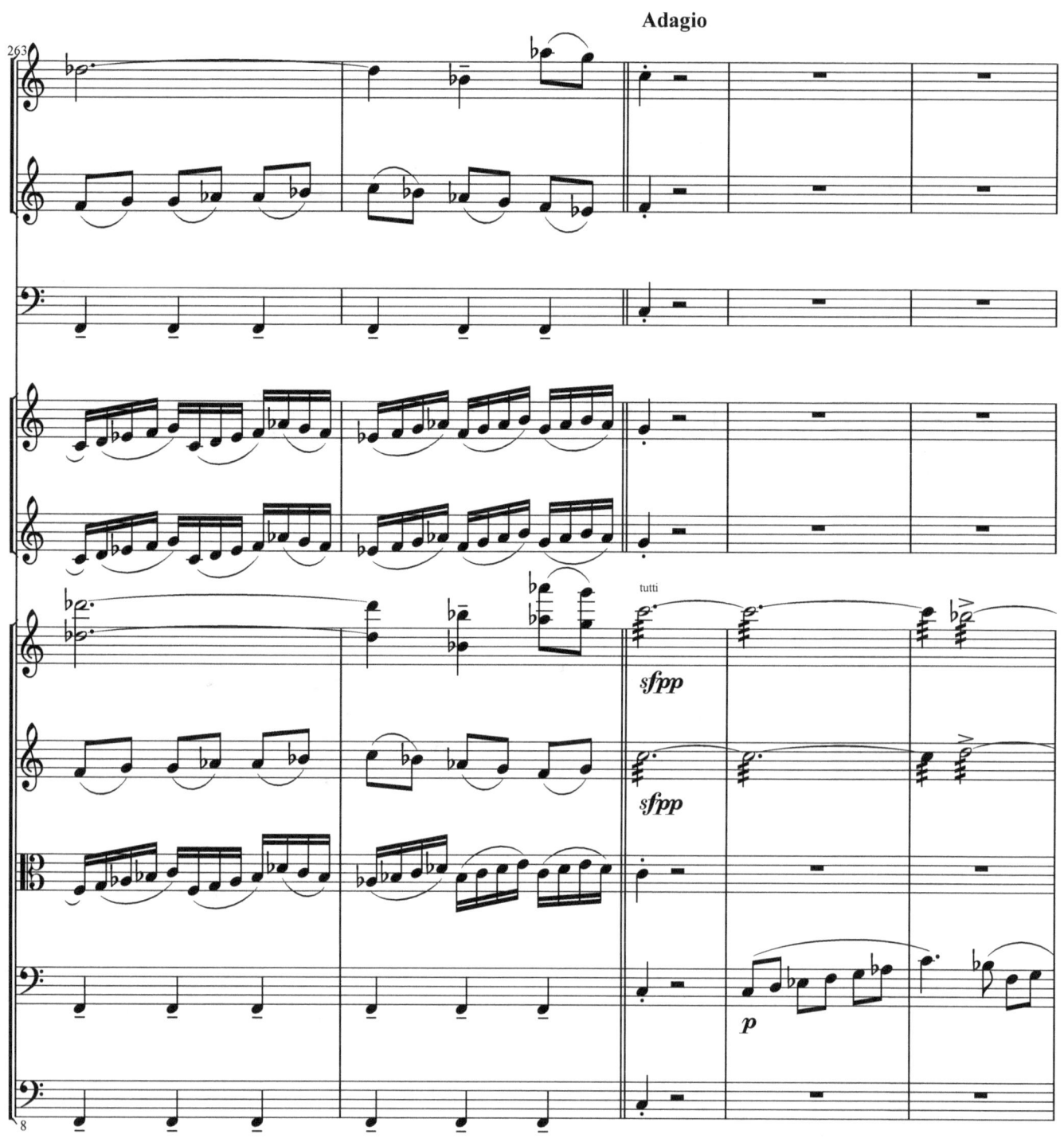

128

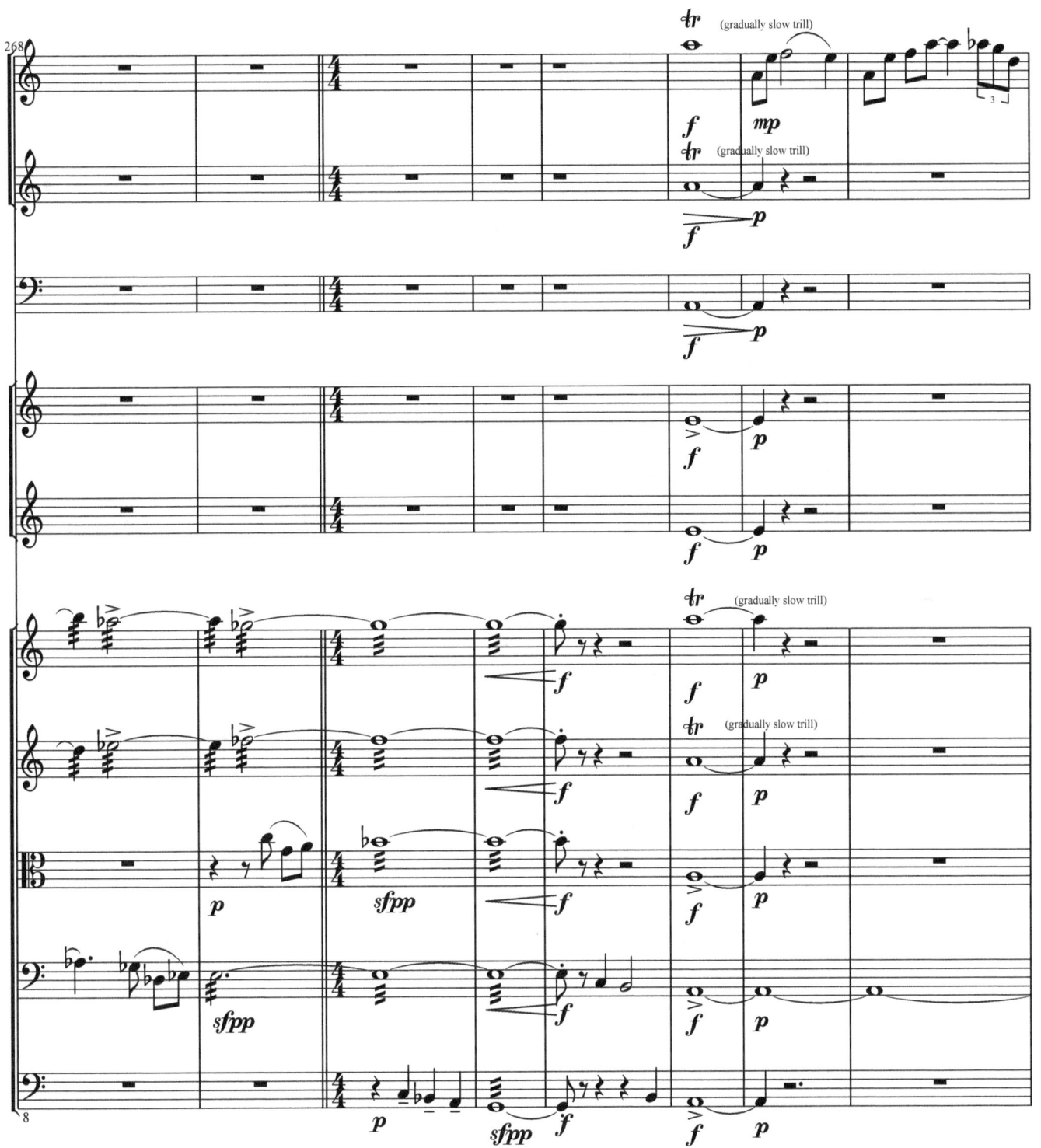

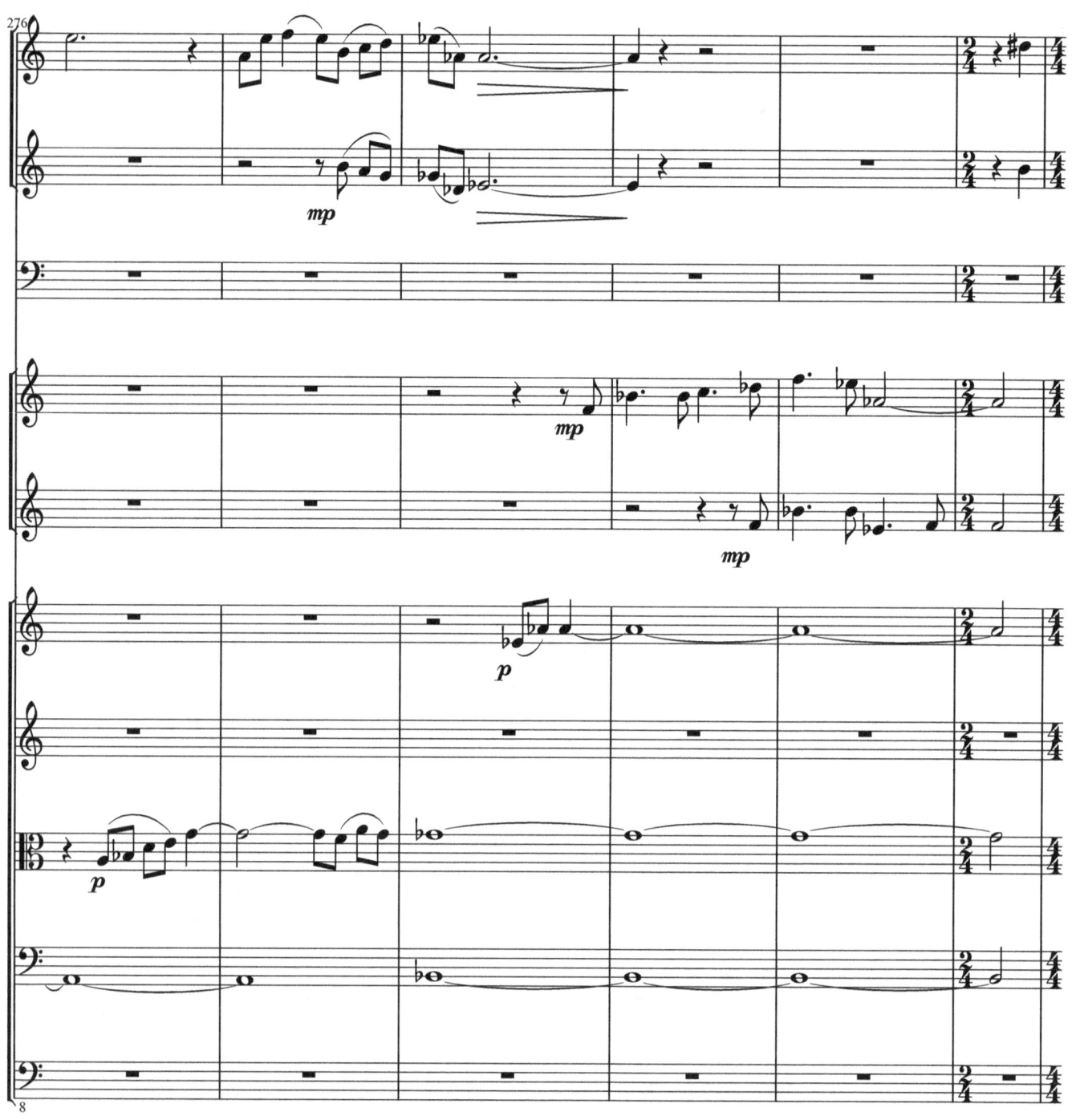

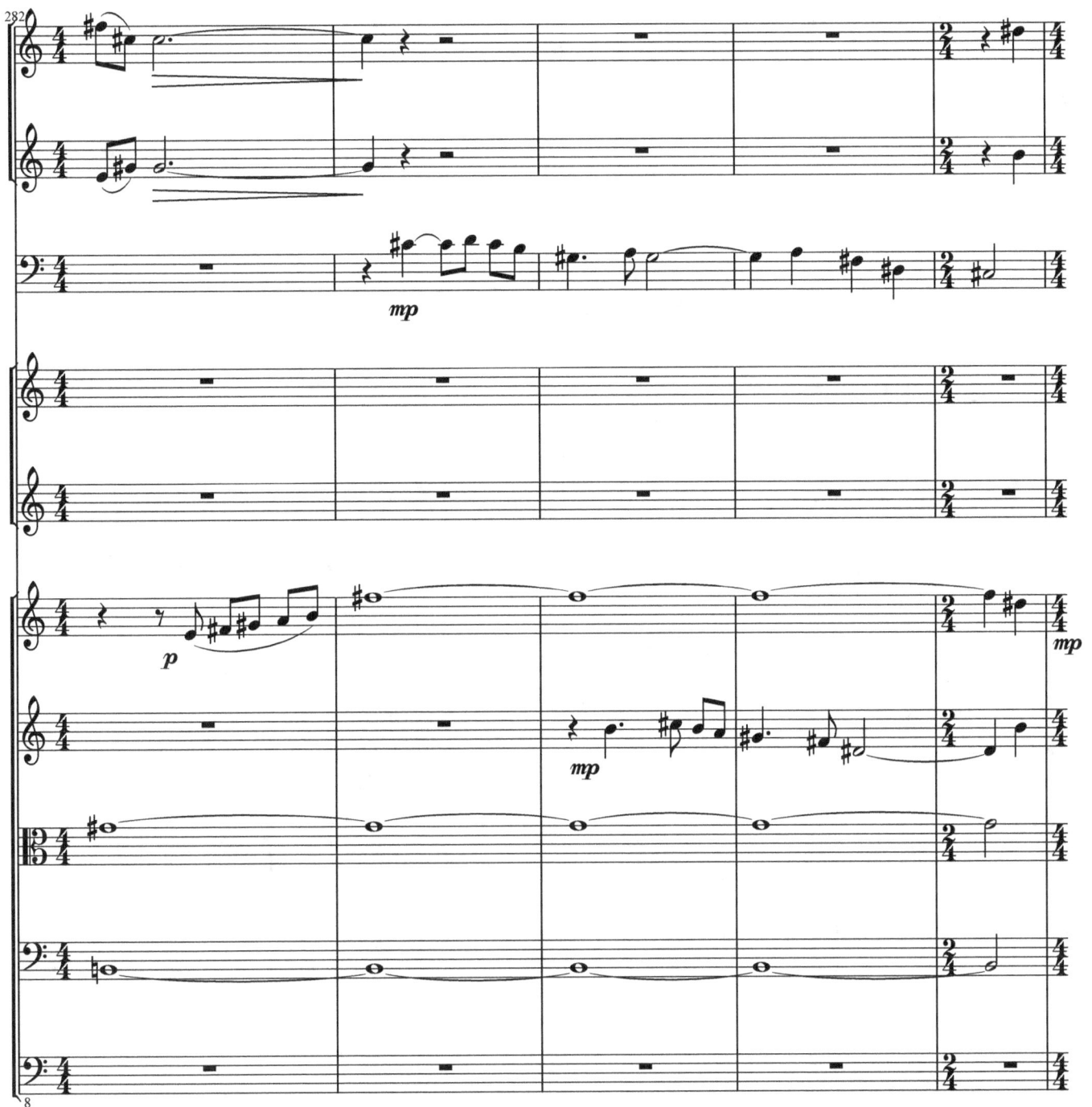

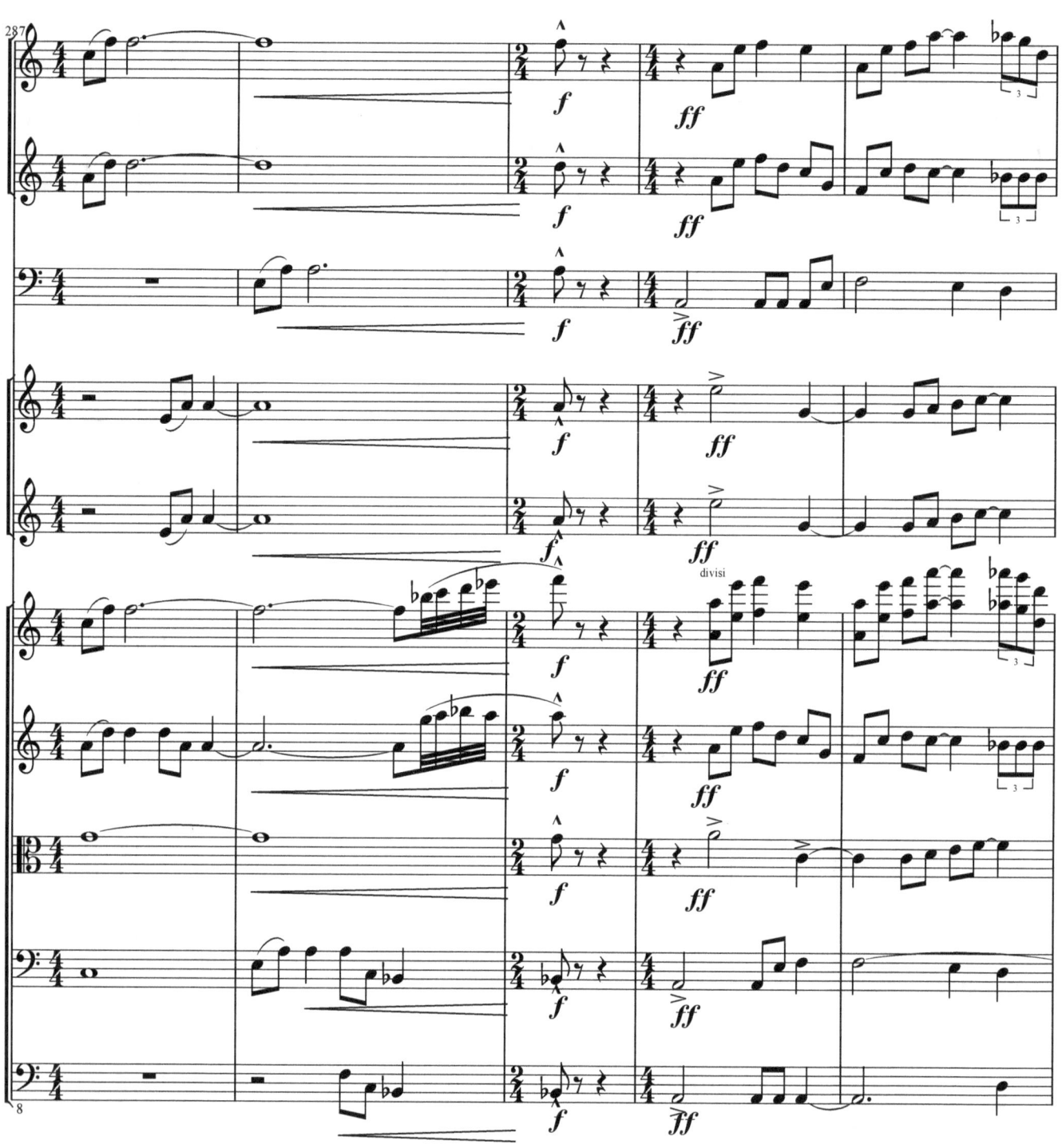

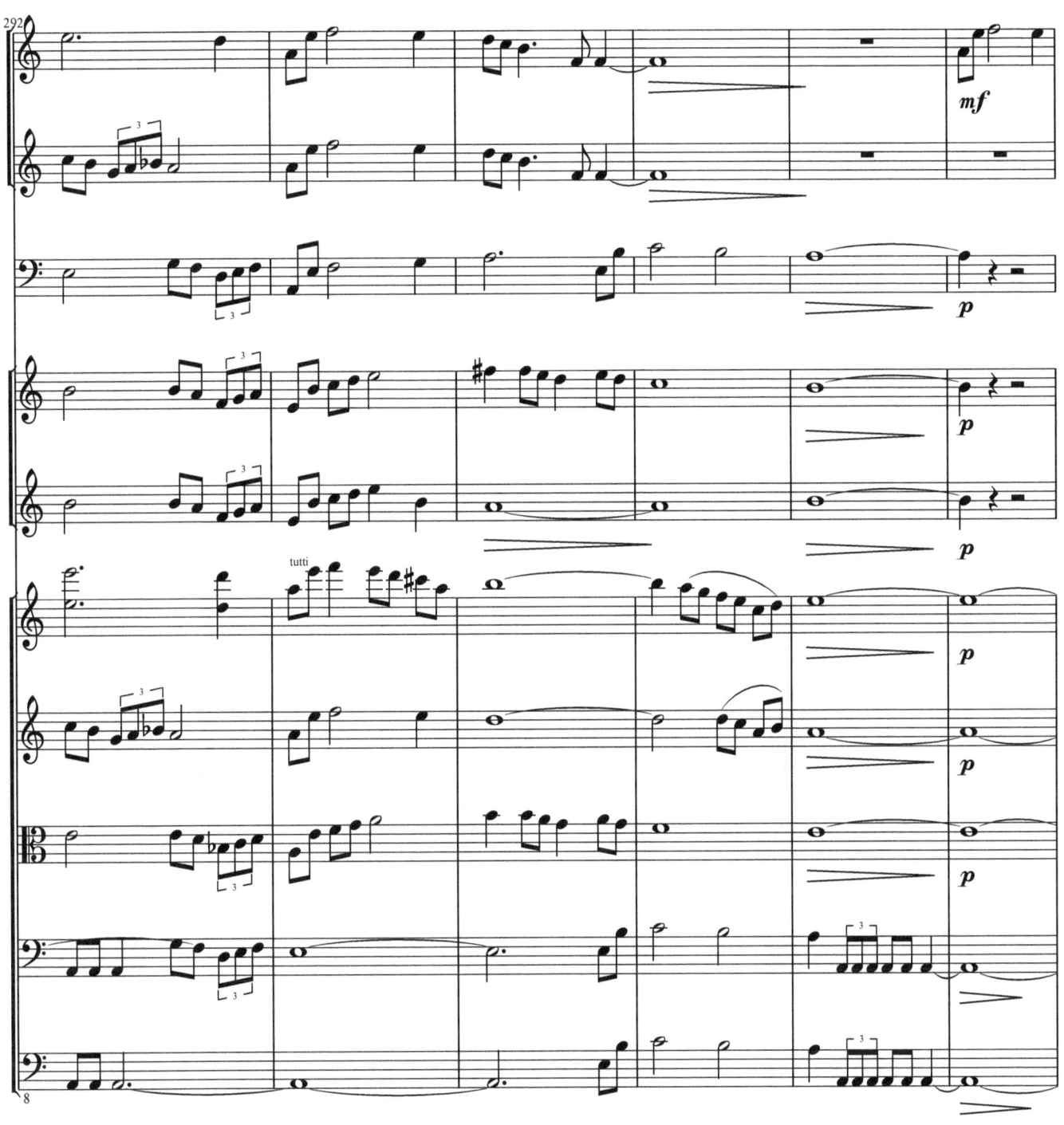

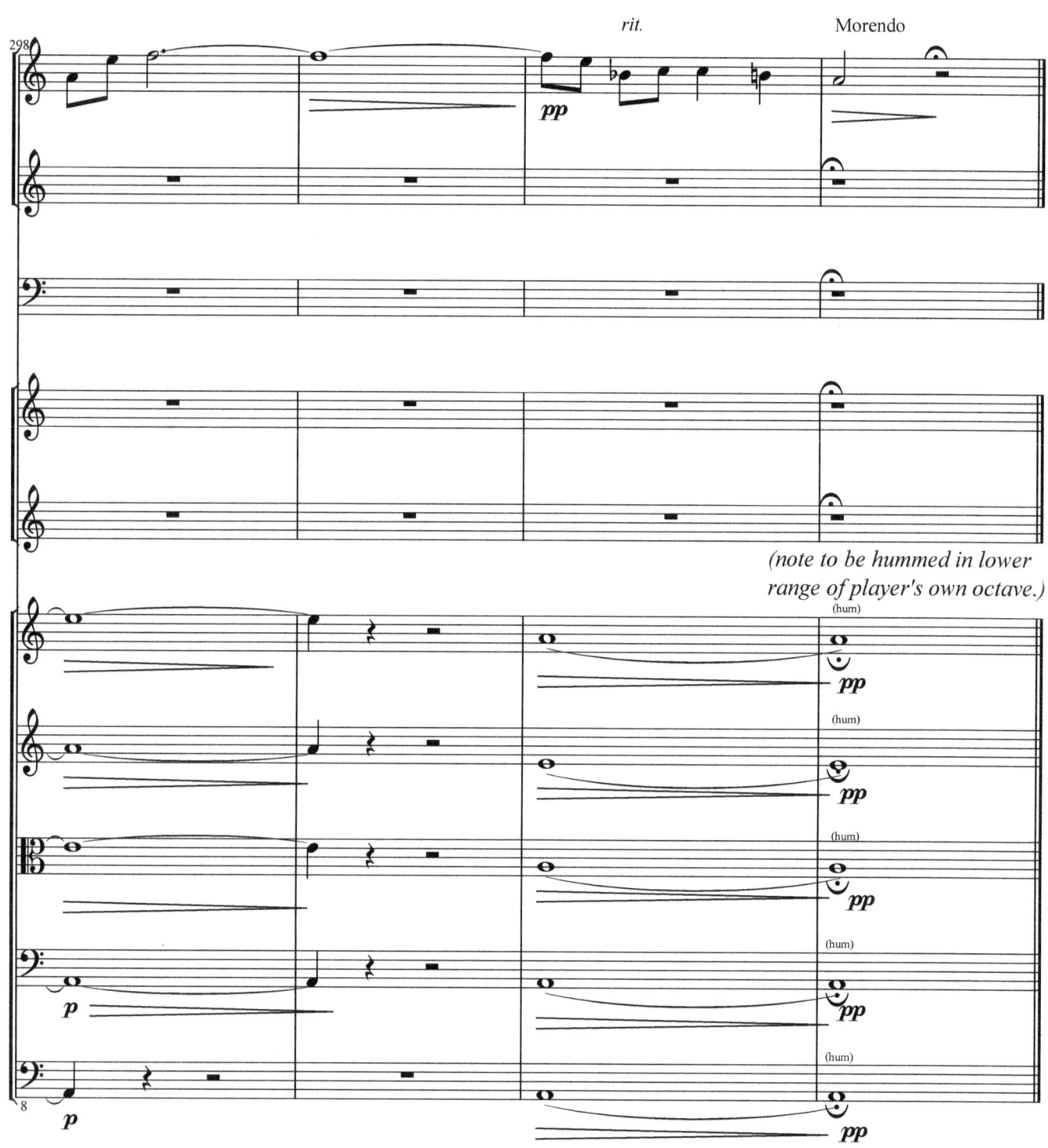

About The Composer

Dr. Kenneth Langer was born in the Pittsburgh area in 1959. He began playing trumpet in the 5th grade and decided in high school to make music his career.

Dr. Langer earned a Bachelor's Degree in Music Education at James Madison University in Harrisonburg, Virginia; a Master's of Music Degree at Radford University in Radford, Virginia; and a Ph.D. In Music Theory and Composition at Kent State University in Kent, Ohio. Since that time, he has taught music at several small colleges.

He has also been the full-time Director of Music and Arts at the Eno River Unitarian-Universalist Fellowship in Durham, North Carolina and the Assistant Conductor and Resident Composer at the Montpelier Unitarian-Universalist Church in Montpelier, Vermont.

During his twenty years of writing over 150 original works of music for various genres including brass, chorus, strings, orchestra, wind ensemble, and woodwinds; he has received numerous awards for his compositions including being named Vermont's Composer of the Year in the year 2000 and winning placement in several international composition contests. He has commercially published well over 30 compositions.

Dr. Langer currently lives in the Boston area with his family where he works as the Head of the Music Program at Northern Essex Community College in Haverhill, Massachusetts.

Publishers

Music For Brass

Nichols Music Company (Ensemble Publications)
P.O. Box 32 Ithaca, NY 14851-0032
www.enspub.com

Solid Brass Music
P.O. Box 2277 Rome GA, 30164
www.solidbrassmusic.com

Cimarron Music Press
15 Corrina Lane Salem CT 06420s
www.cimarronmusic.com

Wehr's Music House
www.wehrs-music-house.com

Music For Chorus

Yelton Rhodes Music
1236 N. Sweetzer Avenue #5 West Hollywood CA 90069
www.yrmusic.com

www.ingramcontent.com/pod-product-compliance
Lightning Source LLC
Chambersburg PA
CBHW080918170526
45158CB00008B/2152